UTOPIA/DYSTOPIA

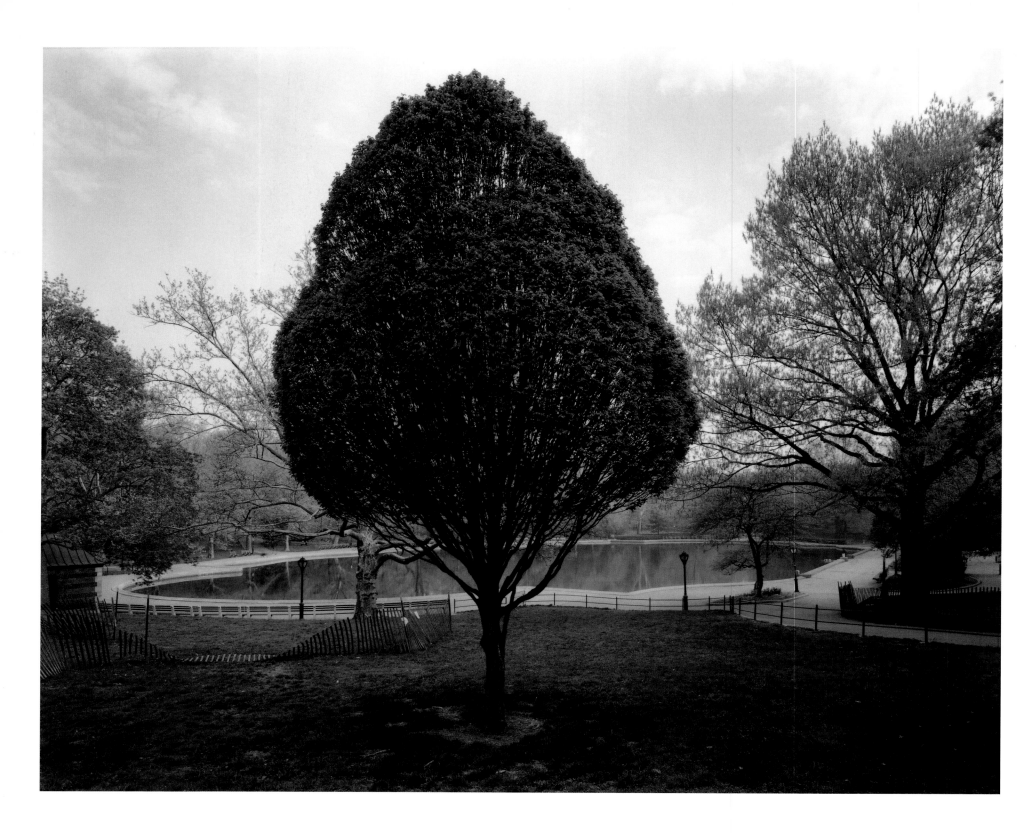

"Allow me," said Mr Gall. "I distinguish the picturesque and the beautiful, and I add to them, in the laying out of grounds, a third and distinct character, which I call unexpectedness."

"Pray, sir," said Mr Milestone, "by what name do you distinguish this character, when a person walks round the grounds for the second time?"

– Thomas Love Peacock, *Headlong Hall* (1815)

UTOPIA/DYSTOPIA
GEOFFREY JAMES

LORI PAULI

WITH ESSAYS BY
STEPHEN BANN
BRITT SALVESEN

CHRONOLOGY BY
KATHERINE STAUBLE

NATIONAL GALLERY OF CANADA, OTTAWA
DOUGLAS & McINTYRE, VANCOUVER/TORONTO/BERKELEY

Published in conjunction with the exhibition
*Utopia/Dystopia: The Photographs of
Geoffrey James*, organized by the National
Galley of Canada.

National Gallery of Canada, Ottawa
30 May – 19 October 2008

Douglas & McIntyre Ltd.
2323 Quebec Street, Suite 201
Vancouver, BC Canada V5T 4S7
www.douglas-mcintyre.com

National Gallery of Canada
380 Sussex Drive
Ottawa, ON Canada K1N 9N4
www.gallery.ca

**Library and Archives Canada Cataloguing
in Publication**
James, Geoffrey, 1942–
Utopia/dystopia : Geoffrey James /
Lori Pauli ; with essays by Stephen Bann
[and] Britt Salvesen.

Issued also in French under title:
Utopie/Dystopie. Geoffrey James
Co-published by Douglas & McIntyre.
Includes bibliographical references: p.
ISBN 978-1-55365-347-9

1. James, Geoffrey, 1942- –Exhibitions.
2. Landscape photography–Exhibitions.
3. Photography, Artistic–Exhibitions.
I. Pauli, Lori, 1960– II. Bann, Stephen
III. Salvesen, Britt IV. National Gallery of
Canada V. Title.

National Gallery of Canada
Chief, Publications: Serge Thériault
Editors: Marcia Rodríguez and Usher Caplan
Visual Documentation: Anne Tessier
Production Coordinator: Anne Tessier
Book Design: George Vaitkunas

Front cover: *Viaduct of the Ohio Turnpike
over Cuyahoga National Park* (pl. 17)
(From a commission by the George Gund
Foundation)
Frontispiece: *Conservatory Water, Looking
North, Central Park, New York* (p. 162)
Back cover: *Seed Company, Lethbridge*
(pl. 36)

Photograph Credits
Photographs have been provided by
the owners or custodians of the works
reproduced, except where noted.

Page 13, fig. 1 and page 19, fig 8: photograph
provided by the author
Page 13, fig. 2: Catherine Lancien, Carole
Loisel
Page 14, fig. 3: Ursula Edelmann / ARTOTHEK
Page 14, fig. 4: Kunstmuseum Basel, Martin
Bühler
Page 24, fig. 2: NSARM, Notman Studio
Collection
Page 45, fig. 5: Musée Carnavalet,
Roger-Viollet

All photographs in the chronology have been
provided by the artist, except where noted.

Pages 165 (middle), 166 (top and bottom),
167 (all), 169 (top right), 170, 171 (left), 173
(left and right), 174 (right): National Gallery
of Canada
Page 165 (right): Kertész Foundation
Page 171 (right): Angles Gallery

Printed and bound in Italy by Conti Tipocolor
Printed on acid-free paper
Distributed in the U.S. by Publishers
Group West

Douglas & McIntyre gratefully acknowledges
the financial support of the Canada Council
for the Arts, the British Columbia Arts
Council, the Province of British Columbia
through the Book Publishing Tax Credit,
and the Government of Canada through
the Book Publishing Industry Development
Program (BPIDP) for our publishing activities.

CONTENTS

FOREWORD

The National Gallery of Canada began collecting the work of Geoffrey James in 1988, when we received a generous gift of three photographs from the Belgian collectors Francis and Evelyn Coutellier. In 1992 and 1995 respectively, the Photographs Collection and the Department of Contemporary Art added to the Gallery's holdings by purchasing prints from his Olmsted and Asbestos series. Our affiliate institution, the Canadian Museum of Contemporary Photography, began acquiring James's photographs as early as 1975, and now owns 108 of the photographer's prints.

A retrospective exhibition gives us the opportunity to view the range of work an artist produces over the course of a career. It is also a chance to look more closely at the various themes and patterns that emerge when a representative number of works by the same artist are brought together in one place at one time. It is the aim of such exhibitions to help us understand the artist's oeuvre in as much breadth as possible, with the hope of providing a deeper and more nuanced appreciation of the artist's intentions, uniqueness of vision, and contribution to the world of art. To mount an exhibition of a living contemporary artist is perhaps even more complex, since it involves an analysis and summing up of what has been done in the past, all while remaining cognizant of what is being created in the present.

We are honoured to present this retrospective exhibition, *Utopia/Dystopia: The Photographs of Geoffrey James*, and would like to thank Geoffrey James for his cooperation in assisting in the realization of this exhibition and accompanying catalogue. We would also like to express our gratitude to the other institutions that generously agreed to lend photographs for this exhibition: The Canadian Centre for Architecture and the Musée d'art contemporain, both in Montreal, the University of Toronto Art Centre, and the Museum of Modern Art in New York.

Pierre Théberge, O.C., C.Q.
Director
National Gallery of Canada

PREFACE AND ACKNOWLEDGEMENTS

For over thirty years, Geoffrey James has used photography to investigate Western society through its landscapes. His ability to locate human aspirations through the built environment coupled with a keen sense of pictorial structure has allowed him to find poetry and irony in the contemporary landscapes in which we live, work, and play.

Utopia/Dystopia was chosen as the title of the exhibition because it signals the two opposing themes that recur in many of James's photographs. From the ideal spaces of formal gardens and sylvan parks to the wastelands of mining and a problematic international border, his photographs explore both the conscious or planned landscapes from the past and the more unintentional landscapes of the present.

The photographs of Geoffrey James have been brought to public attention largely through the publication of books, his preferred method of presentation. James's impressions and experiences are best communicated through this careful sequencing of images, an approach that allows his subjects to be revealed in stages. Every turn of the page provides more information, so the reader begins to feel like a companion on James's investigative journeys.

I would like to join our Director, Pierre Théberge, in expressing my thanks to Geoffrey James for his cooperation. His generosity as a lender to the exhibition and as a collaborator on the catalogue has been a tremendous asset. In addition, I would like to acknowledge Stephen Bann and Britt Salvesen for their superb essays and valuable insights on the artist's work. Special mention must be made of Katherine Stauble's excellent chronology and her meticulous work in compiling the bibliography. I am also grateful to David Mitchell, a hardworking intern for the Photographs Collection during the summer of 2007, for his preparation of research notes about the many places James has photographed.

As usual, the professionalism of the staff at the National Gallery of Canada was instrumental in seeing this project through to completion: my sincere thanks to everyone involved for their hard work and dedication in helping to realize this exhibition and catalogue.

Lori Pauli
Assistant Curator of Photographs
National Gallery of Canada

ARTIFICIAL PARADISE

STEPHEN BANN

Why photograph gardens? Why photograph gardens with a panoramic camera? Geoffrey James has certainly not confined himself to the photography of gardens over the past thirty-five years. Nor have his photographs of gardens over this period been exclusively panoramas. Yet it is my conviction that his panoramic garden photography holds the key to a certain distinctive vision that he has developed over the years, and which singles him out among the preeminent visual artists of the present day. There is of course nothing radical about classifying a photographer as an artist nowadays. Indeed, there is much to be said for Michael Fried's view, forcefully argued in his current study, that today "photography as art matters as never before."[1] Fried has turned his attention in particular to the conjuncture around 1980 when certain artist photographers began to conceive of their works, not as traditional photographic prints to be published in books and magazines, but as large-scale, wall-mounted pieces. He has focused in particular on the large, back-lit colour prints that in scale and address to the spectator turn out to recall the Salon paintings of the eighteenth and nineteenth centuries. Moreover, he has developed the compelling argument that the aesthetic preoccupation with "absorptive" states (the recognition of which he traces especially to the art criticism of Diderot) carries over from the great tradition of Western figurative painting to the artist photographers of the contemporary period.

Yet it is for rather different reasons that we should value the work of Geoffrey James. It is not that he has remained exclusively within the parameters of traditional photography. His work achieved an outstanding exposure when a series of his landscape photographs was shown at the Documenta IX exhibition at Kassel in 1992 alongside the most extensive range of contemporary art production. But in his case, there has been no question of moving unilaterally to a large-scale, Salon mode of exhibition. His photographs still achieve their most intense effect as fine, small-scale contact prints and as sequences of images collected in books. All the same, a special quality distinguishes his work from almost all other current photographers and, by the same token, connects him to the earlier antecedents of the Western visual tradition. In my view, this can be discerned most clearly in the case of his garden panoramas.

Panoramic presentations, in the sense of in-the-round spectacles displaying an urban prospect from a high viewpoint, began in the form of painted scenography in the late eighteenth century, and were then annexed for photographic display in the mid nineteenth. While this original sense of the term implied a construction with a special viewing platform and an encircling vista, the word has also been conventionally applied to the less spectacular but equally significant development of pictorial formats over roughly the same period. Landscape painting as such was acquiring increased prestige and a measure of aesthetic autonomy over the course of the nineteenth century, first in Britain and subsequently in France, where the academic demands of *paysage historique* (historical landscape) had initially controlled the practice of the genre. The rise of the Impressionist movement in one sense consolidated this process, since landscape stripped of academic constraints became a defining feature of artistic modernity. Yet however radical Impressionism would prove to be in the novel handling of pigment to register natural light, it was not so adventurous at first in the choice of format. If by panoramic landscape, we imply a format in which the ratio of width to height is roughly 2 to 1, or more, we can identify a series of stages in the course of which landscape artists adjusted their compositional strategies to take in a broader arena. This gradual process of

adjustment extended across the whole of the nineteenth century, and was well launched before the innovations of the 1870s.

Initially, it was a matter of oil sketches, often done in the open air in the presence of the "motif." The painters of Corot's generation responded to the extensive prospects of both Italy and their native France with entrancing small-scale works that approached a panoramic width in tracing the sinuous lines of a valley or a mountain range. Yet these artists still reserved their main efforts for the grand historical landscapes, peopled with nymphs and heroes, that were destined for exhibition at the Paris Salon. These Salon pictures were, for the most part, more conventional in their proportions. Although the members of the Barbizon School (so called after the village in the Forest of Fontainebleau where these landscape painters congegrated) turned their attention to natural scenery and replaced the creatures of allegory and mythology with the homely round of peasant life, in their major works they rarely strayed from a conventional picture format.

These unquestionably superficial generalizations about landscape painting in nineteenth-century France may serve as a pretext for a brief discussion of the work of Charles Daubigny (1817–1878). In terms of what I would call the panoramic vision, Daubigny is perhaps the major figure who first succeeds in reconciling the perceptual and compositional problems involved in the process that I have schematically conveyed. It has been some years since Peter Galassi suggested that the first photographers were deeply indebted to the practice of the oil sketch, which heralded a new freedom in pictorial composition and a parallel concern with the fidelity of tonal values, especially where the portrayal of landscape was concerned.[2] Galassi's argument has attracted much positive discussion over the intervening years, as well as a certain measure of opposition. In setting up the work of Daubigny as an overture

to the garden photography of Geoffrey James, I am not implying any such form of direct influence, or even a close historical connection. The temporal gap is in any case so wide as to make an argument of this kind no more than speculative. What I would claim here is that the exemplary development of Daubigny in regard to his pictorial format and his attachment to specific types of landscape helps us to appreciate relevant aspects of the morphology and the phenomenology of landscape viewing. In this sense, he offers a model for the panoramic approach. More recent practitioners of landscape painting have also been innovative in their use of a panoramic format, the British painter Ivon Hitchens being a name that springs to mind. But Hitchens's close-knit compositions that evoke dense coppices and woodland pools reflect an English delight in the micro-landscape that goes back to the Shoreham subjects of Samuel Palmer. By contrast, the work of Daubigny, conceived at the very period when the aperture of the camera was opening to startling new visual prospects, clarifies the more spatially extensive possibilities of panoramic viewing in such a way as to illuminate our response to Geoffrey James's garden photographs.

Charles Daubigny, the nephew of Edme-François Daubigny, a landscape painter of the old school, began his career in the popular Paris studio of Paul Delaroche, who was himself originally trained under the landscape painter Louis Watelet. Encouraged by Delaroche to compete for the Prix de Rome in historical landscape in 1841, Daubigny had every hope of being successful, but failed to abide by the rules of the competition and so was disqualified. Rather than compete again when the chance came round in 1845, he decided, in the words of a contemporary critic, "to say goodbye to academic landscape for good."[3] His work attracted increasing attention during the 1850s, and at the Salon of 1859, his *Bateau de l'Oise* was snapped up by the photographer Nadar in advance of

the official opening. Daubigny had by this point decided to focus his landscape studies on the river valleys to the north of Paris, particularly on the Valley of the Oise, which he remembered from his childhood. He eventually made his home at Auvers-sur-Oise, and his paintings came to reflect the route of the leisurely trips that he made by boat throughout the surrounding region. As the critic of *L'Art* later reflected, "He provided himself with a boat with which he accomplished frequent excursions along his favourite rivers … painting, as he followed the current, all the enchanting sites that the caprice of the river unrolled before his eyes."[4] It was as if, through being aligned in their format with the longitudinal movement of the artist's boat, the river landscapes had been extended in their proportionate length – and Daubigny's compositions followed suit in conveying the effect of this travelling viewpoint. To a certain degree, Western landscape painting acquired through this process a kinaesthetic, interactive character comparable to the Chinese scroll paintings that were devised to be unrolled by the viewer.

Yet some of Daubigny's most original work reflects an equally intense preoccupation with the dynamic possibilities of a fixed prospect, with the vanishing point being given a decisive off-centre orientation, and the spatial field being opened up laterally in consequence. We can see the process at work even in the early studies that he completed in the southern landscape of the Isère, to the east of Lyon. His vigorous charcoal drawing from 1852, *Vue prise à Crémieu (Isère)* (fig. 1), wrenches apart the conventional landscape format, in which so-called *coulisses* of foliage tend to frame the prospect on either side, while allowing the distant view to emerge at the centre. In this drawing the vigorous arboreal growth seems to invade the space from the left, forcing the eye to follow the winding track to a sun-lit curve where it vanishes into the distance. In a particularly striking example of a full-scale painting, *Écluse dans la vallée d'Optevoz (Isère)* (fig. 2), Daubigny chooses a broad landscape format whose central feature is a lock. The almost motionless streams that lie placidly on the left-hand side of the composition are counterpoised against the penned energy of the man-made canal that dominates the higher level on the right. So there is a structural discontinuity in the visual field that is cleverly assumed in the composition.

That Daubigny saw the logical consequence of this manipulation of space to be the establishment of two alternative viewpoints

Figure 1
Charles Daubigny, *Vue prise à Crémieu (Isère)*, 1852, charcoal on paper. Illustrated in *L'Art*, vol. 25 (1881, 2): opposite p. 74

Figure 2
Charles Daubigny, *Écluse dans la vallée d'Optevoz (Isère)*, 1855, oil on canvas. Musée des Beaux-Arts, Rouen (D1886.1)

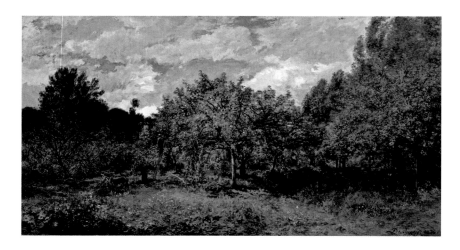

Figure 3
Charles Daubigny, *Le Verger*, 1876, oil
on canvas. Städelches Kunstinstitut,
Frankfurt (23980)

Figure 4
Vincent van Gogh, *Le Jardin de
Daubigny*, 1890, oil on canvas. Collection
Rudolf Staechlin, permanent loan to the
Kunstmuseum Basel

is effectively demonstrated by the magnificent 1876 Salon painting that comes at the end of his career. *Le Verger* (fig. 3) is a work on the same grandiose scale as some of the major historical land-scapes of the French tradition, measuring 168 × 300 cm – almost twice as long as it is high. The subject is one of the rich orchards in his home country north of Paris, where the bright red apples are being harvested from heavily laden trees. In this case, there are obviously two distinct tracks that the eye can take, one leading off on the left, the other starting auspiciously with the painter's signature in the right corner and looping round to the right. The surface handling of the paint is extraordinarily free, yet the spatial arrangement is much more consciously contrived than in the major Impressionist works that are appearing in the same decade. In particular, a daring balance is struck between the plasticity of the intensely worked surface and the plurality of vistas that are offered to the spectator.

One can imagine how important such works by Daubigny must have been as precedents for van Gogh, when he himself retreated to Auvers in the last year of his life. The well-known *Crows over the Wheat Field* – the subject of a remarkable essay by Meyer Schapiro[5] – uses the broad format and the effect of perspectives turning back on themselves to momentous effect. Even if we dis-count the faulty premise that this was the artist's last work before his suicide in 1890, the result is still a powerful one. Even more curiously disquieting, in the light of our discussion, is the extraor-dinary *Jardin de Daubigny* (fig. 4) from the same year. Here, in a painting almost exactly a third the size of *Le Verger*, and similar in its proportions (56 × 101.5 cm), van Gogh has taken Daubigny's own garden as his subject. It is now seemingly a public garden, with an indistinct figure standing in the middle distance. A cat pads across from left to right, in the direction of the painted caption that provides the painting with its title. But the special fascination of the work surely lies in its exemplary enmeshing of the natural and the artificial. Here are carefully planted trees that draw attention to human agency through their neat regularity, and here is a florid flower bed that holds centre stage in a lopsided manner that com-pels our attention. The top of a building peeps over a long roofline, creating an incongruous backdrop to the scene, while on the right the ancient church veers off sideways, cresting a jumble of green foliage and red-roofed village houses. Two different vanishing points are implied, one of them indicated by the convergence of lines beyond the indistinct person in the middle distance, the other veer-ing off where the garden drops away; the gulf is surmounted by the receding church. Daubigny's garden has become the pretext for a distended, even dystopian vision very far removed from the Edenic plenitude of Daubigny's orchard.

In concluding this analogy, I need to admit straight away how totally different from these precedents in their content (if not in their visual mechanics) are the garden photographs of Geoffrey James. Daubigny was reputed to have returned from his visit to Rome – the obligatory pilgrimage for young French academic

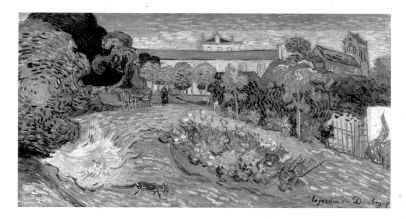

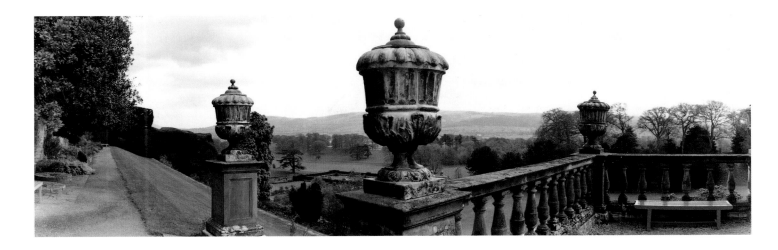

Figure 5
Geoffrey James, *Powis Castle, Wales*, 1985, gelatin silver print. Collection of the artist

painters – with a drawing universally admired by his friends, which represented ... a thistle![6] James has also lingered in the Roman Forum, but what he brings back is an image that is satisfying and replete, redolent of our own period when "commemoration and conservation" are the dominant cultural motifs, rather than the desire to repudiate the signs of academic orthodoxy. Yet such a radical difference does not seem to me to be a matter of mere discontinuities in the pictorial tradition. On the contrary, it could be argued that the nineteenth-century developments I have mentioned relate dialectically to the path James has taken. The antithesis is a clear one. A painter like Daubigny – balked of his Prix de Rome – also sedulously avoids the signs and symbols of the classical tradition. James has, by contrast, sedulously cultivated them, through the very process of selecting so many of the great European gardens of the past as his privileged subject matter. Daubigny relied for his pictorial effects on the foregrounding of painterly values in a panoramic format, and the experimental duplication of vanishing points. James, by contrast, has utilized the technical possibilities of the panoramic camera in order to pluralize vanishing points. He has also confined himself, for the most part, to the fine gradations of black, white, and grey that compose the traditional photographer's palette. Even here, however, there is a kind of dialectical return to the argument, when we reflect that Daubigny himself was the author of no fewer than 117 etchings, as well as of innumerable charcoal drawings. Daubigny too was endeavouring to express the experimental possibilities of new landscape formats through the special artifice of a monochromatic scale.

Among Geoffrey James's first photographs with a panoramic camera are his views of the garden at Powis Castle (fig. 5). That he was himself born in Wales makes this an appropriate starting point, as does the fact that this is a great garden with a particularly complex history and pedigree: mingling French and Italianate aspects in its design, it is also situated on the Welsh side of the once-contested border with England. A view from the terrace at Powis provides what might be regarded as a classic demonstration of the panoramic view. With a proportionate relation of 1 (height) to 3 (width), the photographic print sets out in impeccable clarity the dual prospects that Daubigny and van Gogh (with their roughly 1 to 2 proportions) have to work hard to set apart. The central urn, of three, occupies the middle position. To the right, the stone balustrade recedes to frame a small bench, while offering a view through to the wooded landscape in the valley beyond. To the left, a path overhung with trees sheers off into the distance, where another bench is barely visible against the dense mass of the topiary. This is indeed an image that is as clear as a theorem. The terrace itself has presumably been designed to give a viewing platform that overlooks the hillside site with its steep decline. The camera's prospect does not repeat this vista, but translates the viewer's position into a phenomenological dilemma, as it were. We can well imagine ourselves deciding to approach and sit down upon the nearby bench. Equally, we can imagine making the longer trek to the other bench which benefits from the shade of the topiary. But this reading does not mean that the image is instrumental in a banal kind of way. Arrested as we are by the situation of choice, we have the chance to observe also that distance and substance have been conveyed through the use of a visual code of extreme subtlety. From the random deposits of lichen on the nearby urn to the misty outline of the faraway hills, everything is realized in its particularity, the random and indistinct as well as the close and palpable.

It would be an interesting exercise to imagine what the Powis terrace photograph might have been like, had it taken the form of

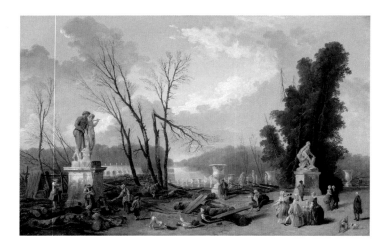

Figure 6
Hubert Robert, *Le Tapis vert*, c. 1775,
oil on canvas. Calouste Gulbenkian
Museum, Lisbon (626)

a painting. As viewed if it had been painted from this particular position, it would probably have appeared too reliant on artifice, too symmetrical, and too dependent on reiterating the man-made articulations of the space. It is in fact precisely the fine grain of the photographic image that succeeds in counteracting this impression, endorsing as it does the high veracity of the registration. A comparison might be struck with Hubert Robert's remarkable small paintings that show parts of the garden at Versailles in the late eighteenth century. In his *Le Tapis vert* (fig. 6), there also happens to be an elaborate urn close to the centre of the composition. But this urn is situated in the middle ground, just to the right of a canal that recedes towards a single-point perspective. Incorporating as it does two of the major sculptures exhibited at Versailles – Pierre Puget's *Milo of Crotona* and a copy of the so-called Ildefonso group once thought to feature Hadrian and Antinous[7] – this is a painting that dramatically celebrates nature in its wild and in its cultivated form. The shattered trees on the left are counterpoised with a vigorous growth of foliage on the right-hand side, where the athlete Milo endures his unequal struggle with the lion that is to devour him. Sundry working and leisure activities are represented among the heterogenous figures that occupy the foreground of Robert's composition. But we are encouraged to identify perhaps only with the contemplative and soberly dressed gentleman who pauses to witness the activity from the extreme right-hand edge of the composition. By contrast, the Powis terrace has no need of staffage to bring the prospect close to us, seeming to be almost at the end of our nose.

Yet James by no means shuns the symbolic possibilities of sculpture in his panoramic garden compositions. Choosing a very different combination of forms from those articulated in the terrace image, he proceeds a little further to photograph the magnificent array of topiary descending a steep slope that is the pride of Powis Castle. Balancing the sculptural figure of Hercules in James's print is a dense jumble of dark masses of foliage that appear to be cascading down the hill into the valley (pl. 13). Hercules makes frequent appearances in historic European gardens, since his killing of the Nemean lion – one of his twelve labours – is used to symbolize the vanquishing of brute nature by human strength and initiative. James's visual confrontation between the rampaging mythological hero and the exuberant natural growth preconstrained by its sculptural form seems to advance this issue of rivalry between nature and culture uncompromisingly into the foreground. The ploy might at first sight appear to be quasi-satirical. Yet I would suggest that James's way of staging contrast is not so much humorous as elegiac. This juxtaposition may impel us to reflect on the vanished world in which the figure of Hercules would have possessed an ample reserve of symbolic power.

It is important to realize that these early panoramic photographs were taken with quite simple technical means. The tripod-mounted camera James was using had a fixed aperture and no exposure controls. The uncoated lens, which proved suitable for European conditions, was hopeless in the face of the more brilliant light of North America. The panoramas were therefore the product not only of historic European gardens, but of historic Europe as a whole, which offered the spectacle of a natural world always subtly inflected by cultural values no less persistent than the soft atmosphere that pervaded every scene. So there is no special need for James to feature statuary as a marker for the classical world in the panorama that incorporates the equally impressive topiary forms of the garden of the Villa Brenzone in northeast Italy, with its magnificent prospect extending over the Lago di Garda. The great sculpted evergreens recede majestically from the left, while only

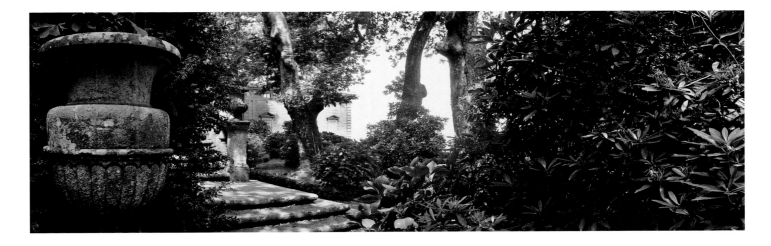

the raking view of a loggia on the upper edge remains to remind us that this is indeed a villa garden. The mountain that emerges faintly through the mist on the other side of the lake seems craggy enough, but somehow is civilized for our viewing by its apparent proximity to the clipped arch forms of the topiary (pl. 9).

Italy indeed has an abundant supply of garden prospects that James can endow with his own special charm. In a view of the main axis of La Gamberaia, in Tuscany, the vista recedes in the direction of a terrace where two trees combine to create a lacy black silhouette. But the left- and right-hand prospects afford a series of contrasts as rich in textural effect as they are piquant in their registration of fine detail. To the left, a whitish wall is delicately inscribed with painted cartouches, themselves fretted over with the trailing branches of wistaria and rambling rose. To the right are the ranged Tuscan terracotta pots planted with citrus fruit trees, which deposit deep shadows on their inner side, but catch the rays of evening light on their outer rims. A long, low hillside caps the clipped hedge, its crest gradually losing definition as it recedes into the distance (pl. 14).

Each time that I attempt to describe the visual effect of a photograph in this way, the limitations of such a verbal description come to seem more and more evident. This is not an original observation, and, in spite of the classical tradition of ekphrasis, it is nothing short of obvious that such descriptions of visual works of art must combat the inadequacy of any descriptive language. Yet there is an additional dimension of inadequacy in trying to conjure up the distinctive atmosphere of works like these. I can perhaps explain it by indirect means. The French critic Théophile Thoré detected as a "vice" Manet's cultivation of "a sort of pantheism which places no higher value on a woman's face than on a bunch of flowers ... which paints everything almost uniformly – furniture,

carpets, books, costumes, flesh, facial features." In John House's words, Thoré saw this attitude as "the triumph of materialism in art and as the essence of a new 'modernity.'"[8] Accepting the point that Manet's material is not the natural world as such but the sophisticated clutter of modern urban living, one would have to comment that precisely the opposite is true of these garden photographs by Geoffrey James. The element of "pantheism" can no doubt be taken for granted, in the sense that the beneficent sun has distributed light and dark accents indiscriminately over the entire scene. We could well endorse the cliché, dating back to the time of Manet and Thoré, that it is the sun as master artificer who is ultimately the author of any photographic process. But the result in photography is not "materialism" in the sense of a democratic uniformity of treatment by the medium. Rather, it is the endowment of each respective surface with a special tincture all its own. That the panoramic format encompasses unusual contrasts of propinquity and distance, in its comprehensive recomposition of the physical elements of the garden space, makes this effect all the more marked.

Without doubt, this feat is radically dependent upon the achievement of especially precise photographic images. Geoffrey James is certainly right to insist that impeccable contact prints are necessary to exhibit many of his most telling and subtle details. I myself cherish such a print that shows the Renaissance garden of the Villa Lante, near Viterbo (fig. 7). Having visited the garden some years ago, I still retain an idea of its overall topography. But I cannot easily recall the point of view from which this prospect is taken. What I see in the left foreground is a splendid urn, almost filling out the frame. What I observe in the right foreground is a dense shrub, some of whose most prominent glossy leaves have caught the light. But the magical effect of this image resides for me in the fact that its shallow depth is bounded by a view of the wall of the Renaissance villa,

Figure 7
Geoffrey James, *Villa Lante*, 1982, gelatin silver print. Collection of the artist

Figure 8
Lucien Gautier, *L'Écluse de la Monnaie*, 1881, etching. Illustrated in *L'Art*, vol. 25 (1881, 2): frontispiece

with two pedimented windows appearing on both sides of a sturdy intervening tree trunk. The masonry at the very edge of the wall defines a clear boundary, beyond which there is simply a domain of pure space. This effect is not just an example of sharp definition, since the positive quality of that space is also evident. The registration of both stone surface and impalpable atmosphere seems as precise as it could possibly be, given the notional distance from which this portion of the villa is being perceived. If I compare my superb print with the book version from the same negative published by the Stamperia Valdonega, Verona, in one of James's early exhibition catalogues, I can observe nothing of the kind. The masonry edge merely leaches into the indefinable white ground, the perception of both space and substance significantly impaired.

This close comparison between variant images suggests that it may be relevant to think of Geoffrey James's panoramic photographs in the traditional context of print connoisseurship.[9] In certain respects, the result of the invention and development of photography was to draw attention away from the qualities traditionally associated with fine engraving, which – at least in its reproductive function – seemed to have been definitively superseded by the new process. In other respects, the reverse was true. The very challenge of photography was such as to encourage printmakers to exploit a range of techniques and effects that presented the most striking contrast to the photographic medium. Etching, with its capacity for creating lustrous dark tonalities and its valorization of the graphic line, underwent a dramatic revival from the 1860s onwards. As has already been noted, an artist like Daubigny, though extremely distinguished as a colourist, continued to put a great deal of effort into rendering his novel forms of landscape in terms of black and white. Other, more specialized, etchers responded to the patronage of editors like Léon Gaucherel of the

sumptuous magazine *L'Art*, and created images of town and country that for a time seemed to outpace the advance of photography since they were able to combine a scale that was impressive (by comparison with the photograph) with the guarantee of graphic quality derived from individual draughtsmanship.

Lucien Gautier's *L'Écluse de la Monnaie* (fig. 8) – a print of the Seine and its banks looking in the direction of Notre Dame – makes a fascinating comparison in this respect with one of the photographs included in James's recent collection of images of Paris: in this case, his *Quai de la Tournelle* (pl. 45), which focuses on a distant view of the same cathedral from behind, as seen from further along the Left Bank. In Gautier's print, it is the extraordinary manipulation of the etched line that animates the broad vista, appearing almost aleatory as it picks up the swirling currents of the river, and yet superfine in tracing the frail branches of the leafless trees that stand before the stone façade of the Mint. In James's photograph, this wayward linearity is replaced by an exact calibration of the respective values of earth and water, of stone and of foliage. But the aesthetic attraction of the image, as we look it over, still seems to reside in following the successive modulations in a scale of

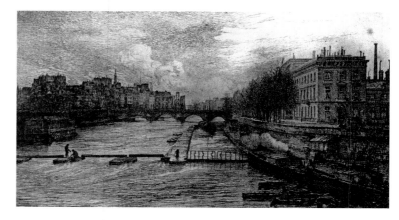

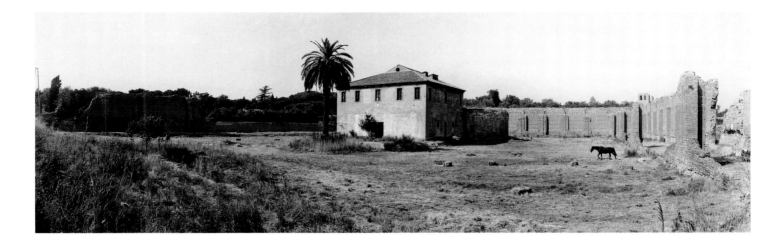

darkening tones that depart from a uniform grey ground in such a delicate fashion as to invest both near and far objects with a quickening sense of substance.

In mentioning the *Paris* collection, I am of course departing from my predominant focus on the garden panoramas. Though I have concentrated principally on this aspect of James's work, I do not mean to dismiss as irrelevant the major projects that he has completed in the photography of urban settings, as in the recent book on Toronto. Nor do I intend – by confining my enquiry to the panoramic photographs in black and white – to set aside such works as the colour panoramas of three Yorkshire landscapes James has recently completed.[10] Quite the opposite. I can confess that with the photographs of the Yorkshire Sculpture Park (taken in the early morning to catch the distinctive quality of English autumnal light), I caught the unique tonalities of the Pennine landscape I have known well since early childhood. As I have argued, this is not necessarily an effect produced only by photography. By a happy coincidence, I was able to sense just the same harmonies of soft green and gritty grey in the work resulting from a rare Yorkshire excursion by Whistler – his small painting (13.3 × 23.5 cm) of the village of Wortley[11] – which I saw for the first time just a few days after James's Sculpture Park panoramas. I have no doubt that the restrained colour values of the latter helped me to be more attentive to Whistler's parallel achievement.

Again, I can foresee the point that to focus specifically on the garden panoramas is to turn away from the many examples of scenes – taken in Europe as well as throughout the rest of the world – that admit discordant and deliberately jarring elements into the idyllic prospect. James's collection titled *La Campagna Romana* (which incorporates the previously mentioned image of the deserted Forum) contains a number of prints in which the panoramic view places incongruous elements of modernity together with vestiges of the antique. Yet to interpret these works in terms of such an obvious rhetorical antithesis is to devalue their impression, which is in fact much less easy to characterize. First in order within the *Campagna* collection is the print of *Circus Massenzio,* or the Circus of Maxentius, which displays a stretch of ancient brick walls encircling a stark modern building, the latter dwarfed in its turn by an immense palm tree (fig. 9). A bedraggled black horse is crossing the broad arena from right to left. Described in these terms, the image might easily be registered by the reader as if I were speaking of a painting by Di Chirico. But there is nothing "metaphysical" about James's panorama. One senses, throughout this collection particularly, the point made by James himself that the "labyrinthine complexity of Italian life" is his subject matter, and this inevitably implies that "the *political* permeates everything."[12] The bedraggled black horse in the ruined arena is at the same time gently evocative of the bread and circuses offered to the populace by the Roman emperors, and a surviving testimony to the precarious suburban lifestyles existing on the margins of the Eternal City.

Finally, I would suggest that there is an equilibrium in Geoffrey James's work as a whole between Utopia and Dystopia. Each series that he undertakes also attempts to condense a process of reading, one that frequently involves the contemporary politics, as well as the history, of the chosen scene. Each series is then the outcome of a journey, more exactly one might say, of a kind of reconnaissance. Yet rarely do we gain the sense that he has paused on his mission, even for a short while, and made a place his home. Perhaps it is the most mysterious, and the most utopian, of all the sites he has explored that proves to be the counter-example. Existing neither in his native Britain, nor among the Italian sites that he has so thoroughly explored, it is the Breton château and estate of

Figure 9
Geoffrey James, *Circus Massenzio (or Circus of Maxentius), Via Appia Antica,* c. 1984, gelatin silver print. Collection of the artist

Figure 10
Geoffrey James, *Kerguéhennec –
The Château*, c. 1994, gelatin silver
print. Collection of the artist

Figure 11
Geoffrey James, *Kerguéhennec –
Maid's Room*, c. 1993, gelatin silver
print. Collection of the artist

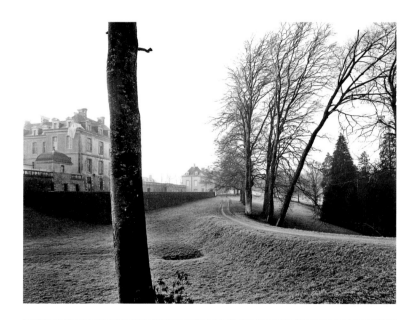

Kerguéhennec (fig. 10), where he stayed for several periods in the 1990s. The works he completed in this centre for contemporary art recall the period when visiting artists were being welcomed as residents, and contemporary works commissioned for the collection of land art displayed in the nearby forest. James's panoramic photographs of the landscape around Kerguéhennec are interspersed with tranquil interior pieces, reminiscent of traditional still lifes in their format, yet inundated with the same soft, ambient light (fig. 11). The whole series appears redolent with the spirit of what Walter Pater in his essay "The School of Giorgione" termed "'park scenery,' with some elusive refinement felt about the rustic buildings, the choice grass, the grouped trees, the undulations deftly economised for graceful effect."[13] Pater's choice of language here identifies a continuing landscape tradition that takes its origin in the paintings of the Venetian Renaissance, and becomes transfused into the world outside through subsequent achievements of garden creation throughout Europe. Such a way of defining "park scenery" brings out the extent to which Geoffrey James's panoramic garden photographs are rooted in the long landscape history of the West.

Notes

1 See Michael Fried, *Why Photography as Art Matters as Never Before* (New Haven and London: Yale University Press, forthcoming). Fried lists Geoffrey James as one of the photographers who is important in the present period, though he does not fall into the category Fried is concerned with in this study.

2 See Peter Galassi, *Before Photography: Painting and the Invention of Photography* (New York: Museum of Modern Art, 1981).

3 These details are taken from a useful article published after the artist's death. See Frédéric Henriet, "C. Daubigny," *L'Art*, vol. 25 (1881, 2): 78.

4 Ibid., 81.

5 See Meyer Schapiro, *Modern Art, 19th and 20th Centuries* (New York: G. Braziller, 1978), pp. 87–99.

6 Henriet, "C. Daubigny," 76.

7 The name Ildefonso comes from the palace of La Granja de San Ildefonso, near Segovia, where the original Roman sculpture was housed by the eighteenth century.

8 W. Bürger [Thoré], *Salons de W. Bürger, 1861 à 1968*, vol. 2 (Paris, 1870), p. 532; John House, quoted in Stephen Bann, *Ways around Modernism* (New York and London: Routledge, 2007), pp. 146–47.

9 Geoffrey James himself has alluded in conversation to the "etched look" of some of his prints, which is dependent to a great extent on the quality of paper on which the photograph is registered.

10 See Patrick Eyres and Fiona Russell, eds., *Sculpture and the Garden* (Aldershot: Ashgate, 2006). The photographs by Geoffrey James were commissioned for the book on behalf of the Henry Moore Institute by Penelope Curtis as editor for the series Subject/Object: New Studies in Sculpture.

11 *Note in Green: Wortley*, c. 1884, oil on wood (Freer Gallery of Art, Smithsonian Institution, Washington, D.C.).

12 Geoffrey James, Foreword, *La Campagna Romana* (Montreal: Éditions Galerie René Blouin, 1991).

13 Walter Pater, *The Renaissance: Studies in Art and Poetry* (London: Macmillan, 1873; reprint, 1906), p. 153.

GEOFFREY JAMES: INVESTIGATIONS

LORI PAULI

The first thing I do is create a framework within which to work. I never walk around aimlessly with a camera hoping I'll find something to photograph. I work on projects, areas of investigation, and so I'm always working on a subject of interest to me. But the actual taking of the photograph is a whole set of other actions, and they are extremely hard to analyze. The main thing is the condition of light.[1]

Geoffrey James characterizes his photographic projects as investigations, and it is a word that aptly describes his working method. His ideas for projects are conceived as general subjects – Paris or Toronto, for example – and they all share a certain affinity for architectural forms, whether in the built environment, the landscape architecture of parks and formal gardens, or the natural architecture of solitary trees. Although his investigations may involve concentrated background reading as a way of knowing a place intellectually, they always involve walking as a way of familiarizing himself physically with the space and setting, using his body to absorb the rhythms of what and where he will photograph. Working within broad categories also provides James with a solid foundation from which to explore the various facets of his subjects. Yet he does not regard these bodies of works as "series" in the narrow sense of the word, since he is never completely finished: "The good places are hard to exhaust."[2] "By the time I've finished a project, I've learned enough to begin."[3] James re-visits subjects, finding more to photograph, more to investigate, more to say. It would be a mistake to categorize the resulting images simply as reproducible records of a particular place or thing. Instead, they are more like commemorations. James is a picture maker who invests the raw materials of light, paper, and chemicals with the "power to recall things."[4]

Panoramas

James's first photographs of gardens were, in his own way of putting it, "haphazard." In the early 1970s, with no clearly defined project in mind, he photographed several parks and gardens in England and Italy, using a 35 mm camera. However, when he travelled to Italy in 1981 to photograph some of its famous gardens and villas with his recently acquired Kodak Panoram rotating-lens camera, he went better prepared. By this time he had steeped himself in the history of European gardens, through an intensive reading of specialists in the field such as Georgina Masson, and he knew exactly which sites he wanted to photograph.[5]

James's early panoramas are elegiac images of some of Europe's most famous gardens as well as some of its almost forgotten ones. The elongated, horizontal format of the panoramas (their width is three times their height) induces us to "read" them from left to right and back again in order to take in all of the information they contain. The panoramic camera, with its moveable lens that sweeps back and forth as light impresses an image onto the surface of the curved film plane, almost mimics the way in which we turn our heads to gradually take in a large scene before us. James has described his affinity to the panoramic format in the following terms:

It seemed to be a different way of making pictures, something that I had instinctively felt I could use, especially in very confined spaces. Italian gardens are usually quite small. Small and complex, with multiple vistas. And it seemed to be very fruitful; the subject was fruitful in relation to the machine. I got wedded somehow to this machine, and it now seems incredible that it was basically all I had. . . . It was very inefficient. You can take only about ten pictures a day working flat out. And you also lost a lot because it was a camera that effectively had no exposure controls at all. Very, very primitive, like the birth of photography.[6]

The word *panorama* was coined at the end of the eighteenth century by an Irish-born painter, Robert Barker, to refer to his pioneering 360-degree wraparound views of Edinburgh and London. Barker's wildly popular and often copied invention required painting a series of landscapes from slightly different

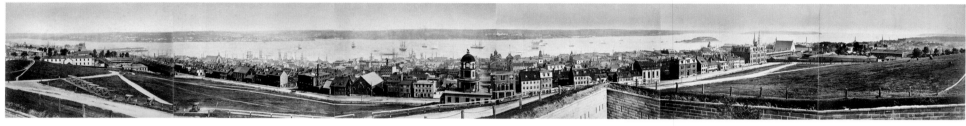

Figure 1
Carleton Watkins, *Panorama of Salt Lake City, Utah*, 1873–74, albumen silver print. Canadian Centre for Architecture, Montreal

Figure 2
William Notman, *Panorama View of Halifax from the Citadel, Showing the Harbour and the Dartmouth Shore*, 1892 or 1893, albumen silver print. Nova Scotia Archives and Records Management, Halifax (N-0377)

viewpoints and then attaching them together on the inside of a huge cylindrical surface. In 1843, an Austrian photographer named Joseph Puchberger patented a hand-cranked panoramic camera whose lens rotated around a series of wide-format daguerreotype plates. By the 1850s, photographers were using the wet-collodion process to make individual prints that could be placed side by side to create a panoramic image. In North America, photographers like Carleton Watkins in California and William Notman in Quebec were making panoramas of a different sort, wide horizontal views showing the expansive terrain of the western frontier and the dense details of cityscapes (see figs. 1 and 2).

The panoramic format seems to have appealed less to twentieth-century photographers, although there were some who continued to explore it. The Czech photographer Josef Sudek first experimented with a panoramic camera in 1916, and then went back to it in a more systematic way in the 1950s.[7] When James first began thinking about how to use the Kodak Panoram given to him by a fellow photographer, Randal Levenson, around 1977 – by which time panoramic roll film wwas no longer available – he decided to look closely at Sudek's work. Based on a careful examination of Sudek's prints from the 1950s, James deduced that the film had been hand-cut from large sheets in order to fit the size of camera. Following this example, he too began cutting strips from 11 × 14 inch

sheet film to use in the Panoram. Eventually, a manufacturer was able to supply him with the custom-sized film he required.

Beyond the technical level, Sudek's influence was also stylistic. James had been acquainted with Sudek's work as early as 1967, having purchased one of his books on a visit to the Czech pavilion at Expo 67. Photographs such as Sudek's *A Walk in the Magic Garden*, from 1954 (fig. 3), evidently resonated with James, whose images of European gardens made over twenty years later convey a similar sense of intimacy and contemplation.

Italy, with its wealth of aging formal gardens, seems to have provided the richest source of subject matter for James's panoramic work. At the Villa Medici in Rome, he turned his attention especially to the stately sculptures that adorn the gardens. In *Villa Medici, Rome (The Loggia)* (pl. 5), for example, we are shown the sculpture of a lion, a copy of Flaminio Vacca's 1598 *Marzocco*, pacing between marble columns. The chalky white stone of the lion stands out against the dark recesses of the inner hallways. The horizontal format and the oblique angle at which James has photographed the scene allow us to see deep into the corner of the Loggia and also give the impression that the lion is striding out of the picture.

The real subject of the Villa Medici photographs, however, is the light itself. In works such as *Villa Medici, Rome (Alley from the Pincio Wall to the Courtyard Garden)* (pl. 4), the soft illumination

Figure 3
Josef Sudek, *A Walk in the Magic Garden*, 1954, gelatin silver print. National Gallery of Canada, Ottawa (37248)

yields an image of quiet monumentality. A rather more dramatic light enlivens one of the other photographs from the series (pl. 11), picking out the central figures of a rearing horse and of Niobe and one of her children. The frieze-like arrangement of the sculptures – positioned in 1967, when the Villa Medici's director was the painter Balthus – is perfectly suited to the horizontal format of the panoramic image.

Beyond Rome, James sought out other Baroque and Mannerist gardens, including the Boboli Gardens in Florence, the Villa Gamberaia in Settignano (see pl. 14), the Villa Barbarigo in Valsanzibio (see pl. 15), the Villa Guarienti di Brenzone in Punta di San Vigilio (see pl. 9) the Villa Lante in Bagnaia, and the Villa Adriana in Tivoli.[8]

James also used the horizontal format of the panorama to photograph the Roman Campagna. He was intrigued by this famous landscape, and by how it is being encroached upon by its modern surroundings. As he himself explained it in a 1988 grant application:

For some time I have been interested in constructed landscapes – in formal gardens or landscape ensembles that are rich in both a visual and a philosophical sense. I have made several visits to Italy to explore the idea of the Italian garden. While single-mindedly grappling with the problem of how to deal with these complex spaces, I kept getting tantalizing glimpses of another world. It was a world seen suddenly from an autostrada, or behind a line of new high-rise apartments – the Roman Campagna. This extraordinary landscape, which attracted travellers and artists for at least three hundred years, now rubs against the modern world of autostradas and suburbs and the sprawl of light industry. It is the friction between these two worlds that interests me.[9]

In his view of an ancient Etruscan road near Veio (pl. 1), gauzy streaks of light create a kind of dreamscape. The light effects in this image were partly due to the Kodak Panoram camera. James later recalled that it was the first time the Panoram worked exactly as he wanted it to:

It was a unique camera in that it had been adapted to take a Berlin Dagor lens that was far superior to the original Kodak lens. One of the camera's several drawbacks, though, was that it would scan evenly only in one direction. (It had to be loaded in a portable changing bag, with the film being taped over the curved back.) The camera also had a fixed aperture and a single shutter speed. For a very brief period, after my Roman camera repairman (I had one in New York and London, too) had a spent a full day tinkering with it, the lens would scan evenly in both directions. This allowed me to photograph the shaded Etruscan road at Veio, which was only a few hundred metres from my house in Isola Farnese, and which I had been looking at for months. I was able to expose the film six times, in effect increasing the exposure by two stops.[10]

The panoramic format was also ideal for the image of the Aqueduct Claudio (pl. 2 and 3), where the rhythmic procession of arches is echoed in the distance by an equally orderly row of pine trees. It is a work that foreshadows James's later interest in bridges and viaducts in North America and in France.

A photograph near the Castel di Leva, just outside Rome (pl. 16), illustrates perfectly James's fascination with the Italian countryside. An abandoned farm house sits isolated in an overgrown meadow, while in the distance we can see a cluster of modernist buildings of the EUR (Esposizione Universale Roma), a 170-hectare Fascist utopia planned by Mussolini for what would have been the 1942 world's fair but was only partially completed and is now functioning mainly as a business complex. The image is divided into two zones – the foreground at the left, with its darker tones and solid presence, and the background at the right, bathed in a vaporous light. This juxtaposition of past and present, primitive and modern, is one of the keys to James's Roman Campagna photographs.

Figure 4
Eugène Atget, *Saint-Cloud, Park*, 1921–22, albumen silver print. National Gallery of Canada, Ottawa (21118)

Figure 5
Eugène Atget, *Saint-Cloud*, 1906, albumen silver print. National Gallery of Canada, Ottawa (21171)

Landscapes and formal gardens outside of Italy also provided inspiration to James. In France, he photographed a number of gardens, including those at the Parc de Saint-Cloud (see pl. 7), where Eugène Atget had created some of his most famous images[11] (see fig. 4). A keen admirer of Atget,[12] James is fully aware of the parallels between his work and that of the venerated Frenchman: "Originally, I was going to do something about the Baroque and I realized I couldn't photograph Versailles after Atget. It just seemed ridiculous. He owned it. It was such a strong vision."[13]

The fact that Atget and James both photographed in Saint-Cloud with a large-format camera naturally leads us to expect correspondences in their work, but there are also significant differences. Most obviously, James's use of the panoramic format means that his images capture a greater horizontal expanse while showing less of the sky and ground. Because of the pronounced horizontality in James's work, the central axis found in many of his images establishes a dynamic tension between the left and right sides. Frequently James will include an element – often a tree-trunk very near the centre (see pl. 7) – that interrupts the view and forcefully divides the picture into two distinct zones. By contrast, a work like Atget's *Saint-Cloud* (fig. 5) is strongly vertical and is unified around the S-form of the winding staircase. Another crucial difference between the two photographers' work has to do with the reshaping of space caused by the curved back in a panoramic camera. James's ability to control the effects of this distortion makes them barely perceptible, but the subtle curvature is nevertheless there, and it is part of the panoramic aesthetic.[14]

A view of the grounds at Chiswick House in West London (pl. 12), originally designed for Lord Burlington by William Kent and Charles Bridgeman in the 1720s, provides an interesting example of James's panoramic work in Britain. James photographed at

Chiswick in 1984, concentrating primarily on the garden's semi-circular hedge, which encloses the slightly recessed space known as the exedra. The light-coloured sculptures of urns and classical portrait busts are thrown into sharp relief against the dark foliage behind them. The overall shape of the hedge is not made obvious, for James has deliberately placed his camera off to the side, forcing us to view the scene from an extreme angle. Near the centre, a tall herm acts as a dividing point or axis, resulting in a disruption of the picture plane. On the left, the front of the exedra recedes in a relatively shallow curve; on the right, its outer side extends deeper into the distance.

In the early 1990s, James replaced his old Kodak Panoram with a Noblex rotating-lens camera. Although it took him some time to "inhabit" the new camera,[15] he gradually mastered this tool, finding it easier to use and more versatile than the Kodak. It was with this camera that James made a series of panoramic photographs in North America. A large example, *Viaduct of the Ohio Turnpike over Cuyahoga National Park* (pl. 17), surprises us with its unconventional view of the busy Ohio highway as seen from below. The highway itself, at the top of the viaduct, is left outside the frame, while we look through a succession of imposing arches reminiscent of the surviving sections of the ancient Aqueduct Claudio in Rome (see pl. 2 and 3).

Olmsted

In 1988, James developed an ambitious proposal to create a comprehensive series of photographs based on the work of the famous landscape architect Frederick Law Olmsted. Titled "The Legacy of Olmsted," the proposal was inspired by James's reading of Robert Smithson's essay "Frederick Law Olmsted and the Dialectical Landscape."[16] Its goal was the creation of a visual catalogue of Olmsted's landscapes – over sixty in all, including Central Park in New York, Franklin Park in Boston, Prospect Park in Brooklyn, and numerous other parks and park systems, suburbs, and private estates.

James presented his proposal to Phyllis Lambert, who was then the director of the Canadian Centre for Architecture in Montreal, and suggested that he undertake this visual accounting of Olmsted's legacy (working in his customary manner of large-format black-and-white prints) in collaboration with the American photographer Lee Friedlander (also working in black-and-white, but with a 35 mm camera). He specifically recommended Friedlander because, as he put it, "he has dealt with the persistence of nature in the city, and with the curious collage that is the North American urban experience." (They were joined by the Canadian photographer Robert Burley.)

James's conception of the Olmsted project and of the direction it would take was made clear on the final page of the proposal:

It is perhaps a good idea to photograph the work of Olmsted with a wide knowledge of his aims, but also recognizing that much, if not most of what he has done has been profoundly altered by neglect, fashion, changing social needs, and the passage of time. It may be that the corners of Olmsted's bucolic, restorative world still exist, but the photographer cannot ignore the chain-link fences in the Long Meadow of Prospect Park, the private parking lot that has replaced the first link in Boston's Muddy River system.

From the very beginning of what turned out to be a seven-year project,[17] James envisaged a collection of photographs that would reveal the gradual and inevitable unravelling of Olmsted's ambitious plans. While the photographs were certainly not meant to be critical of Olmsted's aspirations, they do demonstrate how nature and human nature will eventually transform the shape of a landscape, no matter how rigorous or robust the original plan for it may have been.

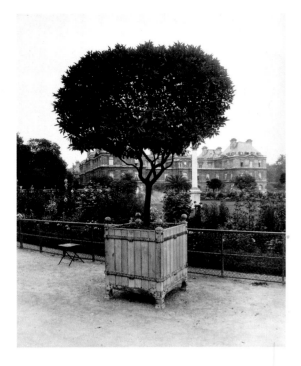

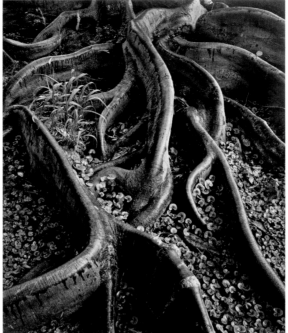

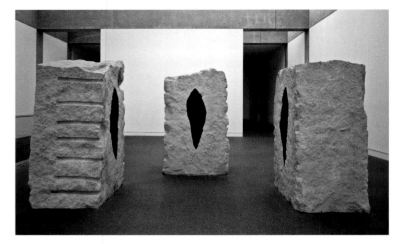

Figure 6
Eugène Atget, *Luxembourg Gardens*, 1922, albumen silver print. National Gallery of Canada, Ottawa (21219)

Figure 7
Ansel Adams, *Roots, Foster Gardens, Honolulu, Hawaii*, 1948, printed before March 1976, gelatin silver print. National Gallery of Canada, Ottawa (20528)

Figure 8
Anish Kapoor, *Three Witches*, 1990, limestone with pigment. National Gallery of Canada, Ottawa (35990.1–3)

What fascinated James most about Olmsted's landscapes was their tenaciousness. He observed that

at the heart of most of these places, the sheer strength of Olmsted's vision and abilities persists. The places have persisted, whatever shape they are in. They haven't been turned into shopping malls yet; maybe into golf courses, but they are still there. There's a kind of persistence, and within them – and possibly in my pictures – there are hints of what might have been.[18]

Most of James's own photographs for the project are visual reminders of the now lost utopias dreamed of by Olmsted for his public parks and private estates. James has said of the Olmsted sites that they are, for the most part, "tragically empty and underused" and that "they speak of some kind of breakdown."[19] In looking over the thousands of Olmsted photographs made by James, one senses a kind of elegiac symbolism in the image of a lone tree in a park with no one around (see pl. 19 and 29). In some instances, the tree is in full bloom, its leaves providing a strongly defined shape against the backdrop of a pale sky. In *Conservatory Water* (frontispiece), for example, James has singled out a European hornbeam whose branches and leaves form a somewhat oval shape. Dark and delicate, the biomorphic arc of its silhouette is echoed in the drooping section of a spindly snow fence and the curve of a man-made pool in the background. Other, less leafy trees hover in the background like supporting members of a theatrical troupe granting centre stage to the spunky, smaller

actor. Here, too, the influence of Atget can be discerned, in a comparison of James's tree in Central Park with one of Atget's in the Luxembourg Gardens (fig. 6).

Typically, the tops of trees are not visible in James's Olmsted images. Instead, attention is usually focused on the calligraphic forms of branches and tree trunks. In some of the photographs, the emphasis is on the tree's roots, the powerful sustainers of its life (see pl. 20). Tree roots have, in fact, been a surprisingly constant subject throughout the history of photography; the complex patterns of their sinuous forms and gnarled surfaces show up in the work of photographers such as Atget, Weston, Ansel Adams, and Friedlander, among others (see fig. 7).

Architectural forms also appear in James's photographs made for the Olmsted project. Stone mausoleums in Olmsted-designed cemeteries photographed at sunset amid palm trees have the atmosphere of a Hollywood stage set (pl. 18). In another photograph titled *The Meadowport Arch, Prospect Park* (pl. 25), James has isolated one of the so-called dry bridges that were among the engineering and landscaping elements used in the creation of Brooklyn's Prospect Park. Although the structure was intended as a place of refuge from the elements,[20] its deep black recesses recall the ominous but strangely inviting tripartite abyss of the Anish Kapoor sculpture *Three Witches* (fig. 8). Unlike the high and airy span of the Ohio Turnpike Viaduct (see pl. 17), these low arches seem like cavernous entrances to the underworld.

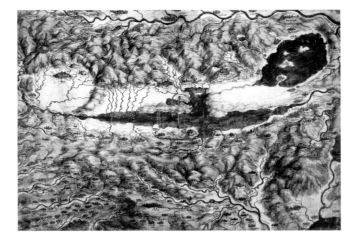

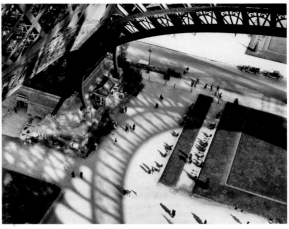

James's decision to position his camera at an angle to the bridge and to wait for certain conditions of light allowed him to convey his experience of the place. The strong sunlight accentuates the sculptural forms and volumes of the bridge, the details of the variegated stonework, and the shadows of tree branches spread out like veins leading us to the heart of the image.

Lethbridge

James first travelled to Lethbridge, Alberta, in the autumn of 1971, in order to see the recently completed University Hall, designed by Arthur Erickson (with Geoffrey Massey) for the University of Lethbridge. James was then working as a journalist for the Canadian edition of *Time* magazine and was preparing a cover story on the life and work of the celebrated Canadian architect.[21] While he was evidently impressed by Erickson's building, he also found himself attracted to the campus's natural surroundings, a distinctive landscape of coulees that reminded him of the undulating terrain seen in certain works by Leonardo da Vinci (see fig. 9).[22] James visited the city again in 1998, this time on the invitation of Joan Stebbins, the director of the Southern Alberta Art Gallery, who had asked him to produce a series of photographs of Lethbridge and its environs that would be exhibited at the Gallery in 1999 under the title *The Lethbridge Project*. The accompanying catalogue presented the photographs under four thematic headings: "Approaches," "In the City," "A Better Way of Life," and "Paradise Canyon and Beyond." This polemical sequencing of the images shows us the city from its agrarian beginnings to today's planned communities. James spent a year on this project, returning to the area four times in order to photograph it with his 8 × 10 inch view camera. The prints for the series were made in three different sizes. The photographs of buildings and landscapes within the city itself were printed as 8 × 10 inch contact prints. James believed that for the images of the suburbs and the landscapes beyond the city confines the prints needed to be larger, to convey a sense of expansiveness, and he therefore enlarged these images to 16 × 20 inches and, in some cases, to 20 × 24 inches.

Lethbridge's early economy was based on the production of coal and depended on an efficient system of transportation for distribution to markets. The city's first rail line was opened in 1885. In 1907, the Canadian Pacific Railway began construction on one of Canada's largest bridges, the High Level Bridge, spanning the Oldman River. Known also as the Lethbridge Viaduct, it is the world's longest and highest trestle. This marvel of engineering, which is still in use today, became the subject of some of the most striking photographs from the Lethbridge series (see pl. 35).

Hints of James's early interest in bridges over land and water can be seen in his Roman Campagna photograph of the Aqueduct Claudio and in his view of the Ohio Turnpike Viaduct from the Olmsted series. In such images he typically concentrates on the rhythmic patterns of arches and on the deep, almost vertiginous recession of the landscape. He is always curious about how man-made structures like these relate to the landscape they traverse. In his diptych of the High Level Bridge, James offers us a mere glimpse of the actual bridge itself: a concrete footing out of which emerge the black interlaced patterns of a steel girder. The imposing presence of the bridge is made visible only indirectly: James waited patiently until the sun was at just the right angle, with the girders creating a striped effect on the ground diptych and the top of the bridge forming a shadow that seems to outline precisely the curvature of a distant hill. A comparison could be made with Kertész's photographs of the Eiffel Tower from 1929, displaying a similar interest in shadow patterns cast by metalwork (see fig. 10).

Figure 9
Leonardo da Vinci, *A Map of the Valley of the Val di Chiana, Italy*, c. 1502, pen, ink, and watercolour on paper. Royal Collection, Windsor

Figure 10
André Kertész, *Eiffel Tower, Paris*, 1929, printed 1970–79, gelatin silver print. National Gallery of Canada, Ottawa (37883)

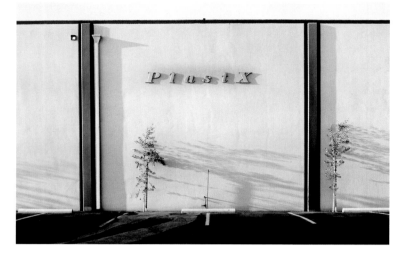

Figure 11
Lewis Baltz, *South Wall, PlastX, 350 Lear, Costa Mesa*, before 1974, gelatin silver print. National Gallery of Canada, Ottawa (19582)

Figure 12
Walker Evans, *Corrugated Tin Façade, Moundville Alabama*, c. July–August 1936, printed later, gelatin silver print. National Gallery of Canada, Ottawa (19421)

Though it was the rugged, eccentric land forms around Lethbridge that initially attracted him to the area, James also ended up photographing a number of architectural sites, including storefronts, factories, and ordinary houses. The neutral style and deadpan humour in photographs such as *Top Hat* (pl. 37) and *Sporting Goods* (pl. 38) relate in some ways to the deliberately aloof quality in the work of the New Topographic photographers, in particular that of Lewis Baltz (see fig. 11). James's rigorously frontal, tightly cropped treatment of the rather dilapidated buildings seen in photographs such as *Bow On Tong Co.* (pl. 39) or *Seed Company* (pl. 40) brings out the simple geometry of the facades, recalling Walker Evans's images of vernacular architecture (see fig. 12).

It is worth noting that in James's landscapes we are rarely in the presence of nature by itself. In almost every instance, we see some form of human intervention. Yet these interventions – including even the colossal High Level Bridge – still seem dwarfed and diminished by the imposing landscapes that surround them. The rakes left behind at a sand trap in *Paradise Canyon* (pl. 32) look like a child's forgotten toys, and the houses are overpowered by the terrain in which they are set. In much the same way, the houses in *Approaching Storm, West Lethbridge* (pl. 42) look as puny as dollhouses under the turbulent sky. Commenting on the Lethbridge series, James noted: "Too often, the human habitations seem indifferent to what surrounds them. In their turn, the landforms retain a strength that makes the human presence appear, at times, almost provisional."[23]

There is a feeling of melancholy that runs through the Lethbridge series, particularly in the photographs of the city itself. In *Seed Company* (pl. 36), the boarded-up depot looms silently beside the railway tracks, a reminder of Lethbridge's more vibrant times.

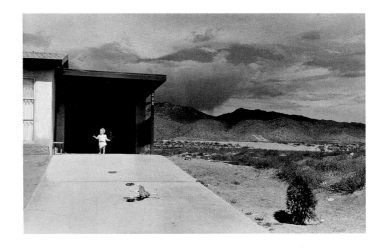

Figure 13
Garry Winogrand, *Albuquerque, New Mexico*, 1958, gelatin silver print.
Corcoran Gallery of Art, Washington, D.C.

The streets are empty, and most of the storefronts look old and slightly neglected. Lethbridge, judging from James's photographs, has the aura of a ghost town.

And there is something else that haunts many of these images, coming not from the past but from the foreseeable future: the endless and indiscriminate spread of the suburbs. For a photograph taken in the north end of the city (see pl. 41), James has positioned his camera so as to include only a partial view of a new suburban home, with its concrete driveway and parked motorcycle. We are given the impression that this house is completely isolated, literally at the proverbial "edge of town," the borderline where human civilization stops.

It is an image that calls to mind Garry Winogrand's *Albuquerque, New Mexico*, from 1958 (fig. 13). The stark contrast between the built and the natural environments, combined with the pervasive atmosphere of isolation, is what gives these photographs their power and poignancy. Similarly in James's *West 34th Street, West Lethbridge* (pl. 31) the wide sky and uninhabited expanse of land make us aware of the fragility of any possible human presence here. In *Deco House* (pl. 33), the orderly, curvilinear form of the house and the geometrical patterns of windows, railing, and sidewalk stand in contrast to the softness of the blotchy sky and the clusters of randomly twisting branches. In fact, the buildings in all of James's Lethbridge photographs seem oddly uncomfortable in their surroundings, as if they were merely temporary dwellings, or even stage sets.

Paris

While staying at a friend's apartment in Paris in June 1992, James went out for a walk very early one morning and made a photograph in front of the Gare Saint-Lazare (see pl. 43). Though he had always resisted Paris as a subject, he was encouraged by the results of this first effort and resolved to continue his explorations.

Soon after, he decided to photograph the so-called *villes nouvelles* around Paris. Towns of this type had been created in many parts of France in the 1960s and 1970s to help relieve the pressures resulting from the rapid growth of the major urban centres. He intended to concentrate on documenting what he regarded as the untenable environments of these newly created towns. James says that just by looking at the graffiti on buildings he was able to sense the impending violence, which would finally erupt in waves of vandalism and rioting in the summer of 2005, and it was this ominous landscape that he wanted to photograph. In September 2000 he was granted a residency at the Canada Council Studio in Paris, to enable him to undertake the project. Unfortunately, when he arrived in France in June 2002, the country's transportation system was in the grip of a massive strike by public-sector workers, making it impossible for him to get out of the city centre. James had no choice but to abandon his original plan.

Instead, he turned his attention again to Paris itself, which he began exploring on foot. He would usually set out in the early morning, when the streets were empty and the light was at its best. With his large-format view camera in tow, James let the city unfold before him serendipitously, without any preconceived plans or favoured sites.

James now regards his 1992 photograph of the Gare Saint-Lazare to be, in effect, the first work in the Paris series made eight years later. A dark metal post in the foreground slices through the image – a compositional device used also in *L'Opéra, rue Auber* (pl. 46) – creating an abrupt division of the picture plane. The left side of the image is filled with a variety of geometrical shapes: triangles, squares, circles, and rectangles. On the right, a wide

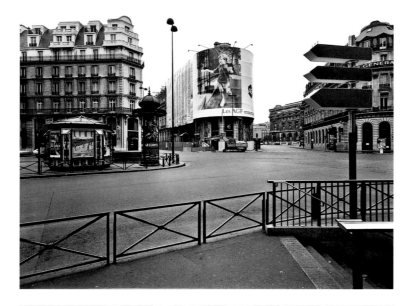

Figure 14
Geoffrey James, *Bd Haussmann (Chaussée d'Antin), Paris*, 2000, gelatin silver print. Collection of the artist

Figure 15
Geoffrey James, *Passage du Prado*, 2000, gelatin silver print. Collection of the artist

street, devoid of all traffic, runs into the distance, and a large, ship-like building appears to sail into the middle ground, with a Coca Cola sign floating on its roof like the remains of a tattered sail. The extreme resolution of the view camera's lens allows us to see clearly the small bits of paper that have collected at the base of a sidewalk curve that draws us into the picture.

Apart from its formal qualities, *Gare Saint-Lazare* is a picture that speaks of the gradual reshaping of Paris over time (there is even a witty reference to this theme in the inclusion of Arman's 1985 sculpture *L'Heure de Tous* at the left). It is also a work in which James makes us see the visual cacophony that stems from the unthinking placement of objects and signage in public places, as he also does in a photograph of the Gare du Nord (pl. 48). Although James has stated that his Paris series is about the "death of working-class Paris," it is equally a rumination on the commercialization of Paris. Advertising billboards appear in at least nine of the works in the series, usually as jarring intrusions into their surroundings. A particularly blatant example is *Bd Haussmann (Chaussée d'Antin)* (fig. 14), in which an overblown advertisement for an insurance company takes over nearly the entire facade of a building.

James has indicated that part of his inspiration for this series came from his reading of the posthumously edited version of Walter Benjamin's large unfinished manuscript known in English as *The Arcades Project*. In this wide-ranging set of reflections on the urban life of Paris in the nineteenth century, Benjamin focuses especially on the importance of the city's *passages couverts*, stylishly constructed iron-and-glass-roofed shopping arcades that were later copied in many other cities around the world. Characterized by Benjamin as "primordial landscapes of consumption," these spaces were designed to offer pedestrians shelter from the bustle of the street and to promote a culture of *flânerie*. The photograph

Figure 16
Attributed to Édouard Baldus, *Façade of a Parisian Mansion*, 1859, albumen silver print. National Gallery of Canada, Ottawa (20530.16)

Passage du Prado (fig. 15), which is perhaps James's clearest homage to Benjamin, illustrates the intriguing dichotomy of indoor and private versus outdoor and public that made these ambivalent spaces so fascinating to Benjamin.

Other images in the series reveal James's continuing interest in the surfaces of buildings. In photographs such as *Quai de la Tournelle* (pl. 45) and *Rue de Charenton* (pl. 52), the strong geometry of the facades is softened by the complicated patterns of a tree's shadow, in a way reminiscent of the Paris photographs made by Édouard Baldus in the 1850s (see fig. 16). The photograph *Boulevard de la Chapelle* (pl. 51) is all about surface: the cracked and pale mottled skin of the aging building with its nineteenth-century sculptures, filigreed metalwork, and medallions, set against the darker graffiti at street level. A corrugated metal fence separates the foreground from the background, with two contemporary edifices hovering in the distance. A large billboard advertising a camcorder straddles the middle ground. A similar interest in facades can be seen in *Rue des Haies* (pl. 49), where the front of a small building reveals bits of decoration from different periods. The superimposition of newer elements, such as the industrial-looking metal shutters seen at ground level, onto older structures is another theme that runs through the Paris series.

Alongside the images of facades are photographs that capture the receding spaces of the long, narrow streets of Paris. Two very different examples can be seen in the photographs *Rue Charlemagne* (pl. 44) and *Rue de Charenton* (pl. 53). In the former, the dizzying repetition of architectural forms is punctuated by the evenly placed black metal parking stanchions. James's facility with the medium of the gelatin silver print is in full evidence here. The dusky tones of the stonework would be completely lost in a colour print, and the image as a whole would be diminished. Looking at *Rue de Charenton*, we can see why James has called light the "primordial" element of his working method.[24] A deep, extended shadow and the side of a long building work together to bisect the picture plane along the diagonal, creating distinct areas of darkness and light.

James's *Pont-Neuf* (pl. 47) is one of the most graphically powerful works from his Paris series. The decision to print this photograph in the larger 20 × 24 inch format fits well with the monumentality of the view. The imposing stone structure forms an elegantly dynamic arc, while the sculpted heads decorating the side of the bridge serve to arrest this thrust with short, staccato bursts. The half-circle of light in the middle ground near the bottom of the image reveals the silhouettes of two dogs and a chicken, a strange ensemble caught fortuitously in the moment.[25]

Trees

In a certain sense, James has been making images of trees throughout his career. There are trees in most of the panoramic images as well as in many of the Olmsted, Paris, Toronto, and Running Fence photographs. They appear less often in the Lethbridge works, and are completely absent from the Asbestos series. In 1993, James photographed trees at the Domaine de Kerguéhennec in Brittany. In 1998, an exhibition titled *Trees* was organized by the Equinox Gallery in Vancouver, marking the first time that James presented this subject on its own. Four years later, he was commissioned by the Toronto Parks and Trees Foundation to make a series of "Tree Portraits," with the purpose of raising the public's awareness of the existence of heritage trees across the Toronto region.[26]

In the course of his work, James has photographed trees in different seasons and in a variety of locales – from an apple orchard in New York State, to Ward's Island near Toronto, to the

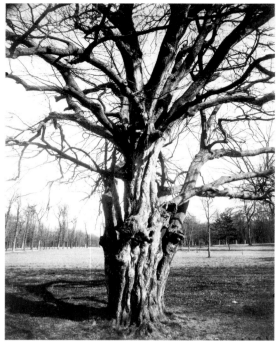

Figure 17
Carleton Watkins, *Grizzly Giant,
Mariposa Grove, 33 ft. Diam.*, 1861,
albumen print from wet-collodion-on
glass negative. Collection of the
J. Paul Getty Museum, Los Angeles

Figure 18
Eugène Atget, *Saint Cloud, Beech,*
1919–21, albumen silver print. National
Gallery of Canada, Ottawa (21156)

Queen Charlotte Islands in British Columbia. On most occasions he has photographed them bare of leaves, their twisting branches silhouetted starkly against a blank sky. At times he has also photographed them in full leaf (see frontispiece and pl. 60), most likely out of an interest in their unusual shapes.

In his very first studies of trees, at the Domaine de Kerguéhennec, James used an 8 × 10 inch view camera. Later he would turn his Kodak Panoram on its side in order to show the tree in its full height.[27] He would continue to use this method with his new Noblex camera, eventually making over a thousand vertical images of individual trees.[28]

Many of James's tree photographs are printed on sheets measuring 24 × 20 inches, though some are as large as 48 × 20 inches. Their size and crisp details allow for an unusually lifelike image, giving the viewer the uncanny impression of standing before an actual tree. The photographs from this large, ongoing series can almost be seen as portraits, with each tree having its own distinct personality, from brooding solemnity to bristling exuberance (see pl. 56 and 58). In *Willow, Ward's Island* (pl. 59), the limbs of a spectacular tree resemble overgrown arms, reaching in almost every direction.

James, of course, is not the first photographer to have made trees his subject.[29] Old and odd-shaped trees were especially attractive to nineteenth-century British and French photographers, who often went in search of the picturesque landscape. James has acknowledged that his inspiration came partly from a series

of photographs of trees made by Carleton Watkins in the 1860s (see fig. 17).[30] And again, we cannot ignore the influence of Atget, whose *Saint-Cloud, Beech* (fig. 18), for example, may be compared with James's *Chestnut, Spadina House* (pl. 57). In both of these photographs, the trees are seen from about the same distance, their massive trunks placed at the centre of the composition while their unruly, bare branches fill the upper portions of the image. In each photograph, a park-like landscape is visible in the background, but it is the gnarled bark of the trunk and the undulating branches and their shadows that command our attention.

905 and Toronto

In 1999, James embarked on a series of photographs that deal with the rapid growth of Toronto's suburbs, addressing what he saw as the transition from "fertile farmland to sterile exurbia."[31] The majority of these photographs, dating from 1999 to 2001, focus on the sprawl of housing developments in the outlying areas. The 905 series (named for the telephone area code in suburban Toronto) is an ongoing project, so far consisting of only a few dozen works. Although it remains small compared to James's other bodies of work, the 905 series is significant in that it marked a major technical shift: it was the first series to be done in colour. James's own explanation for this abrupt move away from black-and-white was that "the subject is inherently vulgar, and seems to demand colour."[32]

From the bright yellow of the sales office (see pl. 72) to the candy-floss pink of insulation batts (see fig. 19), James uses colour to convey the idea that there is something artificial and illusory about the type of housing being built and marketed in the suburbs. Photographs such as *New Housing, Langstaff Road and Dufferin Street* (pl. 71) lay bare the flimsy skeletons of new homes, and the careless scattering of building materials seems to indicate that

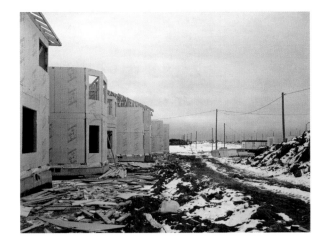

speed and profit are the main considerations. As James himself has remarked in connection with another photograph in the series, "it's the money talking."[33]

Another ongoing project, the Toronto series, was started in July 2003. James has made several thousand photographs for this series, which he intends to edit and expand gradually. He claims, not entirely in jest, that he originally undertook this project as a way to avoid having to fly somewhere in order to do his work. At the same time, it provided him with an opportunity to get to know Toronto better, something he had not managed to do in the years immediately following his move from Montreal in 1994. As he put it:

I'm struggling to deal with the complexity of Toronto, the way it is dispersed. . . . The project is also a way of reconciling myself to the city after having a hard landing here. When I came from Montreal in the 1990s, Toronto was not a very inviting place. Nothing was happening here. . . . We knew an enormous number of people, but it was very hard to find a community. . . . I missed a whole series of small urban pleasures.[34]

James's attentiveness to the formal properties of architecture is particularly evident in his photograph of Metro Hall (pl. 65), one of numerous works in the series that concentrate on the downtown core. He is also clearly interested in how light gives shape to the various architectural surfaces, from the thin edges of the glass panes to the solid roundness of the columns. The reflective glass introduces random segments of landscape into the image, preventing any possible sense of spatial coherence. Here, as also in *Dundas Square* (pl. 61) and *Bay and Adelaide* (pl. 67), a large pillar in the foreground impedes our view, resulting in a complex image with multiple vanishing points. A similar kind of complexity can be seen in *Cloud Garden* (pl. 64), which James chose (rather exceptionally) to photograph from a high vantage point, allowing us to observe patterns of rectangles and squares everywhere.

James also turned his attention to some of Toronto's older and more established residential neighbourhoods. We see, for example, the lush, slightly overgrown gardens of the Bain Co-op (pl. 66), a housing development created in 1913 through the efforts of philanthropists and politicians. The Bain Co-op had been inspired by the utopian ideals of the "garden city" movement established in England at the end of the nineteenth century by Ebenezer Howard, who envisioned planned communities that would contain industrial, agricultural, and residential areas, combining the best of city life and country life.[35] In a photograph titled *Glen Baillie Place* (pl. 63) the surprising juxtaposition of old, ramshackle buildings (most of the houses in the area had been built in the late nineteenth century to accommodate labourers and their families) with more recent renovations is made even more striking by the choice of a vantage point from across an intersection. Two small streets veer off in opposite directions, and where they meet at the centre of the composition there is a small heap of what might be a chair cushion, blankets, and sleeping bag left behind by a street person. A similarly quirky atmosphere pervades a photograph titled *Oak Tree off Spadina and Dupont* (pl. 62), in which a massive tree trunk squats at the edge of a lane that is cluttered with the detritus of our consumer culture. In each of these images we see neighbourhoods that have persisted through time and adapted to new forms of city life with each passing generation. James lovingly records the traces of the past that so far have managed to survive the onslaught of urban renewal.

The inevitable complete homogenization of urban residential areas is well documented in James's photographs of Liberty Village. In *Railtracks near Liberty Village* (pl. 69), the seemingly infinite repetition of townhouses at the left is almost comical in its unimaginative monotony. Other images in this grouping

Figure 19
Geoffrey James, *New Housing, North of Major Mackenzie Dr., Vaughan Township*, 1999, dye coupler print. Collection of the artist

encapsulate the shift from working-class neighbourhoods and old industrial sites to contemporary luxury residences for the rich. *Billboard for Liberty Village* (pl. 68) shows a construction site's plywood fence bearing an advertisement for the lifestyle presumably on offer with the purchase of a condominium. Next to its wintry and somewhat forlorn surroundings, the *trompe-l'oeil* billboard, with its jaunty invocation of modernist design and Pop art, seems weirdly incongruous. The scraggly tufts of grass poking through the snow and the gritty pavement seem to mock the high-pitched promise of a "Hip . . . City" encoded on the billboard.

Asbestos

It was in October 1992, while on his way home from photographing Les Quatre-Vents, Francis Cabot's spectacular garden in the Charlevoix region of Quebec, that James first saw the open-pit asbestos mines surrounding the towns of Thetford Mines and Black-Lake in the southeastern part of the province. The mountainous piles of tailings left over from the extraction process dwarf the many small communities situated next to the mines. James knew immediately that this was a place he needed to photograph, and over the course of the following year he returned to the region several times in order to complete his project.

Some of these man-made mountains could almost be mistaken for natural formations created by some ancient glacial upheaval. Often they are softly rounded in shape, as a result of the porous nature of the rock and silt in the tailing piles (see pl. 74). Over time, as they become gouged and striated with rivulets formed by the rain, they take on an even stranger, moon-like appearance.

James's Asbestos series heralded a new direction in his work. Moving from the idyllic landscapes of the Roman Campagna and the lost utopias of Olmsted toward a more "dystopian" vision,

James was now creating images that could function as warnings, enabling us to see with our own eyes the reshaping of the earth brought about by human aspirations. The belief that asbestos was an almost magical non-combustible material that could transform large areas of modern manufacturing was, as we now realize, tragically mistaken. The promise of prosperity for everyone associated with the industry was irrevocably broken in the 1970s, when asbestos was revealed to be the culprit behind an assortment of deadly lung diseases, including cancer. The mining of asbestos thus left a deep, indelible scar on both the landscape and the people of the region.

James has occasionally come under criticism for the fact that neither the images in the series nor his writings about them make any reference to the devastation caused by asbestos mining in Quebec.[36] Some of the photographs do show aspects of an industry that is clearly dying – empty roads, a silenced conveyor belt (pl. 75 and 76) – but we must keep in mind that the series was never intended to cast blame. Like Mark Ruwedel's images of nuclear test sites (see fig. 20), James's Asbestos photographs are records of a landscape that signifies an overreaching of human ambition. Both Ruwedel and James provide us with the kind of visual evidence that has a strange but compelling beauty while also relaying a bleak warning about hubris and greed.

Anyone looking at these photographs and noting their titles will inevitably apprehend their gravity. The misshapen heaps of tailings have been created with little or no concern for the environmental and human costs. The prime consideration has been what James refers to as the "brute expediency" of the business of mining.[37] His photographs bring to our attention a reality that had long been forgotten: by the time he arrived on the scene, many of the mines had been out of operation for years.

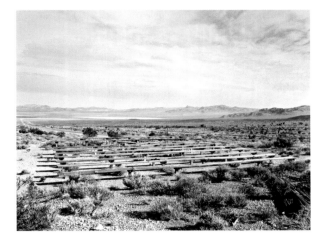

James's 8 × 10 inch view camera was the ideal instrument for photographing the mountainous landscapes of the asbestos mines, with their rugged and sprawling terrain. The generous size of the plate allowed for a maximum of detail, and it is hardly surprising that in this series James, for the first time, went to a 30 × 40 inch format, enabling him to convey not only the monumentality of the views but also the sheer graphic power of the resulting images.

Running Fence

In late 1993, during an exhibition of the Asbestos photographs at the Power Plant in Toronto, James was introduced to Hugh Davies, the director of the Museum of Contemporary Art in San Diego. Davies was taken by James's work and invited him to be an artist in residence at the museum. Although intrigued by the offer, James doubted at the time that he would find any interest in photographing in the San Diego area. Three years later, however, while on a visit to the city with his family, he happened to catch a glimpse of the recently constructed barrier along the international border with Mexico, separating San Diego from the immediately adjacent metropolis of Tijuana, and was instantly fascinated. As he later recalled: "What drew me to it was its great incongruity. It doesn't look as if it has been made by the world's only superpower, but rather by some Mexican body-shop guys. I found it so crazy and contradictory that I had to photograph it."[38]

That same day, James went to the Museum of Contemporary Art to express his new interest in the original offer, and the residency was soon arranged. James photographed the barrier in the course of two brief working trips, in January and April 1997. The name that he assigned to the series, Running Fence, alludes to an identically titled 1976 installation by Christo and Jeanne-Claude that had consisted of a six-metre-high white cloth divider snaking across some forty kilometres of Sonoma County and Marin County in northern California.

The United States–Mexico border spans over 3,000 kilometres, from the Gulf of Mexico in the east to the Pacific Ocean in the west. Its large eastern portion, bounding the State of Texas, is formed by the winding Rio Grande. From close to El Paso, Texas, it extends westward overland along the boundaries of New Mexico, Arizona, and California, through a mixed terrain that includes empty deserts, rugged mountains, and urban areas. To stem the tide of illegal immigration and drug smuggling, the American side is guarded by the U.S. Border Patrol. In the 1990s, several barriers were erected at strategic heavy-traffic locations along the border, arousing considerable controversy as to its effectiveness and its impact on the livelihoods and physical safety of illegal immigrants who would now seek out more remote and often hazardous routes instead.

The particular barrier that James saw and photographed, the "San Diego wall," extends approximately twenty-three kilometres, going from the shore of the Pacific Ocean eastward past the San Ysidro Border Crossing and ending abruptly at the Otay Mesa mountain range. Along this relatively short route, the barrier exists in a variety of forms, including corrugated steel sheets, chain-link fence, closely spaced steel posts, and concrete pillars.

Although James started his career as a print journalist, there is never a strictly journalistic purpose in his photographs, and we rarely see even the hint of a narrative that could be construed as serving the purpose of reportage. Other photographers who have treated the United States–Mexico border as a subject tend to include people in their images and sometimes record scenes of illegal crossings, as in the work of Alex Webb (fig. 21).

Figure 20
Mark Ruwedel, *The Witnesses, Nevada Test Site (Viewing area for 14 Atmospheric Tests at Frenchman Flat, 1951–1962)*, 1995, gelatin silver print. Canadian Museum of Contemporary Photography, Ottawa (EX-96-68)

Figure 21
Alex Webb, *San Ysidro, CA*, from the book *Crossings*, 1979, dye coupler print. Magnum Photos

Nevertheless, given their subject matter, the Running Fence photographs are without a doubt politically charged works, perhaps even more so than the Asbestos series. This was, in fact, a large part of James's attraction to the subject:

As a barrier, it is completely useless, in that I watched small boys climb over or through it to recover their footballs. It is such a transparent place – you get a clear idea of the great economic forces at work, even the system of people who help the migrants cross, for a hefty fee. A landscape of expediency, and of great interest to me.[39]

The barrier and the no man's land on the American side function essentially as an elaborate example of security theatre, giving the impression of impermeability without completely assuring it. In reality, different levels and branches of government in the United States, reacting to economic and political pressures,are divided on the question of how to deal with the security problem along the Mexican border. It has been argued that the American government, while claiming that it means to stop illegal immigration, in fact "continues to acquiesce to the demand that business have unlimited access to an ever-expanding pool of cheap mobile labor."[40]

One of the remarkable features of the Running Fence series is its depiction of the contrasting landscapes on the two sides of the barrier. In *Settlement along the Fence, Tijuana* (pl. 82), for example, a tight cluster of ramshackle, slum-like dwellings, piles of tires, the occasional small tree, rocks, and a string of hydro lines can be seen pressing close to the barrier on the Mexican side, while on the American side there is nothing but a dirt road monitored by a lone Border Patrol vehicle. *The End of the Fence, Looking West* (pl. 86) shows a seemingly endless rocky landscape on the American side, punctuated by just a steel post and a line of scrub brush, while on the Mexican side, right up against the barrier,

an entire town extends far into the distance. In writing about the United States–Mexico border, Rebecca Solnit quotes the San Diego architect Teddy Cruz:

It's almost like the wall becomes a dam that keeps the intensity of this chaos from contaminating the picturesque order of San Diego. . . . It's a whole country leaning against the other. . . . The ever more militarized border makes San Diego "the world's largest gated community."[41]

Like the photographs in the Asbestos series, the prints for Running Fence are large, typically measuring 30 × 40 inches. The 8 × 10 inch view camera allows for a high degree of precision in these images, and the grey tonalities of the gelatin silver medium are well suited to the tough subject matter – the complex issue of illegal immigration and the economic realities that drive and support it. James has adopted two distinct viewpoints, or what he calls "visual modes," to investigate each side created by the jerry-built barrier. Many of the landscapes are photographed from a great distance, as if scanned through the far-reaching binoculars of a Border Patrol agent. The second viewpoint moves in closer: the fence as seen through the eyes of someone trying to navigate the chaotic tangle of steel and concrete. The perspective of the latter images makes us acutely aware of the fence's menacing physical presence. By presenting both points of view – that of surveyor and surveyed – James has made these photographs vehicles for "positioning consciousness" and igniting our "moral imaginations."[42]

Notes

1 Geoffrey James, in Peter O'Brien, "Ugly Beauty: An Interview with Geoffrey James," in *Geoffrey James: Past, Present, Future* (Toronto: University of Toronto Art Centre, 2003), p. 24.

2 David Harris, "Interview with Geoffrey James" (23 June 1995), in *Viewing Olmsted: Photographs by Robert Burley, Lee Friedlander, and Geoffrey James*, ed. Phyllis Lambert (Montreal: Canadian Centre for Architecture, 1996), p. 99.

3 Geoffrey James, conversation with the author, 3 December 2007.

4 David Harris, "Interview with Geoffrey James," p. 100.

5 Georgina Masson was the pseudonym of the English writer Marion "Babs" Johnson (1912–1980). Her works include *Italian Villas and Palaces* (1959), *Italian Villas and Gardens* (1961), and *The Companion Guide to Rome* (1965).

6 David Harris, "Interview with Geoffrey James," p. 96.

7 Anna Fárová, "Josef Sudek" (an interview with Josef Sudek, Prague, December 1975 and February 1976), in *Josef Sudek (1896–1976): Sixty Pigment Prints from the Artist's Estate* (New York: O'Reilly Galleries, 1998), pp. 36 and 158.

8 James had previously been to the Villa d'Este and Villa Adriana in Tivoli during a childhood trip in 1947, and the experience left a lasting impression.

9 Geoffrey James, Project proposal for Guggenheim award, 1988, Artist Files, National Gallery of Canada, Ottawa.

10 Geoffrey James, email correspondence with the author, 15 November 2007.

11 Many of James's panoramic photographs of France are reproduced in the 1986 publication *Morbid Symptoms: Arcadia and the French Revolution*.

12 James gave a lecture to the Toronto Friends of the Visual Arts, Toronto, in May 2003, titled "Eugène Atget: A Photographer's Photographer."

13 Geoffrey James, in Robert Enright "Viewfinder: The Photography of Geoffrey James," *Border Crossings* 21, no. 1 (February 2002): 46.

14 As James observed: "The first thing you try not to do is to photograph a long wall at right angles. . . . You tend to seek out spatial amphitheatres, which the machine then straightens out a little. . . . I have a predilection, I think, for dealing with deep space. Of course, this machine upsets the rules of single-point Renaissance perspective – it does crazy things to the orthogonals." Geoffrey James, email correspondence with the author, 16 November 2007.

15 See Geoffrey James, in Large Format discussion group, 29 October 2002, photo net forums: Photo.net/BBoard.Q-and-A-fetch-msg?msg_ID=003XFE

16 Robert Smithson, "Frederick Law Olmsted and the Dialectical Landscape," in *Robert Smithson: The Collected Writings*, ed. Jack Flam (Berkeley: University of California Press, 1996), pp. 157–171. Originally published in *Artforum* 11, no. 6 (February 1973): 62–68.

17 *Viewing Olmsted: Photographs by Robert Burley, Lee Friedlander, and Geoffrey James* opened at the CCA in October 1996.

18 David Harris, "Interview with Geoffrey James," p. 101.

19 Ibid., p. 100.

20 The structure's elegant style is based on the architecture of Delhi's Pearl Mosque, built in 1659. See New York Architecture, Prospect Park, Brooklyn, http://www.nyc-architecture.com/BKN/BKN006.htm (accessed 28 November 2007).

21 Geoffrey James, "Erickson: The Architect as Superstar," *Time* (Canada), 14 February 1972, pp. 16–21.

22 Geoffrey James, Preface, in Geoffrey James and Rudy Wiebe, *Place: Lethbridge, A City on the Prairie* (Vancouver: Douglas & McIntyre, 2002), p. 8.

23 Geoffrey James and Rudy Wiebe, *Place: Lethbridge, a City on the Prairie*, p. 9.

24 John Bentley Mays, "Growing Pains," *Canadian Architect*, June 2004, p. 16.

25 According to James, the animals belonged to a street performer by the name of M. Augustin (conversation with the author, 21 November 2007).

26 Two desk calendars were published in 2005 and 2006 by the Toronto Parks and Trees Foundation, illustrated by James's Tree photographs.

27 Josef Sudek also turned his panoramic camera on its side to make photographs of trees between 1946 and 1966. See Anna Fárová, *Josef Sudek, Poet of Prague: A Photographer's Life* (New York: Aperture, in association with the Philadelphia Museum of Art, 1990), p. 86.

28 David Harris, "Interview with Geoffrey James," p. 98.

29 Wolfgang Kemp, "Images of Decay: Photography in the Picturesque Tradition," trans. Joyce Rheuban, *October* 54 (Autumn 1990): 112–13, 115.

30 Geoffrey James, conversation with the author, 21 November 2007.

31 Sarah Milroy, "Toronto the Beautiful," *Globe and Mail*, 15 November 2003.

32 Geoffrey James, email correspondence with the author, 19 October 2007.

33 Robert Enright, "Viewfinder," p. 48.

34 John Bentley Mays "Growing Pains," p. 15.

35 http://www.100bain.com/History.html

36 Peter MacCallum, "Geoffrey James: The Power Plant, Toronto, *C Magazine*, no. 41 (Spring 1994): 56–58.

37 John Bentley Mays, "Portrait of a Landscape as Ambiguous," *Globe and Mail* (Toronto), 18 December 1993.

38 Geoffrey James, email correspondence with the author, 11 November 2007.

39 Ibid.

40 Wade Graham, "Masters of the Game: How the U.S. Protects the Traffic in Cheap Mexican Labor," *Harper's Magazine*, July 1996, p. 50.

41 Rebecca Solnit, "Nonconforming Uses: Teddy Cruz on Both Sides of the Border," in *Storming the Gates of Paradise: Landscapes for Politics* (Berkeley: University of California Press, 2007), p. 105.

42 Geoffrey James, in *Geoffrey James: Running Fence* (Ottawa: Ottawa Art Gallery, 1999), n. p.

GEOFFREY JAMES
AND THE ART OF DESCRIPTION

BRITT SALVESEN

The powers requisite for the production of poetry are: first, those of Observation and Description, – *i.e.*, the ability to observe with accuracy things as they are in themselves, and with fidelity to describe them, unmodified by any passion or feeling existing in the mind of the describer; whether the things depicted be actually present to the sense, or have a place only in the memory.

– William Wordsworth, Preface to *Poems* (1815)

Replace those lengthy chats . . . by descriptions to which our tongue is so well suited.[1]

– Honoré de Balzac, *Illusions perdues* (1837–43)

These two exhortatory passages – one issued by the leading theorist and practitioner of English Romantic poetry, the other by the progenitor of the French Realist novel – make claims for description as an aesthetic pursuit. The invention of photography, following quickly upon these pronouncements, points to a cultural preoccupation with description that ultimately, and inextricably, links the verbal with the visual. Geoffrey James inherits this preoccupation, his work being essentially an exploration of the medium's descriptive nature. In the mode of Wordsworth, he invests in observation; in the manner of Balzac, he delights in fluency.

By taking a purposefully descriptive approach, James engages with perception itself, situating photography within the range of pictorial and linguistic performance that also includes naming, mapping, listing, characterizing, and surveying. The apparently simple, objective act of describing leads directly to consideration of the complex, highly subjective concepts of style, memory, and knowledge. To express it in broadly philosophical terms, James adopts an "externalist" attitude, a stance that implies a priori acceptance of the world as a material reality out there to be described. "I have a fairly uncomplicated view about the notion of reality," he has stated, adding that he sides with Samuel Johnson,

who countered Bishop Berkeley's idealism by kicking a stone and proclaiming, "I refute it thus."[2] James's approach – refined with respect to theoretical, historical, and literary precedents – must be considered deliberate in conceptual as well as physical terms. A materialist worldview such as his implies that the selection of medium, tools, and means is likewise deliberate, based on an individual's store of knowledge, experience, and opinion. Implicating oneself in this way raises the stakes. Authorship is claimed rather than evaded, and an image retains a concrete link to the time and place of its making. In addressing viewers actively rather than passively, James sets in motion cycles of seeing, showing, and saying.

In these dynamic, dialogic cycles, James uses description to create points of entry, establish internal rhythms, and suggest potential meanings. This is not to say that he deploys description in a dictatorial or overdetermining manner. Rather, he exploits its potential to demonstrate the contingency of perception. Thomas Kuhn and other philosophers have posited that we may each see the same objects, but as individuals we see them "in terms of" particular assumptions and expectations.[3] In James's sustained photographic projects, he depicts places that any one of us could visit and see for ourselves. Yet his pictures of these places have the power to alter our view of them. The exercise in James's terms proves rewarding: by gaining new knowledge about the world, we may also gain insight into how we construe the world through our own descriptions of it.

The precise function and value of description have long been contested by literary critics, art historians, philosophers, and linguists. Like photography vis-à-vis painting, description is a somewhat disparaged handmaiden to poetic invention. Leading Modernists, reacting to the preceding generation's positivist

aesthetic, found much to dislike about description: Stéphane Mallarmé deemed it prosaically attached to reality, whereas Paul Valéry, by contrast, judged it insufficiently natural.[4] Later, Roland Barthes reached the influential conclusion that description supports and signifies what he called the "reality effect" rather than any actual content or referent.[5] To believe, or take pleasure, in this effect suggests naïve susceptibility on the part of the reader – a form of oppression that Barthes could counter with the critical methods known as deconstruction. More recently, however, theoreticians have sought to recuperate description from a subservient or even suspect position. The literary critic Michel Beaujour writes: "Description, which opens (or should in principle open) windows in the reader's imagination, which expands worlds and multiplies quasi-perceptions, ought to be considered a life force, the ever-available key to inexhaustible treasures."[6] For Beaujour, description can be a tool used by, rather than against, the reader.

James does not ignore this longstanding debate. On the contrary, he participates by playing with the subtle pictorial connotations of description. This proposal can be tested against the word's etymology. According to the *Oxford English Dictionary*, the word description (from the Latin verb *describere*) has three broad, interrelated meanings: first, to narrate, copy, or transcribe; second, to define or fix; and third, to classify, assign, or divide.[7] The pertinence of all these senses to photography is striking. In what follows, I will argue that James works with each of these three meanings in different bodies of work, finding within description a wealth of communicative and expressive potential.

Narrating

In the Asbestos and Running Fence series, James set out much in the spirit of Wordsworth –"observing with accuracy" – and in the tradition of nineteenth-century photographic projects such as the Mission héliographique (established 1851) in France, the joint American-British survey of the forty-ninth parallel along the U.S.–Canadian border (1858–61), or the Western Surveys in the United States (1867–73). The Mission héliographique, commissioned by the Historic Monuments Commission, sent five calotypists (Édouard Baldus, Henri Le Secq, Hippolyte Bayard, Gustave Le Gray, and Auguste Mestral) around France to record the medieval and Gothic structures then threatened by urbanization and industrialization (fig. 1). In the less aesthetically charged, more systematic effort to record the forty-ninth parallel, key participants included scientists and the British Royal Engineers, some of whom later applied their photographic training in Palestine, China, India, Greece, and Panama.[8] The American survey photographers, supported by the military and the railroad companies, concentrated for the most part on the spectacular natural sites found in the frontier territories soon to be made accessible to the forces of settlement and development. In all three instances, an awareness of impending change drove the need for description, in the sense of accurate rendition and, by extension, official narration.

Complex in their contemporary motivations and functions, these projects have since been subject to various interpretations, not least by artists intrigued by their predecessors' intrepid expeditionary fortitude, sophisticated compositional strategies, and elusive aesthetic sensibilities.[9] Like those photographers attached to the nineteenth-century surveys, James depicts the environment in such a way as to register or envisage the impact of human activity, thus acknowledging the view of nature as a resource that lies at the heart of these earlier pictorial endeavours. Whereas the Mission héliographique and the Western Surveys

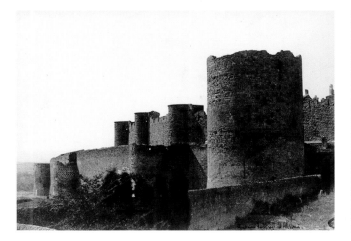

evoked past achievement and future potential, James witnesses the present-day effects of these two persistent but limited attitudes toward history.[10]

His Asbestos series deals with a particular natural resource, one exploited at the expense of the land and, as it turns out, at the expense of human lives. James's published project comprises twenty-nine photographs taken in southeastern Quebec between October 1992 and October 1993 in the region of Thetford Mines and Black-Lake, where asbestos deposits were discovered in 1876. The fibrous form of several minerals and hydrous silicates of magnesium, asbestos is mined, most commonly using open-pit methods. A non-flammable substance, it has for centuries been woven into cloth or used in construction for fire-retardant purposes. In all of its guises, asbestos promises safety: to firefighters, to schoolchildren, to homeowners.

As revealed in the 1970s, however, asbestos has other, insidiously threatening properties. Inhaled, some forms of the tiny invisible fibres can cause asbestosis, a delayed-onset lung disease, and mesothelioma, a deadly lung cancer. Efforts at immediate removal tend to make matters much worse by dispersing fibres into the air. More prudent abatement methods, strict regulatory statutes, and the development of substitute fire-retardant products have reduced the incidence of asbestos-related illnesses. For most North Americans, asbestos can be considered a problem solved and nearly forgotten. Yet quite apart from its latent presence in older buildings, asbestos has a legacy in the landscape as well. Abandoned pit mines, together with disused equipment and structures, remain as stark evidence of the industry's precipitous decline; some residents of this region in Quebec have paid both a physical and an economic price for extracting asbestos from the earth. James, in his uncompromising yet awe-inspiring

documentation, reminds us that this substance is natural. It is our wasteful extraction and profligate use that have produced the unnatural circumstances of environmental depredation and destruction of the human body.

James conveys this message without showing us stricken children, gutted buildings, craven insurance agents, or any other staples of social-documentary photography. Nor does he update this representational tradition with a self-reflexive conceptual move, as Simon Starling does in his platinum/palladium series *One Ton, II* (fig. 2). Starling's title and image refer, respectively, to the amount of raw material that yielded the tiny amount of platinum used in making the prints and to the South African quarry from which the ore came. Like Starling, James refuses to pretend that the decision to respond to environmental depredation by making photographs is a passive one, but he does not collapse the medium and the message so literally. Instead, he uses photographic description to bring out both the tangibility and the tragedy of the looming mounds (see pl. 74) and disused equipment (see pl. 76) – evoking their physical presence and metaphoric significance in equal measure. The mounds are tailings of loose ore (*le stérile*) left over after the extraction of the fibres and thrown off the conveyors, later to be shaped by the constant forces of wind and rain. The facts of their formation are not spelled out in the image, which instead triggers a broader, deeper meditation on waste and desolation. These are ruins of the twentieth century; without a photographic record, selective cultural memory would likely allow them to disappear without a trace.

James's convincingly monumental renderings allude visually to the lens-based distortions exploited by many photographers, from Carleton Watkins to Ansel Adams (fig. 3). Yet relative proportions are difficult to discern in images such as *Vimy-Ridge* (pl. 74) and

Figure 1
Gustave Le Gray and Auguste Mestral, *The Ramparts of Carcassonne*, 1851, salted paper print from paper negative. Metropolitan Museum of Art, New York, Gilman Collection, Purchase, Harriette and Noel Levine Gift, 2005 (2005.100.34)

Figure 2
Simon Starling, *One Ton, II...*, 2005, platinum/palladium print (1 of 5). Courtesy The Modern Institute, Glasgow

Black-Lake (pl. 77), for the thirty-metre-high mounds "create their own scale," as James puts it, obliterating their surroundings.[11] Rather than explaining the mystery of this environment, James examines it in such a way as to imply that we actually do not want it to be explained, that we prefer to ignore or transform it. By taking a peculiarly alert artistic stance, he rehearses and makes sense of Wordsworth's two additional points about description: after remarking upon the qualities of accuracy and fidelity, the poet speaks of the describer's dispassion, and finally puts forward the possibility that what is described does not exist (or no longer exists). Although James chooses to make pictures with "a recording device entirely indifferent to my feelings,"[12] at the same time he questions the camera's objectivity, suggesting that history relies on the fallible processes of memory and perception.

Like the Quebec mining country, the U.S.–Mexico border at San Diego–Tijuana is a no man's land, but the desolation of this territory results not from its abandonment but from its contestation. Here, too, James found himself drawn to a place where the land has been forcibly shaped by self-protective impulses of almost primal intensity. Mexicans seek to cross the border; Americans try to prevent them from doing so; the altered landscape bears the signs of this ongoing conflict. The running fence, built in 1994 by the U.S. Border Patrol and taken up by James as the leitmotif of his 1997 photographic project, is a line in the sand of the most literal kind (pl. 84 and 86). However, as James observes with characteristic acuity, its twenty-three kilometre course across the terrain is improvised and, ultimately, arbitrary. His image of the fence's western endpoint in the ocean at Playas Tijuana hints at the almost comical futility of drawing a frontier in the water.[13] His overviews of its abrupt eastern terminus at Otay Mesa, in the foothills of the San Ysidro Mountains, reveal the perilously exposed dirt footpaths traced by migrants attempting to circumvent it (pl. 79 and 80). Along the way, he finds interruptions and reinforcements in the corrugated-metal barrier, calling attention to its vulnerability to breach and deterioration as well as its imposing impenetrability (pl. 83).

Responding to the particular nature of this place as a focus of individual and political attention, James incorporates several levels of narration into the Running Fence series. Although the layout of the book follows the fence from west to east, the stories he told are not linear. People not only pass through this territory, they live in it, building settlements for more or less permanent residency on both sides of the nominal border (pl. 81, 82, and 84). When James describes the land with his camera, when he transcribes the line of the fence, he suggests that this imperialist attempt to divide two countries has resulted in a third territory, a nationless zone that may elude the control of those who created it.[14]

This is a moralism in which James's pictures do not indulge, but he does provide the cues for engagement in some sort of ethical reflection, both on history and on the present. It is germane to return for a moment to the photographic exploration of the American West in the nineteenth century, specifically the now iconic images of the frontier's conquest following the authorization by the U.S. Congress in 1862 of a transcontinental railroad. Photographs of the construction show vast tracts of land made

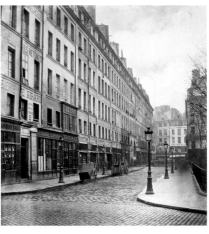

accessible through backbreaking work (fig. 4). When the Union Pacific and Central Pacific lines met in Promontory, Utah, on 10 May 1869, the driving of the final, golden spike was cause for rejoicing – the coast-to-coast line promising to unite the young, Civil War–torn nation and to allow distribution of resources among all its citizens.[15] The fence depicted in James's photographs is a sad echo of this proud, arrogant line across the country (pl. 79 and 84). Instead of uniting and distributing, it divides and hoards; instead of optimistic expansionism, it signals suspicious isolationism. The lettering advertising Coca-Cola on a modest Tijuana restaurant (pl. 81) becomes ironic more than aspirational, like the name of the community where it is located: Colonia Libertad. Photography, previously deployed to celebrate capitalism's potential, here reveals its costs. The San Diego–Tijuana fence describes a boundary, and James describes its effects.

Defining

The photographs in the Asbestos and Running Fence series, while not pure landscapes as such, do present the land as their primary subject. Human habitation is thematically, if not always formally, evident. In choosing to also photograph cities, James had to take a different approach, working with both the forms and the idea of the built environment. He questions the ready catchphrase "urban landscape," an oxymoron that points to nostalgia, denial, and definition through branding.[16] Is there anything natural about cities, James asks, or in the representational conventions we have developed to naturalize them? In considering the second part of the question, he reveals the pointlessness of the philosophical posturing implied by the first part. Cities exist and continue to function, like the machines to which they are frequently compared: sometimes breaking down, often requiring replacement parts,

consuming and producing resources and goods in varying ratios. This is not to say that James discounts history. On the contrary, he is acutely aware of historical forces without relying on historical artifacts to indicate them. If an individual living at the turn of the twenty-first century undertakes to describe a city – in description's second sense of defining or fixing – he must commit to that moment and relinquish the temptation to transform or renovate it through metaphor.

Photographic precedents for depicting cities abound, but they tend to promote precisely the metaphorical allusions that James is determined to minimize or eradicate. Jacob Riis, working in the slums of late nineteenth-century New York, captured individuals in their environments to illustrate an explicitly reformist agenda. Nearly a century later, commissioned by the St. Louis Art Museum, Joel Meyerowitz approached the city of St. Louis from a self-consciously artistic perspective; he was encouraged to convey an "emotional viewpoint."[17] James operates somewhere between and beyond these formulas. His Paris, Lethbridge, and Toronto series are sustained and rigorous, particularly when seen in book form, and must each be examined in turn for their distinctive qualities. In the case of Paris, a project initiated in earnest in 1992 and published in 2001, James had to set aside his fond, youthful memories of the city in order to "test the city's capacity for resistance," to use Hubert Damisch's phrase.[18] In their clear-eyed attentiveness to the city's objects – lampposts, curbs, signs, kiosks, balconies – James's photographs (see pl. 43 and 46) evoke those of Charles Marville, who was officially hired by the city of Paris in the late 1850s to document the capital's ancient quartiers before Baron Haussmann's modernization plan was put into effect (fig. 5).[19] James and Marville share several Parisian motifs, notably the Opéra, but ultimately a comparison between the two falters.

Figure 4
A. J. Russell, *Embankment, East of Granite Canyon*, 1868, albumen print. Union Pacific Museum, Omaha, Nebraska

Figure 5
Charles Marville, *Rue des Innocents, (de la rue Saint-Denis), Paris (I^{er} arr.)*, c. 1865–68, albumen print. Musée Carnavalet, Paris (34244-7)

Marville, as James has pointed out, made pictures to order,[20] using photography (a medium his government commissioners associated with veracity and modernity) instrumentally, to map and thus control the city's rapid transformation. For James, change – whether in the form of heedless destruction, ill-considered enhancement, or graceful decay – is a given, as is our human adaptability to and adaptation of whatever surroundings we choose to occupy. Rather than a means to understanding, photography is an end in itself.

With his considered acknowledgment of (and departure from) the seductive charms of Paris, James also nods to Surrealism, a connection drawn by Damisch in his essay for the *Paris* book: "Are we still struggling today to explode the immense forces of 'atmosphere' concealed in the capital, and thereby reveal the energy which the Surrealists, and Benjamin after them, did not hesitate to call 'revolutionary'?"[21] The incendiary rhetoric of these earlier Modernists may now sound dated, but the desire to define a city's identity as shaped by history, myth, and chance survives in James's work, and in fact constitutes its contemporaneity.

This insistence on the present operates somewhat differently in the projects devoted to younger cities of the so-called New World. In Lethbridge, Alberta, for example, the relative freedom from association with long-past events and individuals places the burden of representation on eloquent vernacular architecture (see pl. 37, 38, and 39) and inelegant junctures between the built and the unbuilt (see pl. 32, 41, and 42). James first visited Lethbridge in 1971 to see the new Lethbridge University building, which was designed by the Canadian architect Arthur Erickson (with Geoffrey Massey). According to Erickson's website, this building – which houses lecture halls, classrooms, laboratories, offices, and student residences under one roof – claimed to solve every potential problem related to the site's topography and climate. Impressed as he was by Erickson's achievement, James found himself more interested in Lethbridge's unresolved aspects. Returning in 1998 on the invitation of Joan Stebbins, then director of the Southern Alberta Art Gallery, he was able to pursue that interest.

The resulting book, *Place*, suggests a wary but curious circling, a questioning of civic rhetoric, and an ambivalent retrieval of myth as an entry point to history.[22] The table of contents structures the reader's experience as a cumulative one: "Approaches" scans the prairie environment, traced by roads and bridges; "In the City" portrays a variety of time- and weather-worn commercial and residential structures in the once-bustling centre; "A Better Way of Life" moves to the new, larger houses on the outskirts of town; "Paradise Canyon and Beyond" looks at the boundary between the manicured greens of a golf-course community and the volcanically formed coulees in the Oldman River Valley headlands. In the final chapter, "Where the Black Rocks Lie in the Old Man's River," the Canadian writer Rudy Wiebe meditates on Lethbridge in an account blending personal memory, family lore, wartime stories, Native American legacy, and impressionistic landscape sketches. The imperfect integration – the nearly opposed descriptive functions – of images and text make *Place* a rich and challenging volume.

In his Toronto series, James deals most directly with the notion, or rather the impossibility, of definition through description. While his long residence (twelve years) in Toronto might make his selection process appear more incisive, it also renders his conclusions more challenging. The city he depicts appears to suffer an identity crisis: neither for tourists (who want a theme park), nor for citizens (who want a domestic idyll), nor for social critics (who want unmitigated ugliness), James's Toronto becomes something else entirely, in offering all of these points of view and the permeable boundaries

between them. Indeed, boundaries themselves are the true subjects of many pictures. Fences feature equally in new suburban housing developments (see pl. 72), where traditional white pickets indicate the parcelling of once open land, and downtown (see pl. 65), where a utilitarian chain-link barricade suggests the containment of disorder. The somewhat dishevelled laneways of older neighbourhoods (see pl. 62) seem both pleasant and shabby, laden with meanings beyond their everyday function as passageways. Finally, in a group of photographs depicting an early phase of the Liberty Village development – its name echoing Tijuana's Colonia Libertad – James focuses on the borders defined by railroad tracks (see pl. 69) and billboards (see pl. 68).

Classifying

Although hints of description's third primary sense – classification – are found in James's city projects, this impulse emerges most clearly in his images of trees, and of parks and other sites designed by Frederick Law Olmsted. Once again, photography's history comes into play. From its invention, photography was brought to bear in the taxonomic activities of scientists – geologists, archaeologists, and botanists, for example – the new medium soon challenging, supplementing, or supplanting other means of documentation such as drawings, charts, and statistics. In two related but distinct bodies of work, James interrogates this conceptual and photographic impulse.

In his pictures of trees, he keeps Eugène Atget (fig. 6) in mind but relinquishes the latter's comprehensive intent in order to embrace a certain arbitrariness and artificiality. Since his earliest substantial bodies of work have to do with gardens (see Stephen Bann's essay in this volume), James has frequently encountered remarkable trees while engaged in other projects. Only gradually

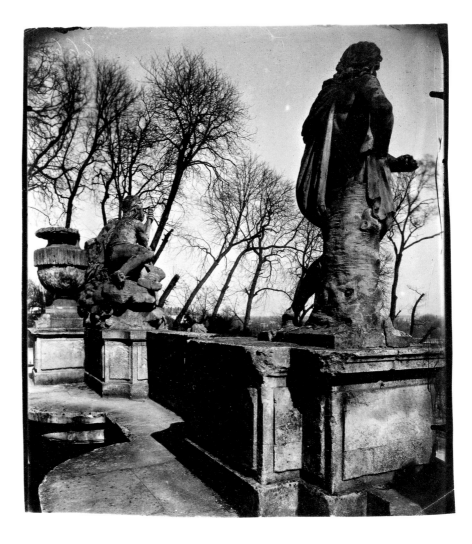

Figure 6
Eugène Atget, *Saint-Cloud*, 1907, albumen silver print. National Gallery of Canada, Ottawa (21141)

did they emerge as a project in and of themselves. Seen together, as in this publication, the images of single trees remain individual specimens rather than massing as a forest. They are evidently situated in different places, but we cannot tell where. Their surroundings do matter, however, because each tree acquires meaning not only through its fascinating physical idiosyncrasies but also through its interaction with and role in the landscape. The motif's simplicity makes us aware of how much extraneous knowledge we bring to our viewing activity and how much we extrapolate from certain details. For example, one tree appears Japanese (although it is actually located in New York State); by categorizing it as "Asian," a Westerner pretends to adopt another culture's view of the world. In noting that another tree is nudged by a neat white fence, we acknowledge the impulse to contain and own land as property.

If yet another tree metamorphoses into a gnarled monster, we recall traditional fairytales and modern special effects as well as sobering natural disasters. James reminds us that there are any number of ways to classify trees beyond genus and species, all of them symbolic, none of them natural.

The idea of artifice thus becomes crucial to James's pictures of trees – and it is embedded in the means as well as the ends. As the consistent one-to-three proportions indicate, he uses a vertically scanning panoramic camera for these photographs. This seems perfectly logical: tall, narrow subject, tall, narrow format. For once, we feel, a tree is pictured accurately. Yet while these may be accurate pictures in some sense, they bear no relation to the way we see trees of this height with our own eyes.[23] James first used the panoramic camera in 1995 to photograph single trees while working in Brittany at Kerguéhennec. Later, he learned to get close to the tree and tilt the camera, which has no viewfinder. This manoeuvre "straightens" the trunk and provides the viewpoint we might have if suspended in the air, midway up the height of the tree, at some distance, and with no obstacles in the way. This is sleight of hand to the point of stylization, achieved through James's precise knowledge of how camera vision works and his instincts for making it look natural, rather than distorted. Exploiting the disparity between camera vision and natural vision, he sustains the fiction of the equivalence between these two perceptual modes – and produces images that are satisfying in every respect.

Some of these towering specimens, it turns out, have distinguished addresses: James encountered them while working on an extensive investigation of the landscape design of Frederick Law Olmsted. This project, which was commissioned by the Canadian Centre for Architecture (CCA) in Montreal, dates back to October 1987. The idea was James's. Photographing in and writing about Italian, French, and British gardens during the early to mid 1980s, he became immersed in the legacies of the eighteenth-century landscape gardeners Lancelot "Capability" Brown and Humphry Repton as well as the author and artist William Gilpin, known for his writings on the picturesque – all sources of inspiration for Olmsted. Looking for contemporary images of Olmsted's parks, James found little that encompassed their present state, which, he observed, was often one of neglect. He approached the CCA director Phyllis Lambert, who supported some initial research and subsequently reviewed a formal application in which James proposed that he, Lee Friedlander, and (identified later in the project) Robert Burley would make photographs of Olmsted sites, completely at their own discretion and in consultation with the landscape historian Cynthia Zaitzevsky.[24]

According to the CCA's press materials, this ambitious effort would not only examine Olmsted's legacy and the role of planned green spaces in cities, but also "remind people of the scale of action needed to reinvigorate our cities in the future."[25] Deliberately referencing such historical precedents as the Mission héliographique and the U.S. government–sponsored Farm Security Administration (FSA) projects of the 1850s and 1930s, respectively, the CCA commission spoke to its own time by acknowledging the predominance of aesthetic concerns, and by admitting that "no settled, iconic image was possible."[26] James certainly did ponder the parks' social function, thinking especially about the ways in which that function has changed from Olmsted's day to the present, but this was by no means his subject. As he suggests in an interview with David Harris, the physical subject is "the conditions of light" and the conceptual (or "real" subject, as James calls it) is the "persistence" of the parks.[27] These themes cannot be evoked, nor perhaps even contemplated, except through photography, with its apparent capacity

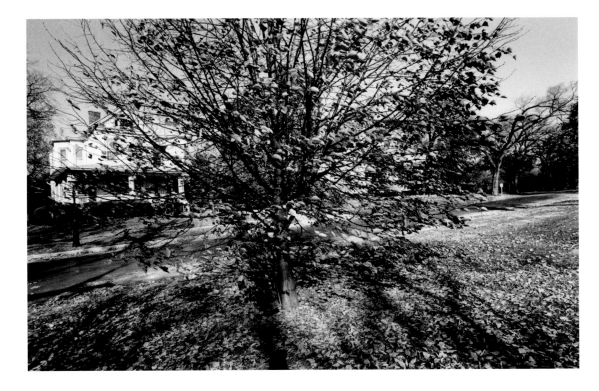

Figure 7
Lee Friedlander, *Fairbank Road, Riverside*, 1988, gelatin silver print. Canadian Centre for Architecture, Montreal (CCA PH1991:0055)

to capture transient effects and depict direct experience. "I don't have a huge didactic ambition," James explained in the same interview, "but everything I've done is an attempt to convey my sense of excitement about these creations. And not just to illustrate them, but to give a sense of what it's like to be there. Which is what the best photography does. It's like being there; it has a mnemonic power that no other medium has."[28]

But, as he has remarked more recently, "a photograph is not the same as its subject, and the Olmsted project shows how three photographers came back with completely different symbolic reports."[29] Of Olmsted's hundreds of completed projects (urban parks, park systems, suburban communities, college campuses, private estates, cemeteries, and conservation schemes), Zaitzevsky selected seventy-four sites to be explored by James, Burley, and Friedlander. Working independently over a seven-year period (1988–94), they generated thousands of photographs, 940 of which have been archived at the CCA.[30] James brought an 8 × 10 view camera and a panoramic camera to the Olmsted sites, Burley used a 4 × 5 and shot in colour, and Friedlander (fig. 7) carried a 2 ¼-inch Hasselblad (he also used a panoramic camera on occasion). In published commentaries, each man suggests that he was trying to enter Olmsted's mindset, to walk in his footsteps, to figure out the master plan, to see the parks as works of art.[31] But as citizens of the late twentieth century, each recognized the futility of this exercise in projection. Inevitably, "Olmsted frequently recedes in these views," as the professor and landscape architect Gary R. Hilderbrand wrote in a review. "Often the focus of attention has more to do with later interventions, or with the evidence of contemporary use – such as graffiti, or cars, or eroded banks, or unmanaged vegetation – because that is what's there, and that is what was interesting to the photographers."[32]

For James, viewing Olmsted was not solely a matter of looking and picturing. Trying to describe Olmsted's parks photographically, he found himself reflecting on their formative conditions and on their subsequent reception and use. Robert Smithson, the incisive theorist of entropy and anti-monumentality, proved to be a crucial link for James between the utopian optimism of Olmsted's time and the careless cynicism of our own day. Smithson not only acknowledged the human alteration of nature, he took an active stance, articulating the landscape artist's particular responsibility: "The authentic artist must not turn away from the effects of urbanism, materialism, industrialism, on the landscape. We can not afford to project a face of innocent pseudoarcadias . . . and shrink into an easy spirituality."[33] James inherits this idea and applies it in all of his work. In his ongoing exploration of Olmsted's parks, he has become increasingly interested in the transformation of some (like New York's Central Park) through private investment, which has reversed breakdowns caused by prior inattention. Photography can capture such changes in cultural priorities, prompting reflective, metaphorical comparisons across time and place.

The multifaceted connotations of description have structured this overview of James's photographic production over the past twenty years. Other, less programmatic organizational schemes would no doubt produce more finely nuanced interpretations, but the

set of ideas associated with description must be central to any account. The dispassionate attitude stipulated by Wordsworth in the first of this essay's two epigraphs has been identified by several commentators as a distinguishing characteristic of James's work and the source of its rich ambiguity. However, James takes the descriptive mode further by virtue of his keen historical awareness; he depicts time as well as place. In so doing he operates as Balzac's hero suggests in the second epigraph, bypassing the *causeries* of nostalgia and instead describing real sites in the present day. The camera both shapes and responds to this intention.

Notes

1 "Remplacez ces diffuses causeries par des descriptions auxquelles se prête si bien notre langue." English translation from Édouard Morot-Sir, *The Imagination of Reference II: Perceiving, Indicating, Naming* (Gainesville: University Press of Florida, 1995), p. 115.

2 Geoffrey James, email to the author, 14 June 2007. Berkeley summed up his theory of immaterialism with the dictum *esse est percipi* (to be is to be perceived); Johnson countered by asserting his commitment to common sense and hard facts over metaphysical speculation. For the Johnson episode, which took place in 1763, see James Boswell, *The Life of Samuel Johnson*, vol. 1, ed. G.B. Hill, rev. L.F. Powell (Oxford, 1935), p. 471; cited and discussed by Douglas Lane Patey, "Johnson's Refutation of Berkeley: Kicking the Stone Again," *Journal of the History of Ideas* 47, no. 1 (January–March 1986): 139–45.

3 Thomas Kuhn is discussed in this context by Arthur C. Danto, "Description and the Phenomenology of Perception," in *Visual Theory: Painting and Interpretation*, ed. Norman Bryson, Michael Ann Holly, and Keith Moxey (New York: HarperCollins, 1991), pp. 205–06.

4 The literary theorist Philippe Hamon traces what he terms "la dérive descriptive" in his introduction to *La description littéraire de l'Antiquité à Roland Barthes: une anthologie* (Paris: Macula, 1991), pp. 5–12. See also Hamon, "The Rhetorical Status of the Descriptive," in "Towards a Theory of Description," special issue, *Yale French Studies*, no. 61 (1981): 1–26.

5 Roland Barthes, "The Reality Effect," in *Realism*, ed. Lilian R. Furst (London: Longman, 1992), pp. 135–41.

6 Michel Beaujour, "Some Paradoxes of Description," in "Towards a Theory of Description," p. 47. See also Janice Hewlett Koelb, "Introduction: Ecphrasis, Description, and the Imagined Place," in *The Poetics of Description: Imagined Places in European Literature* (New York: Palgrave Macmillan, 2006), pp. 5–6.

7 See also Morot-Sir, *The Imagination of Reference II*, pp. 110–11.

8 The Americans began the survey in 1857. The following year they were joined by the Royal Engineers, who had begun to receive training in photography from Charles Thurston Thompson in 1855. The final report of the forty-ninth parallel survey was not completed owing to the onset of the American Civil War. See Mary Warner Marien, *Photography: A Cultural History* (New York: Harry N. Abrams, 2002), pp. 119–20; and William Goetzmann, *Army Exploration in the American West, 1803–1863* (New Haven: Yale University Press, 1959), pp. 427–29.

9 Notable in this regard is the Rephotographic Survey Project, undertaken in the American West between 1977 and 1979. See Mark Klett, Ellen Manchester, JoAnn Verburg, Gordon Bushaw, and Rick Dingus, *Second View: The Rephotographic Survey Project* (Albuquerque: University of New Mexico Press, 1984); and Klett et al., *Third Views, Second Sight: A Rephotographic Survey of the American West* (Santa Fe: Museum of New Mexico Press in association with the Center for American Places, 2004). For a concise assessment of the RSP, see Thomas W. Southall, "*Second View*: A Search for the West That Exists Only in Photographs," in *Perpetual Mirage: Photographic Narratives of the Desert West* (New York: Whitney Museum of American Art and Harry N. Abrams, 1996), pp. 193–98.

10 Richard Rhodes, in Geoffrey James, *Asbestos* (Toronto: The Power Plant, 1994), p. 63, discusses James's "mediating line": "He takes photographs like a historian (the discipline in which he was trained), encouraging the thinking-through of history's overlap with the contemporary world. "

11 The enlargement of a foreground element in this way is a standard photographic illusion. James has remarked on the scale of the "new nature," that is, man-made nature, which makes "normal" nature look strange. Geoffrey James, conversation with the author, National Gallery of Canada, Ottawa [hereafter NGC], 26 April 2007; and email to the author, 3 October 2007.

12 Geoffrey James, artist's talk, NGC, 26 April 2007.

13 See Geoffrey James, *Running Fence* (North Vancouver: Presentation House Gallery, 1999), plate 2.

14 The writer and historian Dot Tuer develops the related idea of "nomad space" in the essay "Imaging the Borderlands" (*Running Fence*, pp. 105, 107). The journalist John Borrell takes a different view: "There is fusion, especially where the two countries meet. But the region is also a fault line where the tectonic plates of nationalism grind away despite such tokens of integration as Big Macs in Mexico City and tortillas in Tucson. There certainly is no identifiable third country in the making here, as popular myth would have it" ("Journey along the Border," *Time*, 24 October 1988).

15 See Susan Danly, "Photography, Railroads, and Natural Resources in the Arid West: Photographs by Alexander Gardner and A. J. Russell," in *Perpetual Mirage*, pp. 49–55; and Anne M. Lyden, *Railroad Vision: Photography, Travel, and Perception* (Los Angeles: The J. Paul Getty Museum, 2003). Russell's "Golden Spike" image is reproduced in Marien, *Photography: A Cultural History*, p. 122, figure 3.54.

16 Geoffrey James, conversation with the author, NGC, 28 April 2007. James admits to a partiality for the writings of W.G. Sebald. In this context, one thinks of Sebald's *On the Natural History of Destruction*, trans. Anthea Bell (New York: Random House, 2003), which includes an essay, "Air War and Literature," on the rarity of depictions of urban destruction in postwar German literature. The scholar Mark R. McCulloh notes that Sebald's "exacting power of description" is one of the salient features of his work (together with "the scope of his cultural and historical knowledge" and "his ability to unite a multitude of narrative threads"); see *Understanding W.G. Sebald* (Columbia: University of South Carolina Press, 2003), p. xx.

17 On social reform photography, see Peter Bacon Hales, *Silver Cities: The Photography of American Urbanization, 1839–1915* (Philadelphia: Temple University Press, 1983); for Riis's articulation of his agenda, see the anthology *Photo Story: Selected Letters and Photographs of Lewis W. Hine*, ed. Daile Kaplan (Washington, D.C.: Smithsonian Institution Press, 1992). By contrast, an emphasis on subjectivity and beauty in James Wood's introductory essay to Joel Meyerowitz's *St. Louis and the Arch: Photographs* (Boston and St. Louis: New York Graphic Society and St. Louis Art Museum, 1980) suggests a deliberate rejection of social commentary.

18 Hubert Damisch, "Fils croisés / Crossed Lines," in Geoffrey James, *Paris* (Paris: Services culturels de l'Ambassade du Canada, 2001), p. 30.

19 On Marville, see Maria Morris Hambourg and Marie de Thézy, *Charles Marville: Photographs of Paris at the Time of the Second Empire* (New York: French Institute and Alliance Française, 1981). See also Shelley Rice, *Parisian Views* (Cambridge and London: The MIT Press, 1997).

20 Geoffrey James, email to the author, 13 June 2007.

21 Damisch, in *Paris*, p. 28. For a discussion of the Surrealists' ideas about literary description, see Joseph Halpern, "Describing the Surreal," in "Towards a Theory of Description," pp. 89–106. On "Surrealist realism" – the phrase is Louis Aragon's – and its identification with the medium of photography, see Ian Walker, *City Gorged with Dreams: Surrealism and Documentary Photography in Interwar Paris* (Manchester: Manchester University Press, 2002).

22 Geoffrey James and Rudy Wiebe, *Place: Lethbridge, A City on the Prairie* (Vancouver, Boston, and Lethbridge: Douglas & McIntyre, David R. Godine, and Southern Alberta Art Gallery, 2002).

23 Geoffrey James, conversation with the author, NGC, 27 April 2007.

24 Geoffrey James described the origins of the Olmsted project in an email to the author, 13 June 2007. He also shared a typescript copy of the original proposal he wrote for Phyllis Lambert.

25 Phyllis Lambert, quoted in "Viewing Olmsted: Photographs by Robert Burley, Lee Friedlander, and Geoffrey James," press release, Canadian Centre for Architecture, Montreal, October 1996.

26 Ibid.

27 David Harris, "Interview with Geoffrey James" (23 June 1995), in *Viewing Olmsted: Photographs by Robert Burley, Lee Friedlander, and Geoffrey James* (Montreal: Canadian Centre for Architecture, 1996), pp. 98, 101.

28 Ibid., p. 100.

29 Geoffrey James, email to the author, 14 June 2007.

30 "Olmsted Archive at the CCA," in *Viewing Olmsted*, pp. 117–19.

31 For a related observation, see Herbert Muschamp, "Sunday in the Park with Fred: Visualizing Olmsted's Legacy," *New York Times*, 28 February 1997.

32 Gary R. Hilderbrand, "Reviews: *Viewing Olmsted: Photographs by Robert Burley, Lee Friedlander, and Geoffrey James*," *Land Forum*, spring/summer 1998,. http://www. spacemakerpress.com/lfjune98/lfpage07. htm (accessed 13 May 2007).

33 Robert Smithson, quoted in Suzaan Boettger, "Smithson's Olmsted: Ecologist of the Real," *Artnet*, 1997, http://www. artnet.com/magazine_pre2000/features/ boettger/boettger97-4-3.asp (accessed 14 May 2007).

PANORAMAS

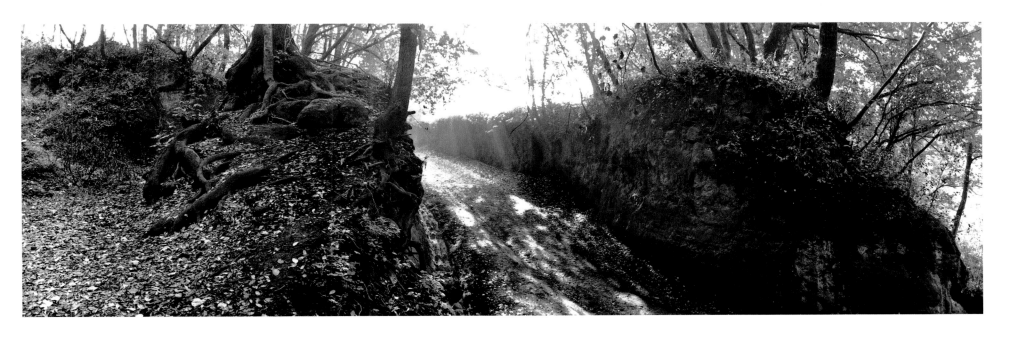

1. ETRUSCAN ROAD, VEIO

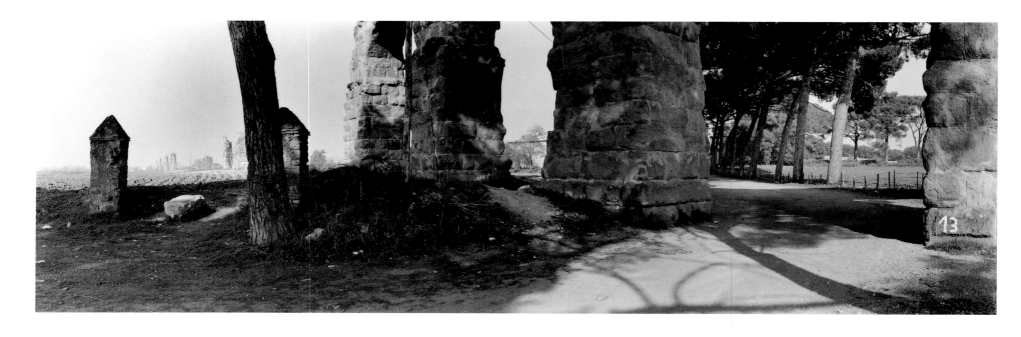

2. THE AQUEDUCT CLAUDIO (left side of double)

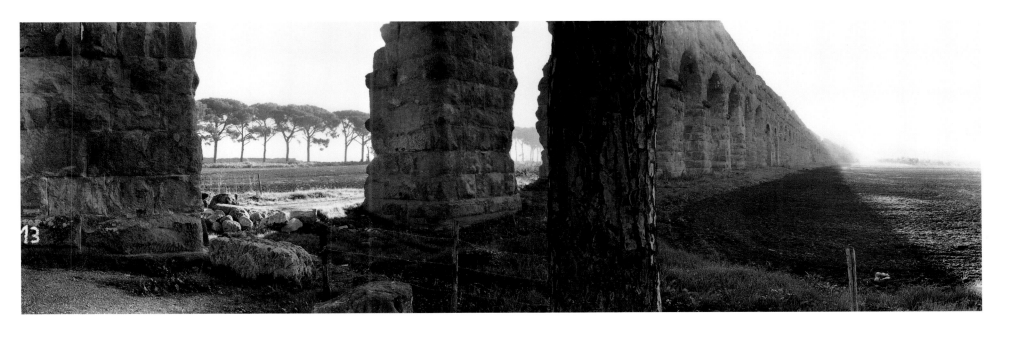

3. THE AQUEDUCT CLAUDIO (right side of double)

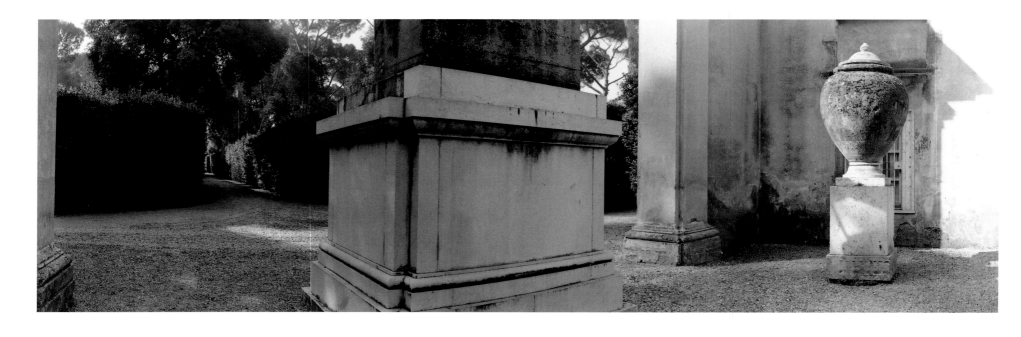

4. VILLA MEDICI, ROME (ALLEY FROM THE PINCIO WALL
TO THE COURTYARD GARDEN)

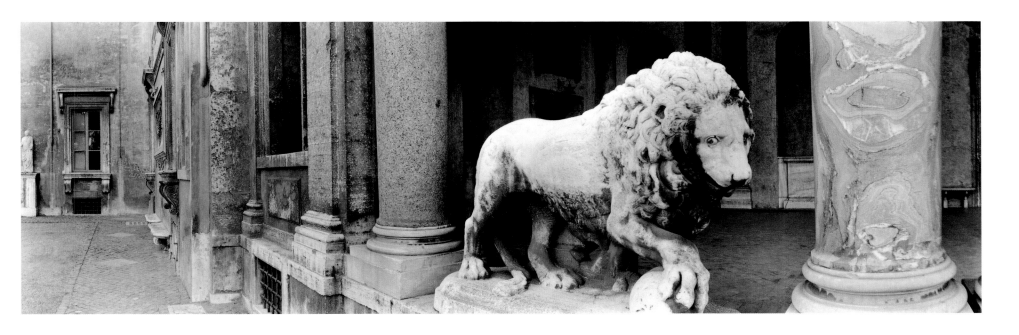

5. VILLA MEDICI, ROME (THE LOGGIA)

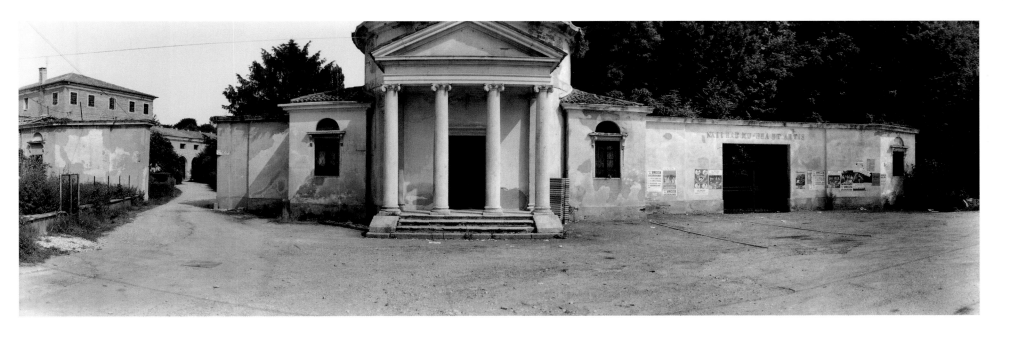

6. VILLA VALMARANA, SAONARA

7. SAINT-CLOUD

8. DESERT DE RETZ

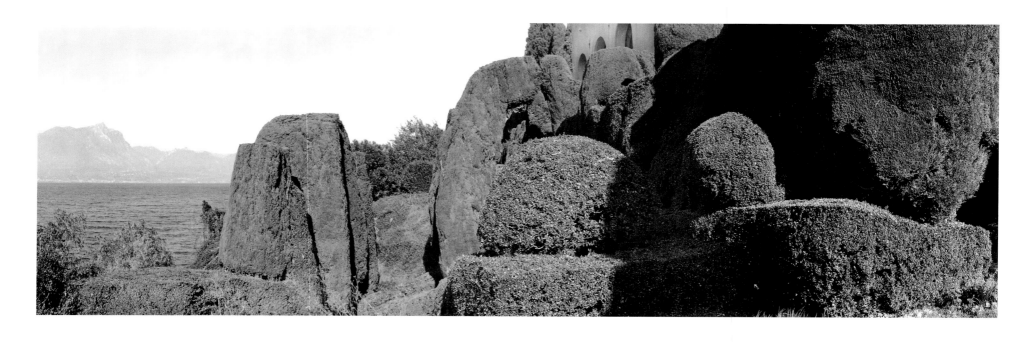

9. VILLA BRENZONE, SAN VIGILIO, LAGO DI GARDA

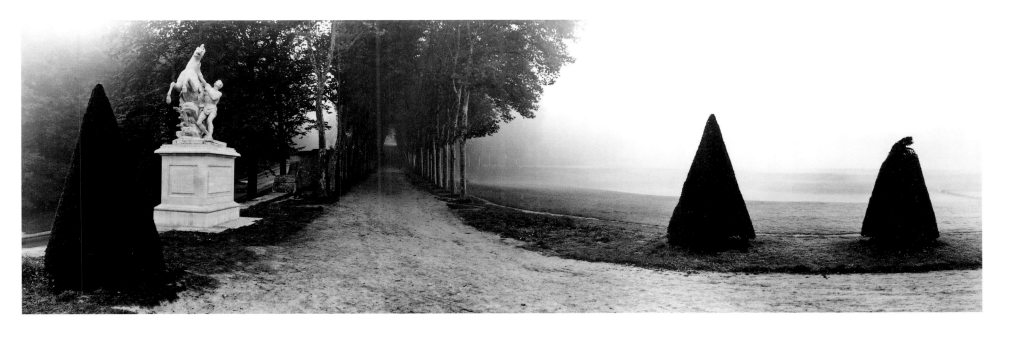

10. MARLY-LE-ROI

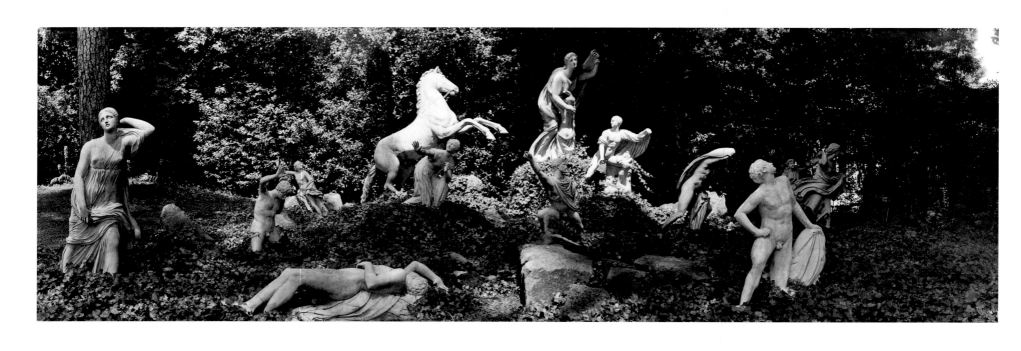

11. VILLA MEDICI, ROME (NIOBE AND HER CHILDREN)

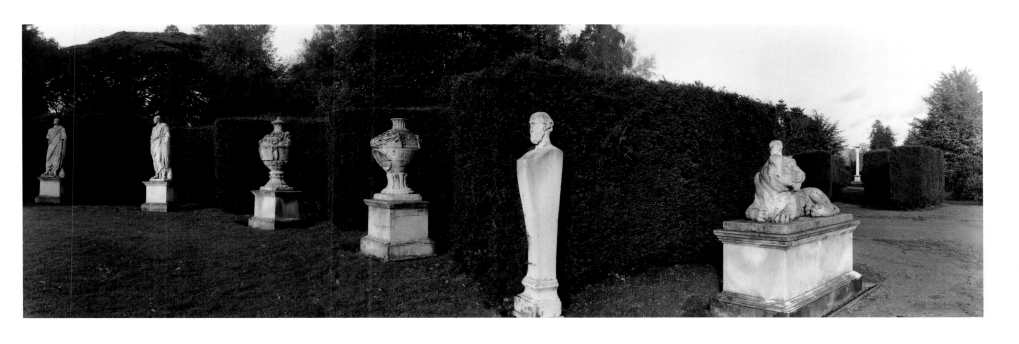

12. CHISWICK PARK, LONDON

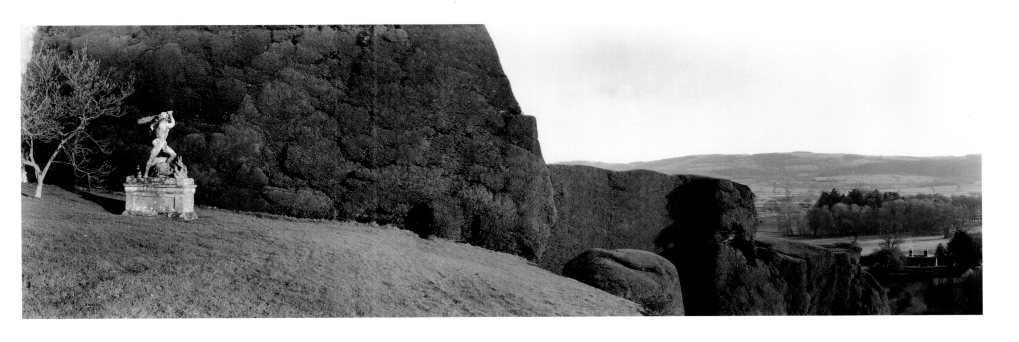

13. POWIS CASTLE, WALES

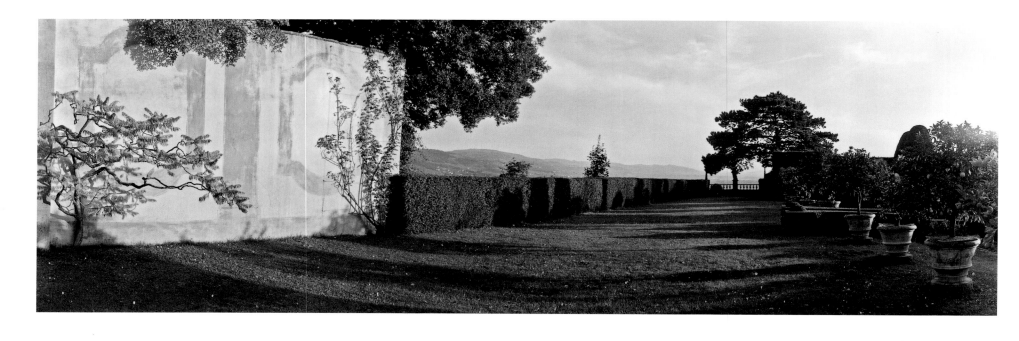

14. LA GAMBERAIA, SETTIGNANO, FLORENCE

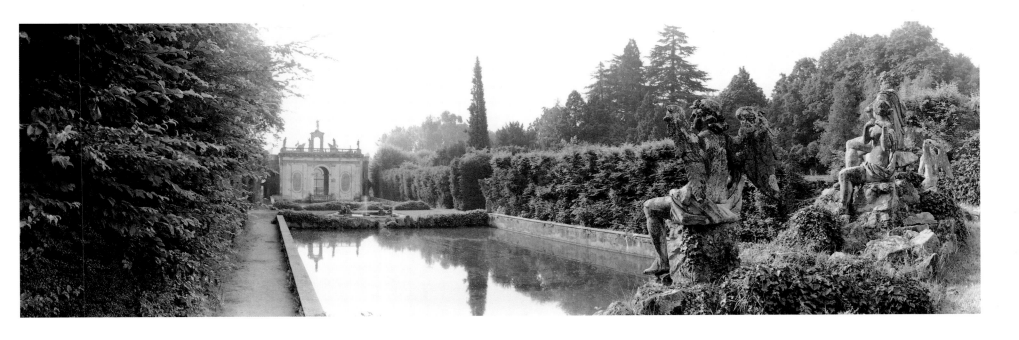

15. VILLA BARBARIGO, VALSANZIBIO

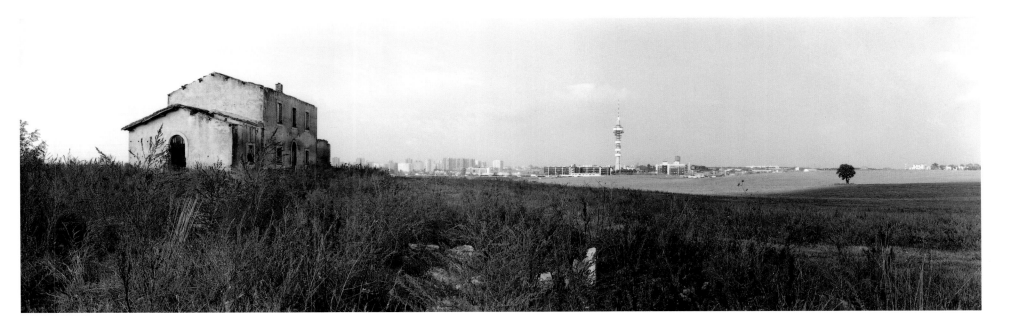

16. CASTEL DI LEVA

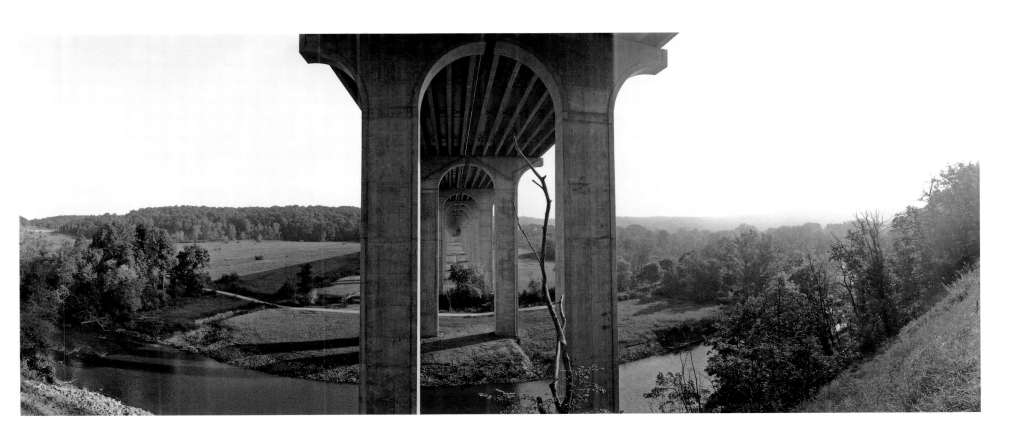

17. VIADUCT OF THE OHIO TURNPIKE OVER CUYAHOGA NATIONAL PARK

OLMSTED

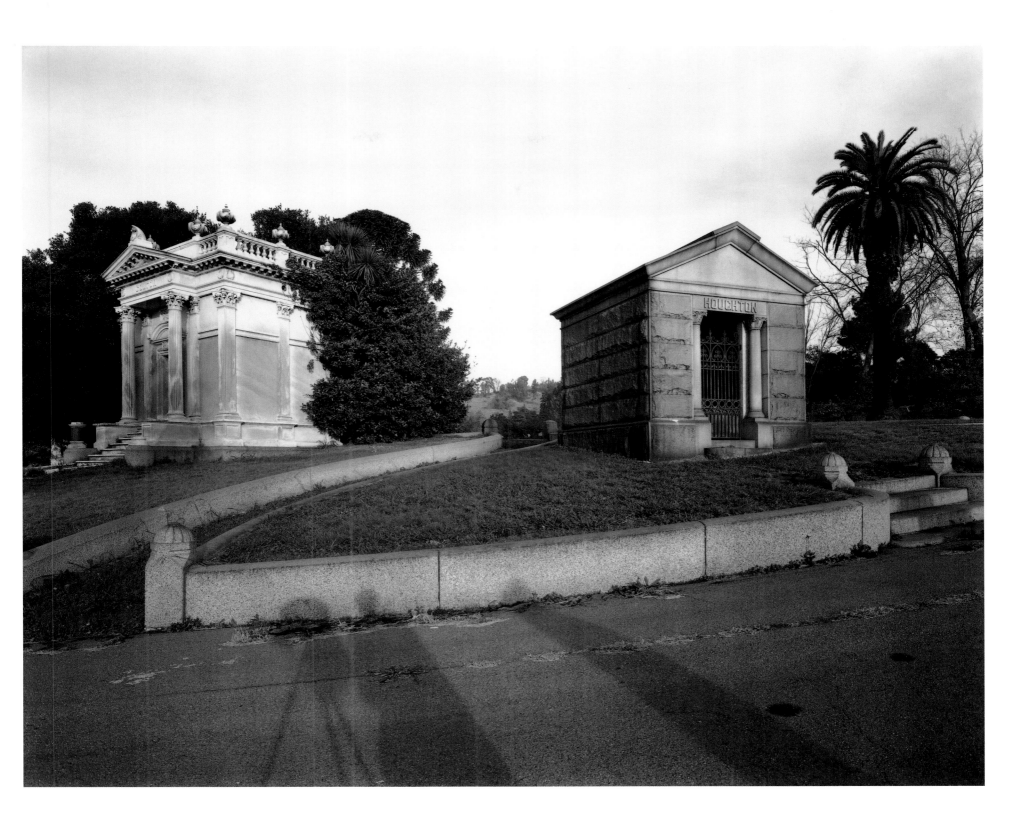

18. COLTON AND HOUGHTON MAUSOLEUMS, MOUNTAIN VIEW
CEMETERY, OAKLAND, CALIFORNIA

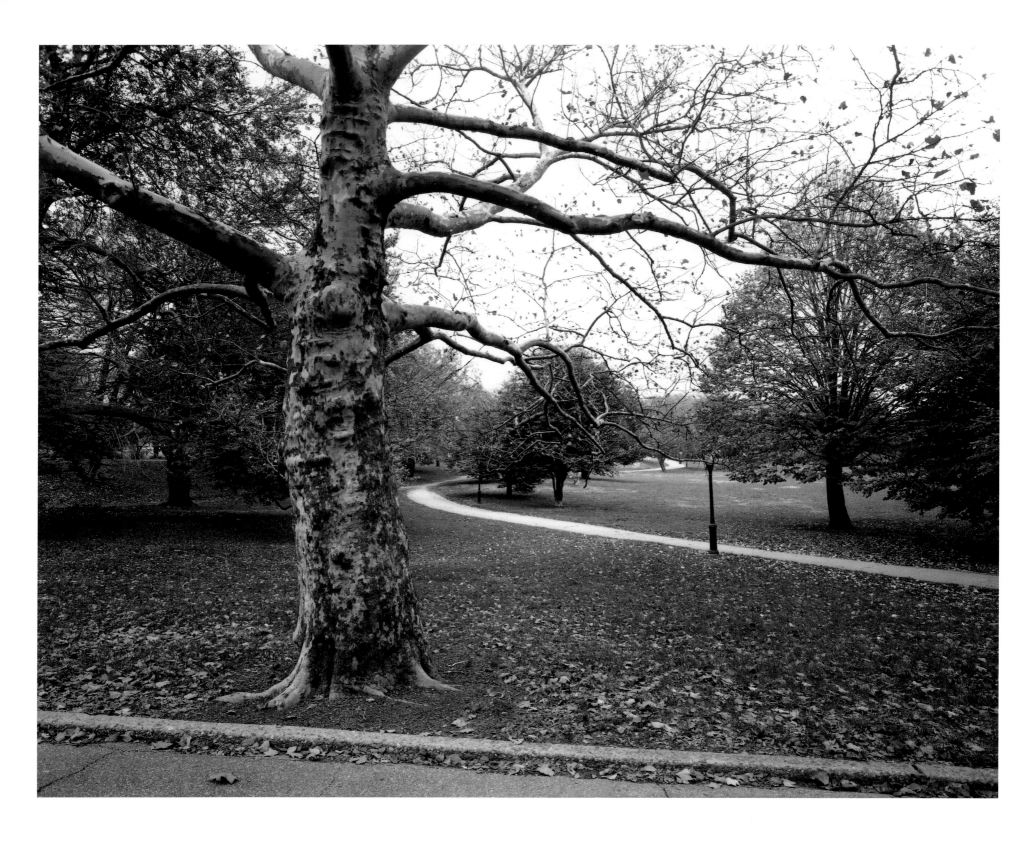

19. SYCAMORE, JUST EAST OF THE RAMBLE,
CENTRAL PARK, NEW YORK

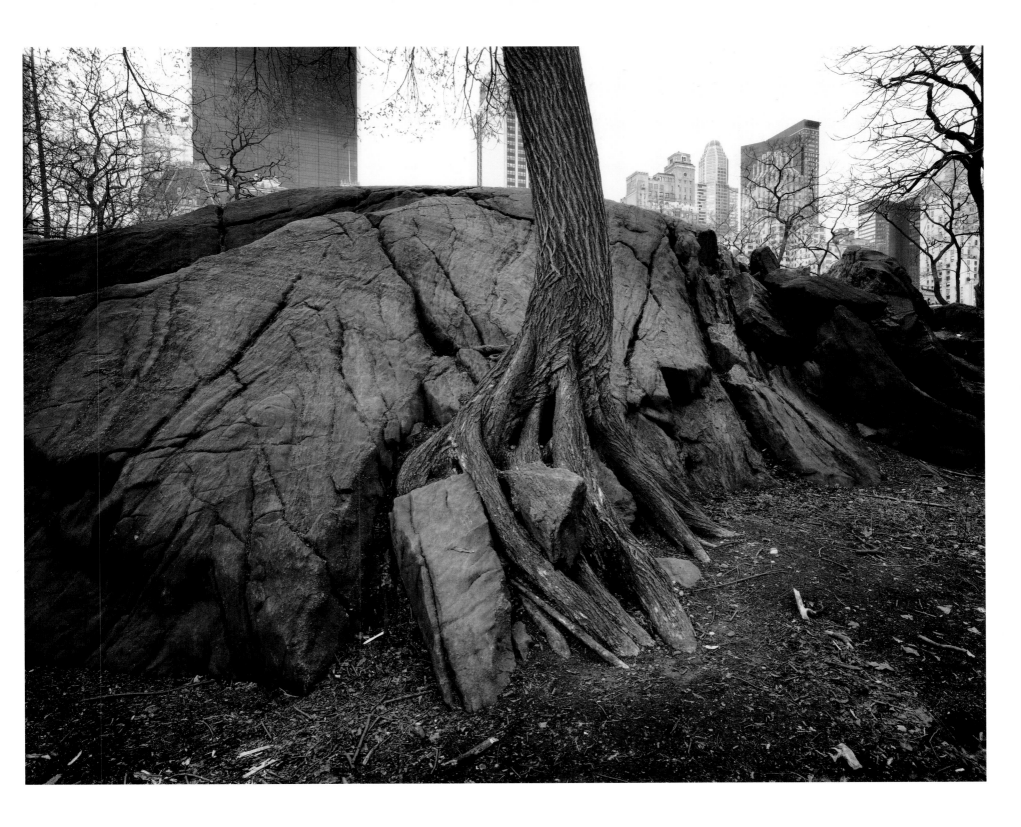

20. TREE ROOTS AND ROCKS, LOOKING TOWARDS THE DAKOTA,
CENTRAL PARK, NEW YORK

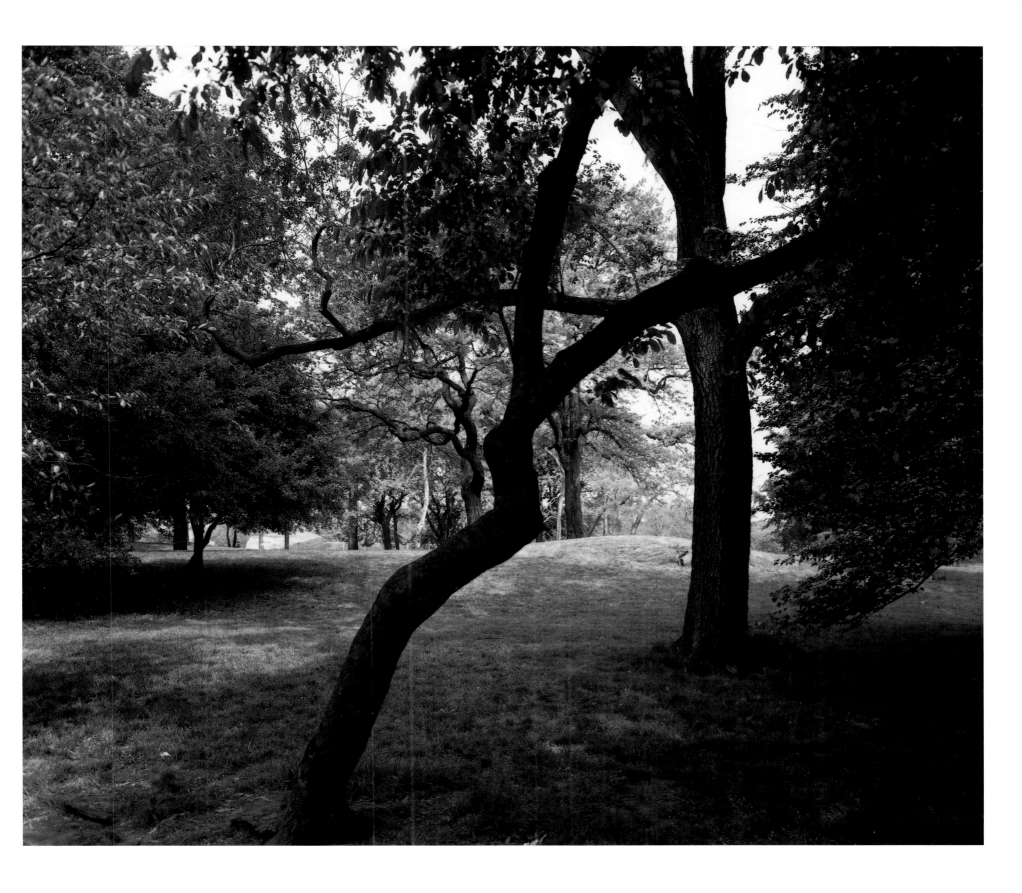

21. EAST MEADOW, CENTRAL PARK, NEW YORK

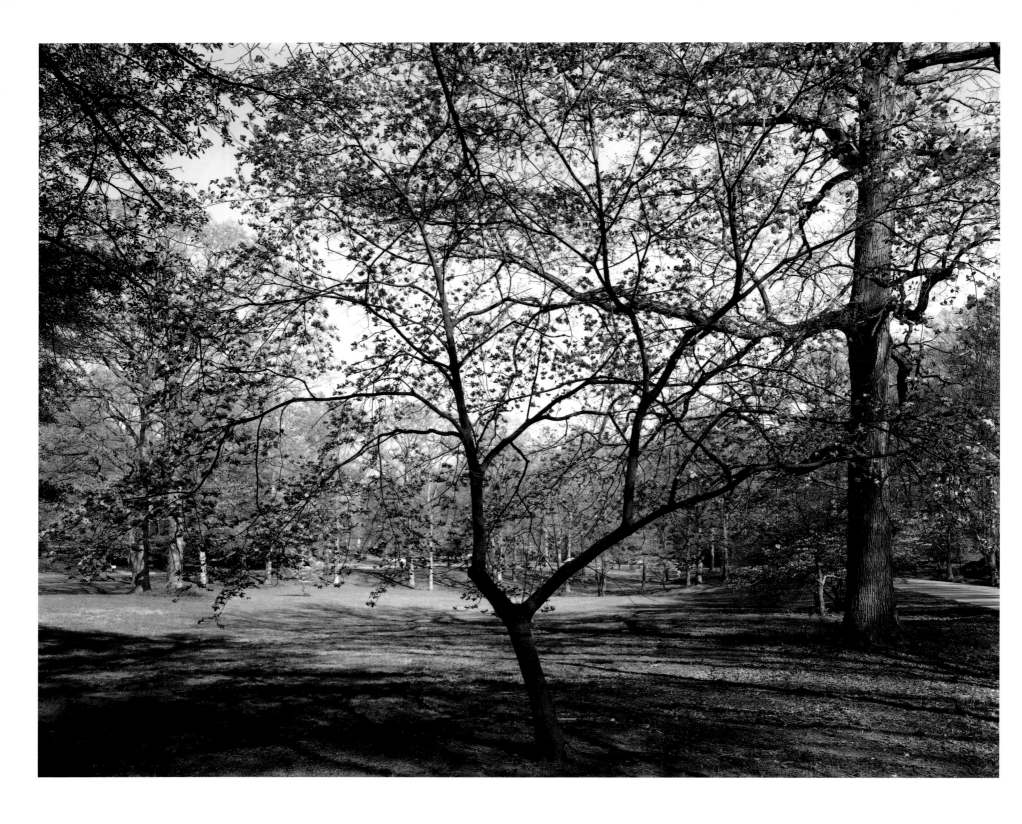

22. DRUID HILLS, ATLANTA

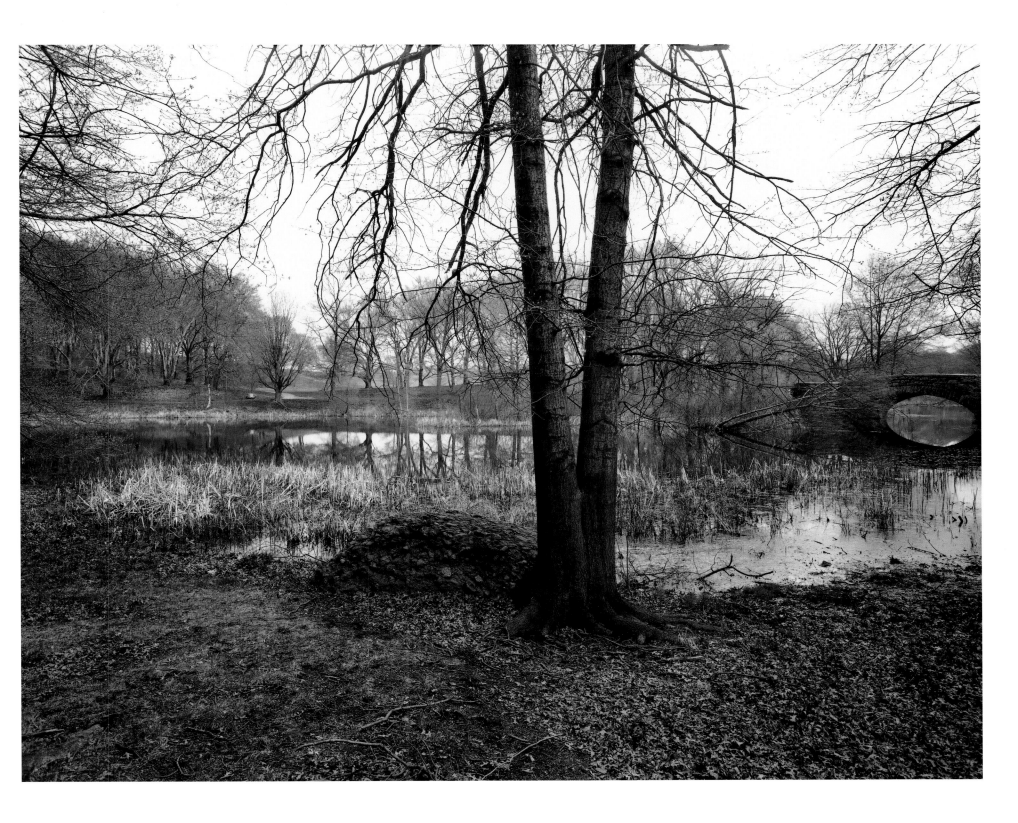

23. VIEW FROM THE EDGE OF THE SCARBORO POND TOWARDS THE
COUNTRY PARK, FRANKLIN PARK, BOSTON

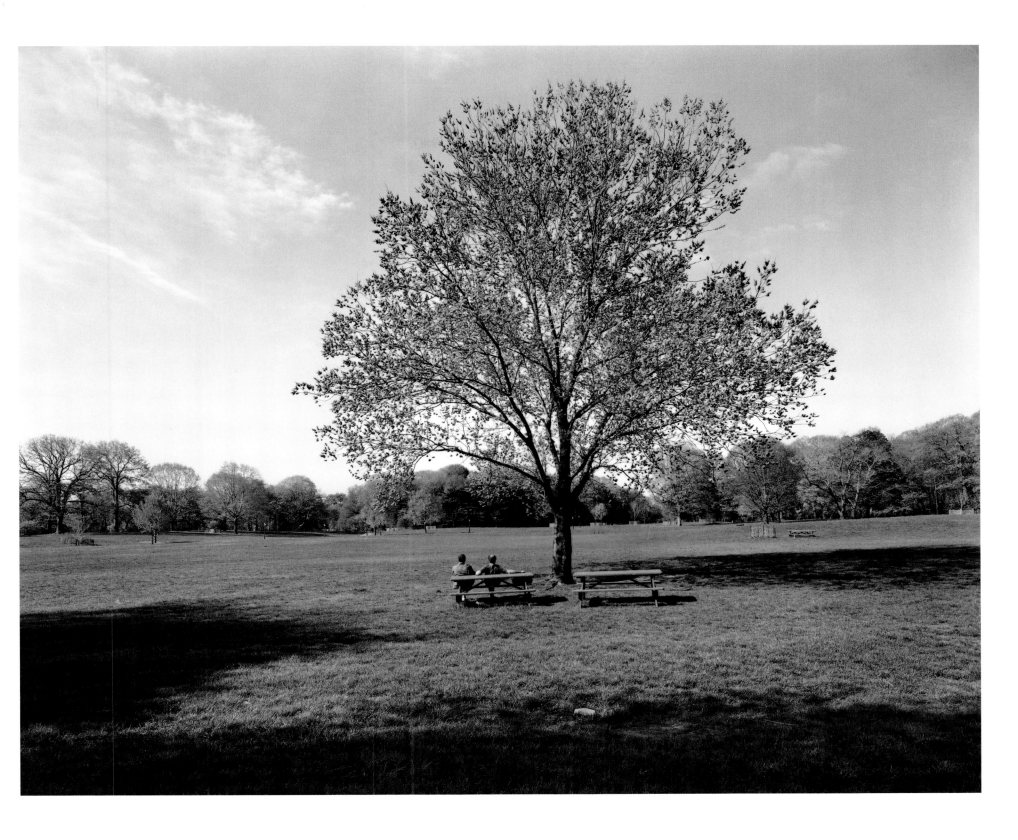

24. VIEW OF THE NETHERMEAD, PROSPECT PARK, BROOKLYN

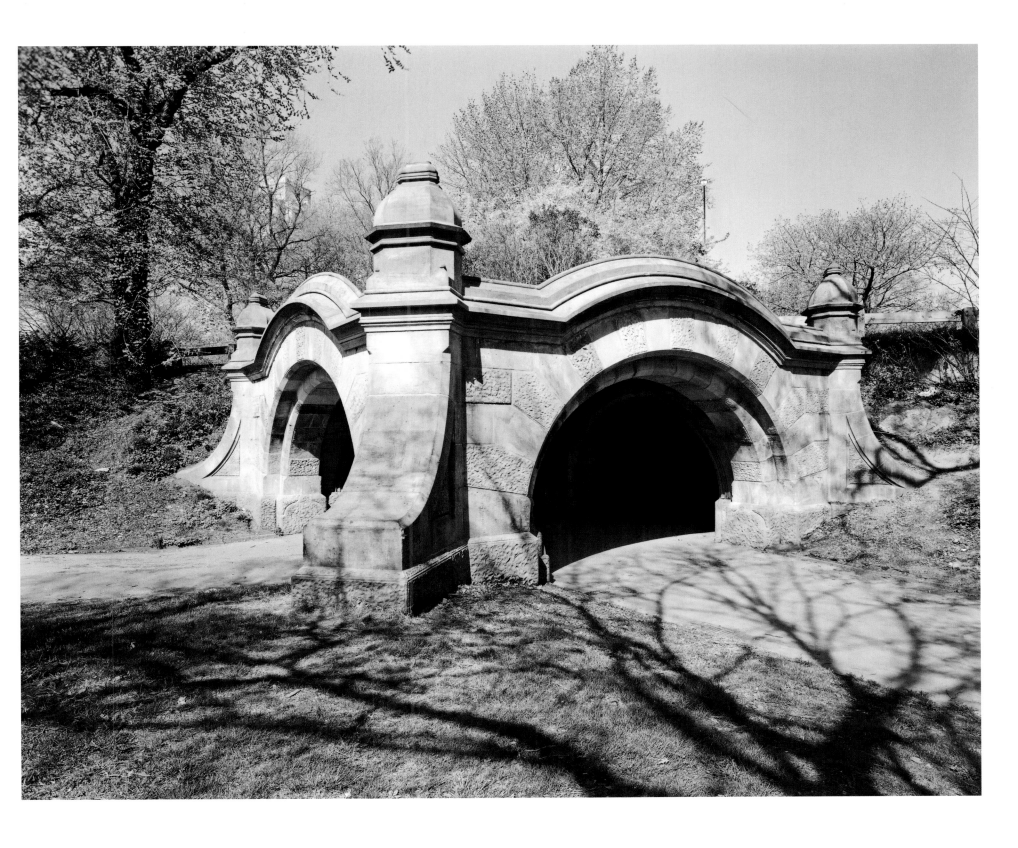

25. THE MEADOWPORT ARCH, PROSPECT PARK, BROOKLYN

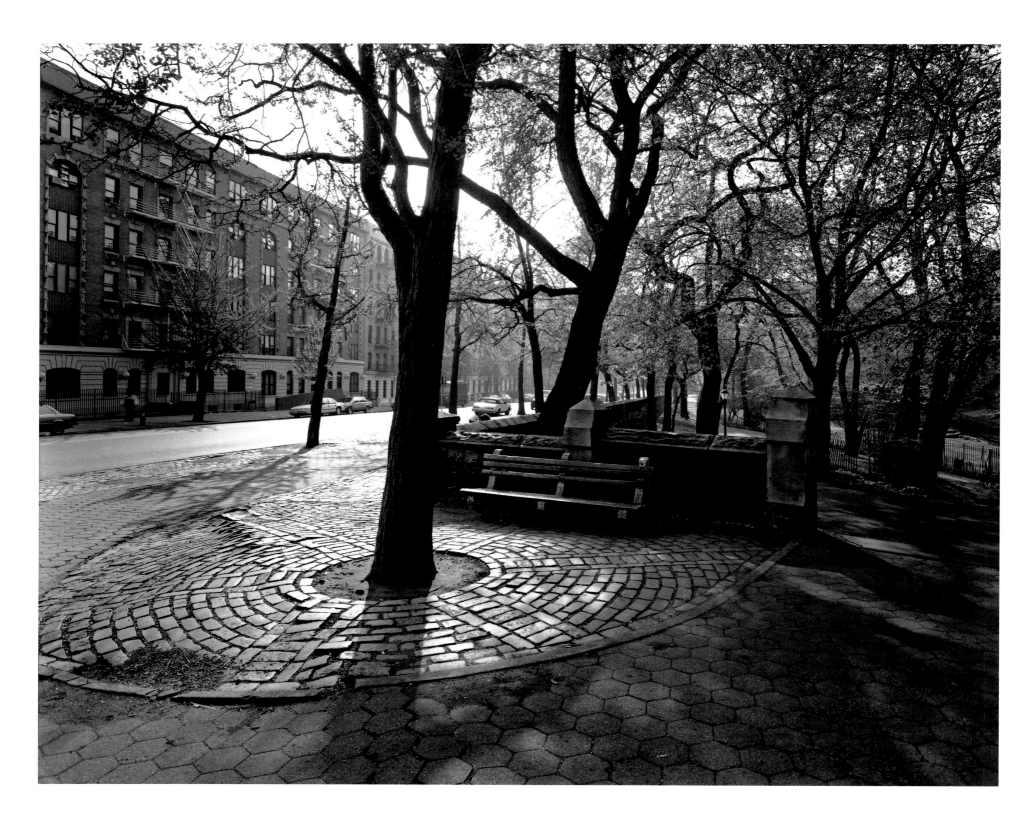

26. STRANGER'S GATE AND 110TH STREET, CENTRAL PARK, NEW YORK

27. THE RAMBLE, CENTRAL PARK, NEW YORK

28. AT THE WATER'S EDGE, MARINE PARK, BRIDGEPORT, CONNECTICUT

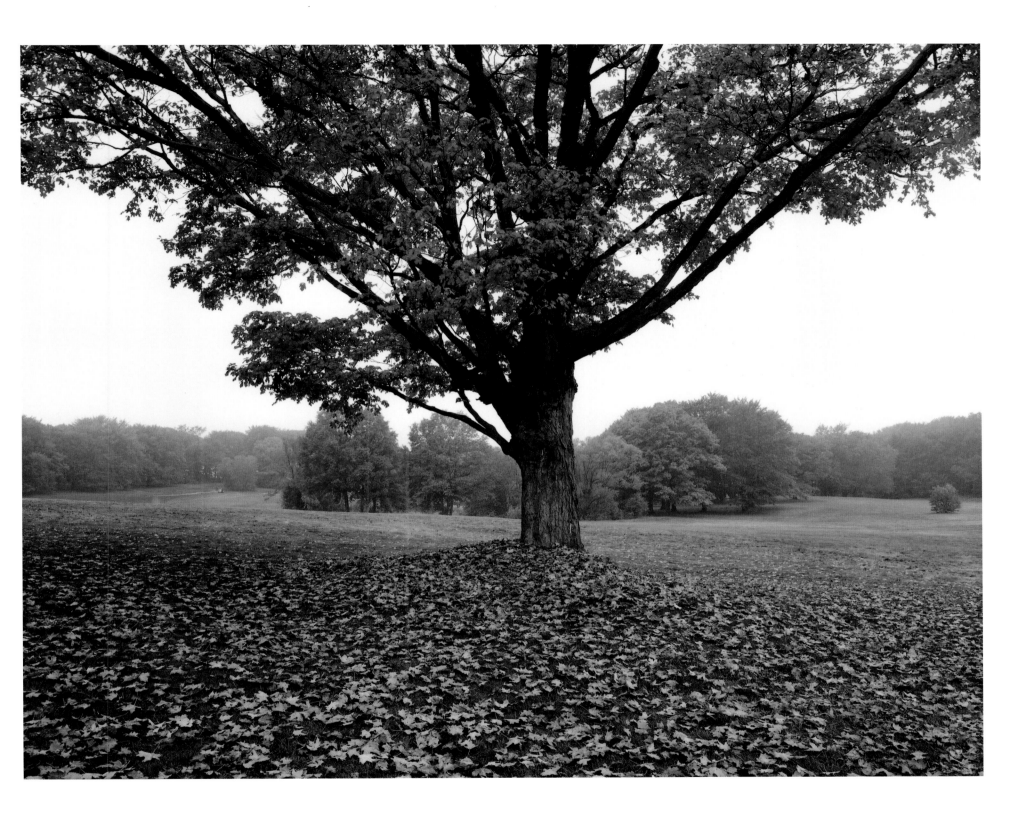

29. COUNTRY MEADOW, FRANKLIN PARK, BOSTON

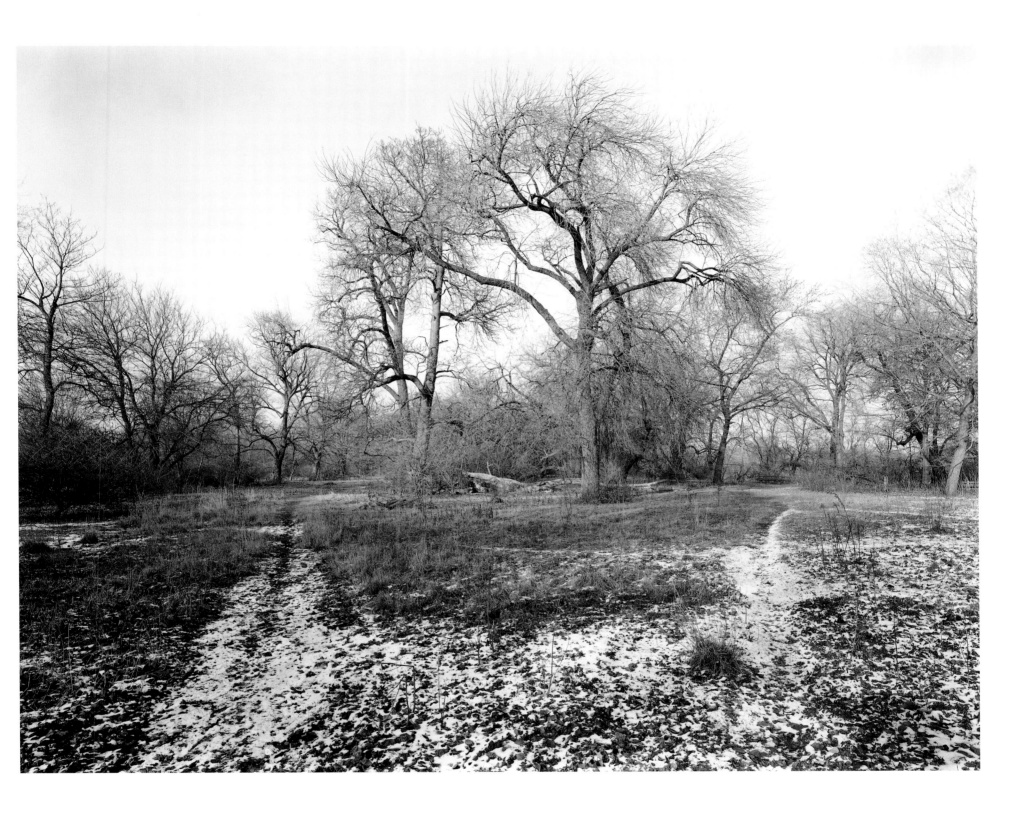

30. JACKSON PARK, CHICAGO

LETHBRIDGE

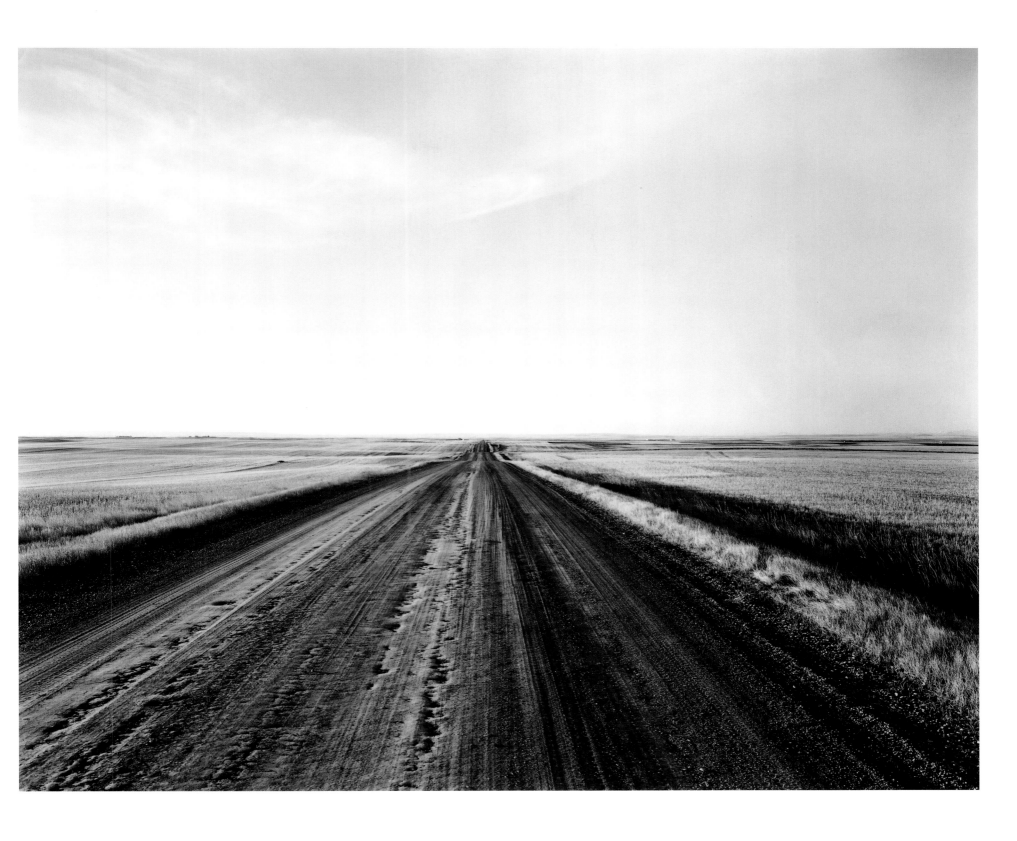

31. 30TH STREET W., WEST LETHBRIDGE

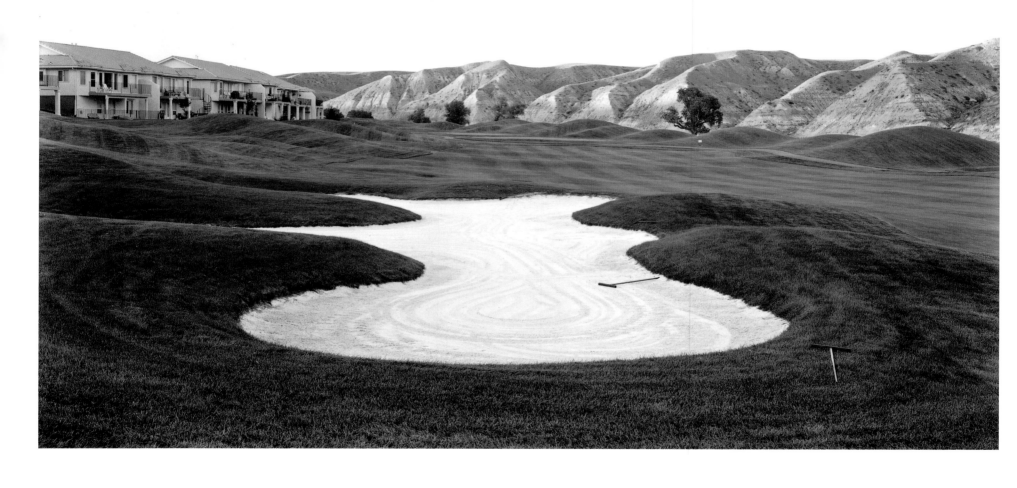

32. PARADISE CANYON, LETHBRIDGE

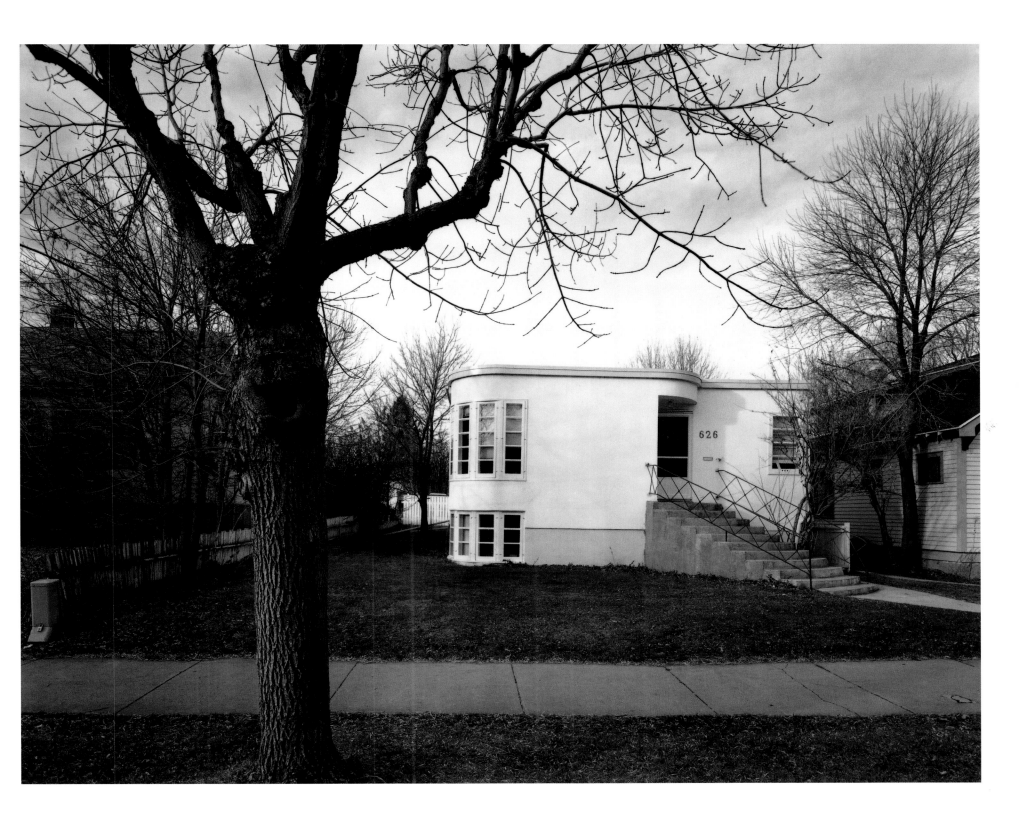

33. DECO HOUSE, LETHBRIDGE

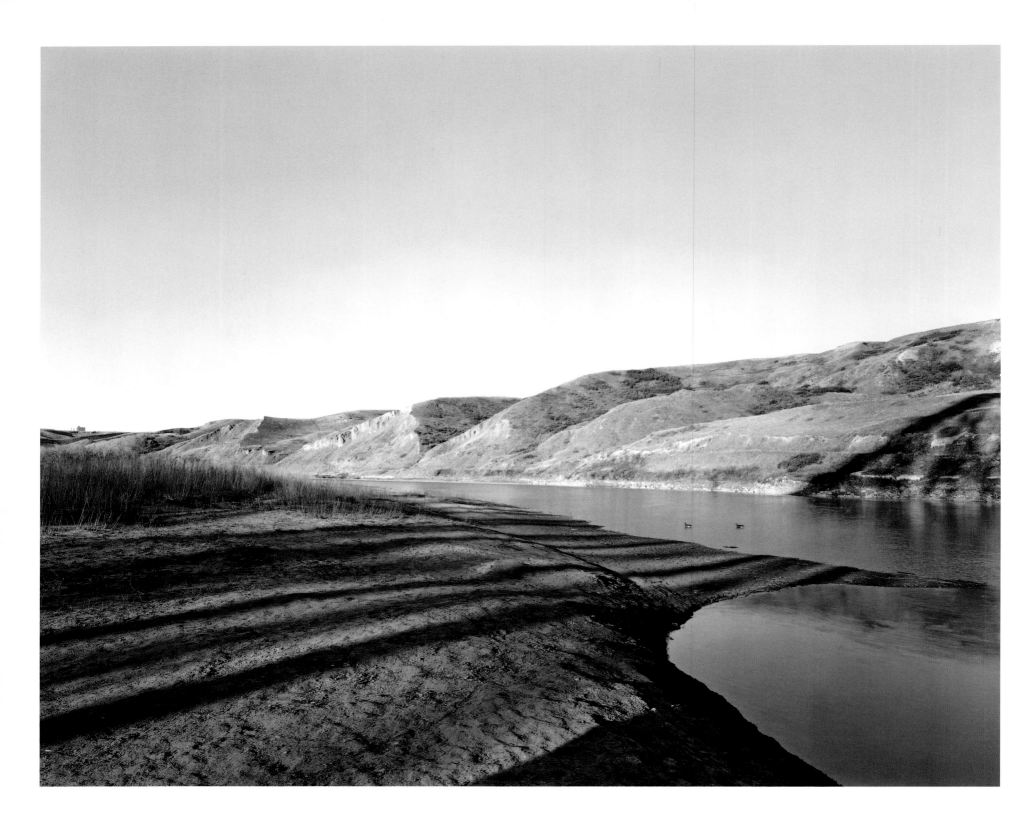

34. BESIDE THE HIGH LEVEL BRIDGE, LETHBRIDGE

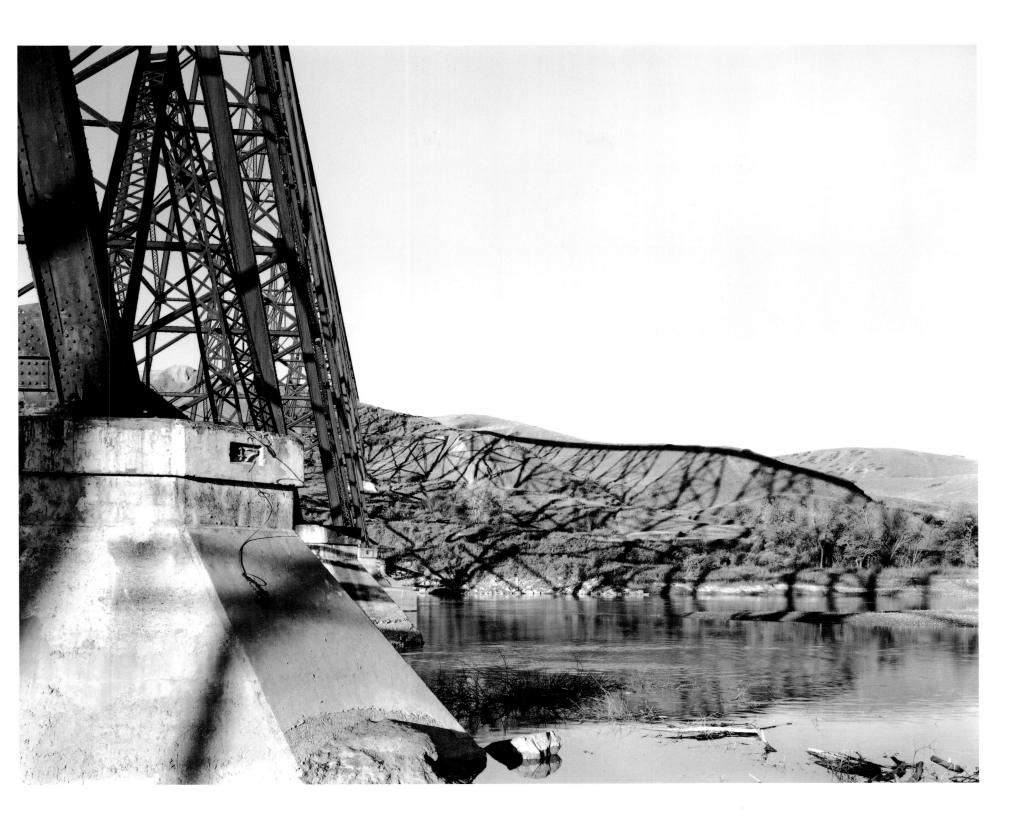

35. THE HIGH LEVEL BRIDGE, LETHBRIDGE, LOOKING WEST

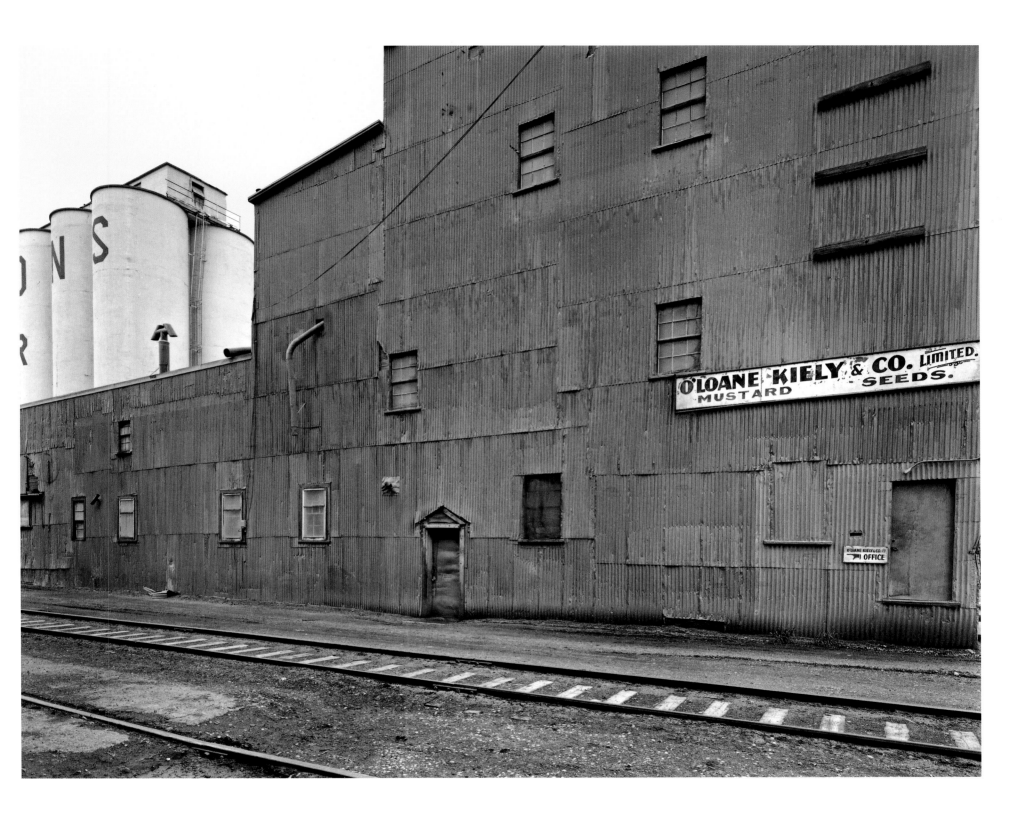

36. SEED COMPANY, LETHBRIDGE

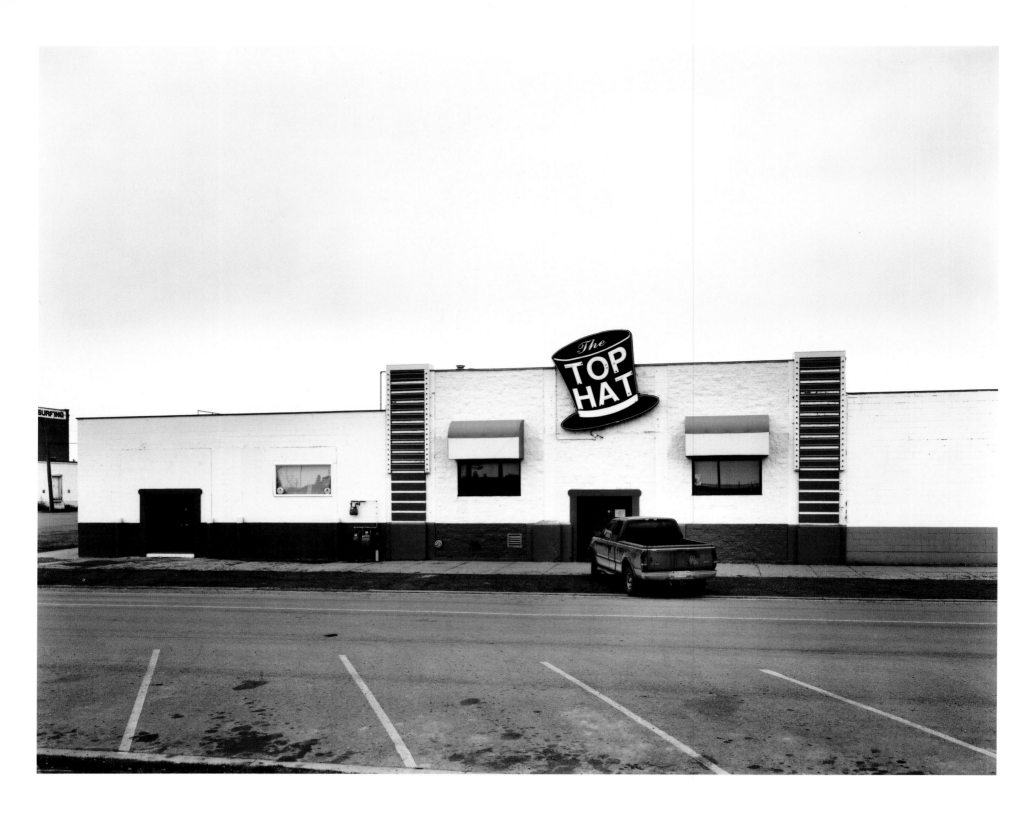

37. TOP HAT, LETHBRIDGE

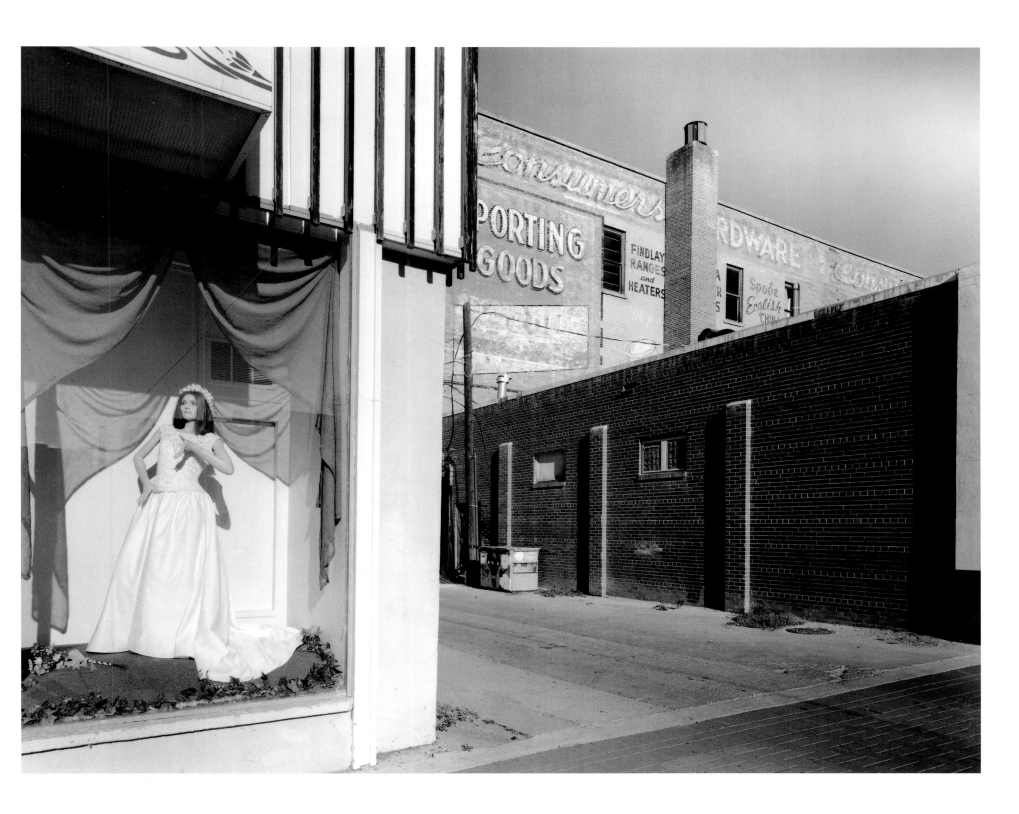

38. SPORTING GOODS, LETHBRIDGE

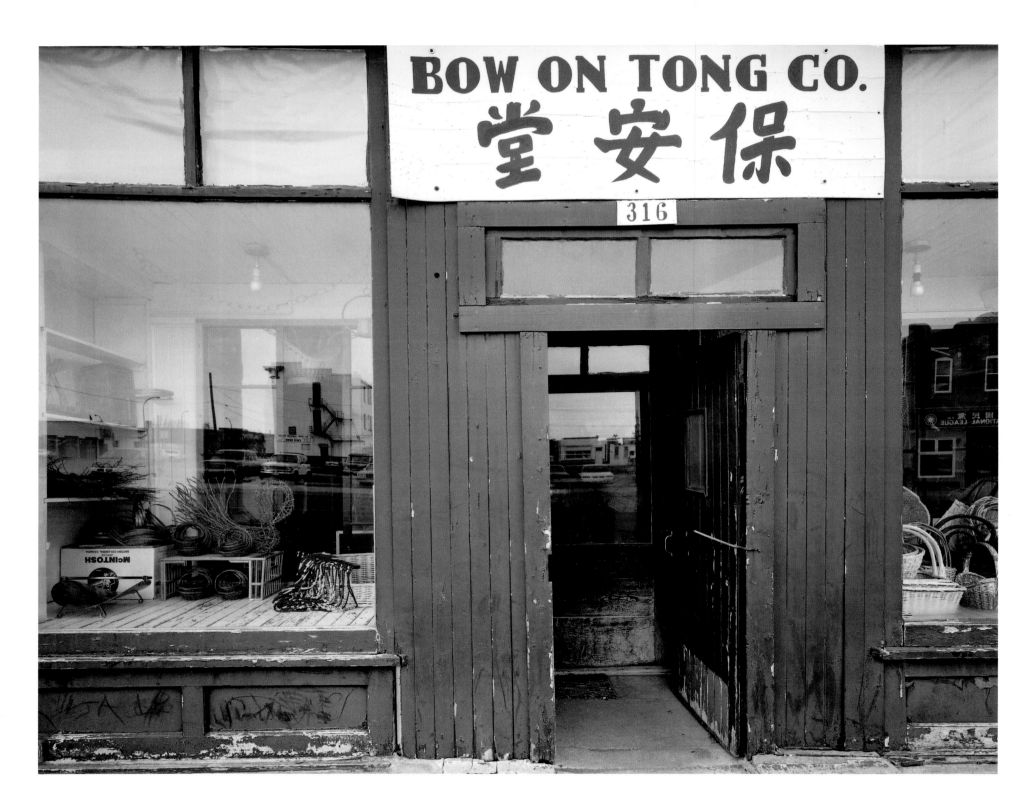

39. BOW ON TONG CO., LETHBRIDGE

40. SEED COMPANY, LETHBRIDGE

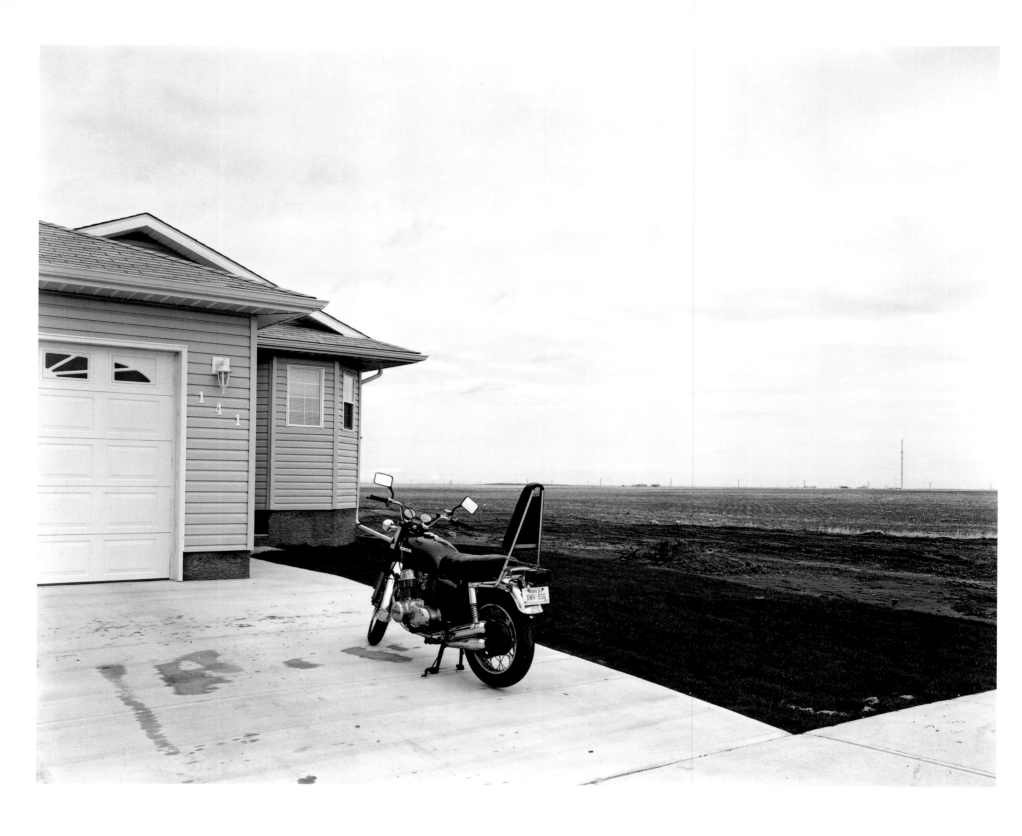

41. UPLANDS, LETHBRIDGE

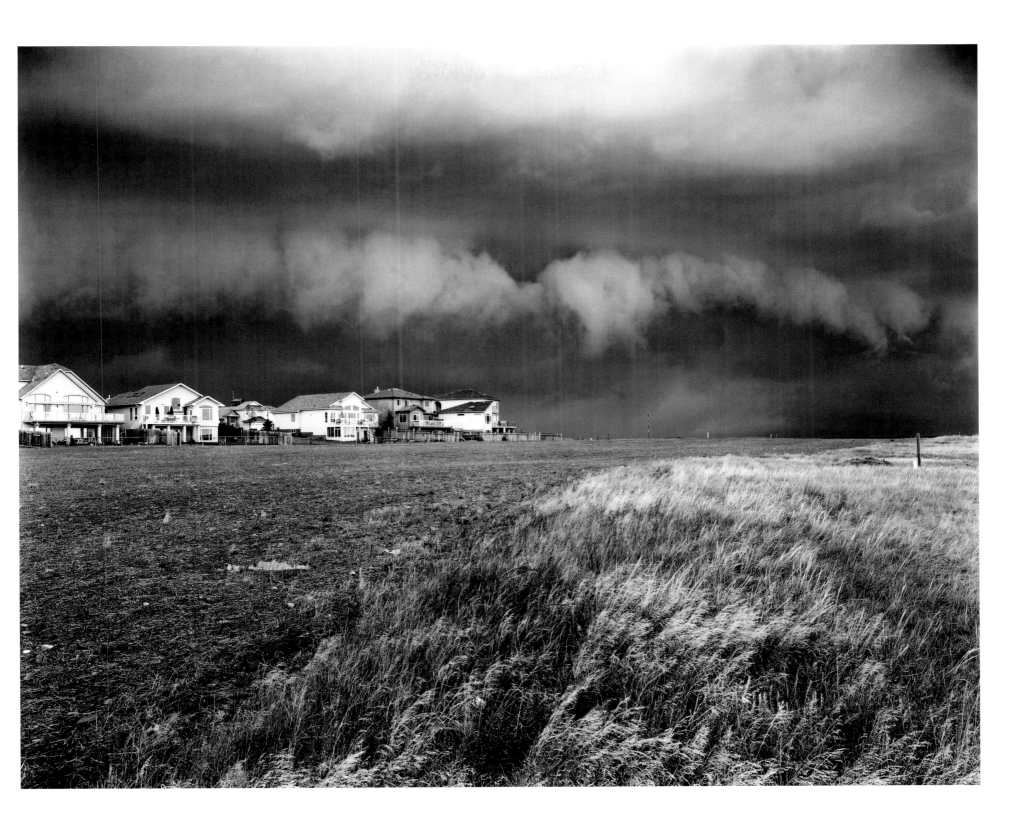

42. APPROACHING STORM, WEST LETHBRIDGE

PARIS

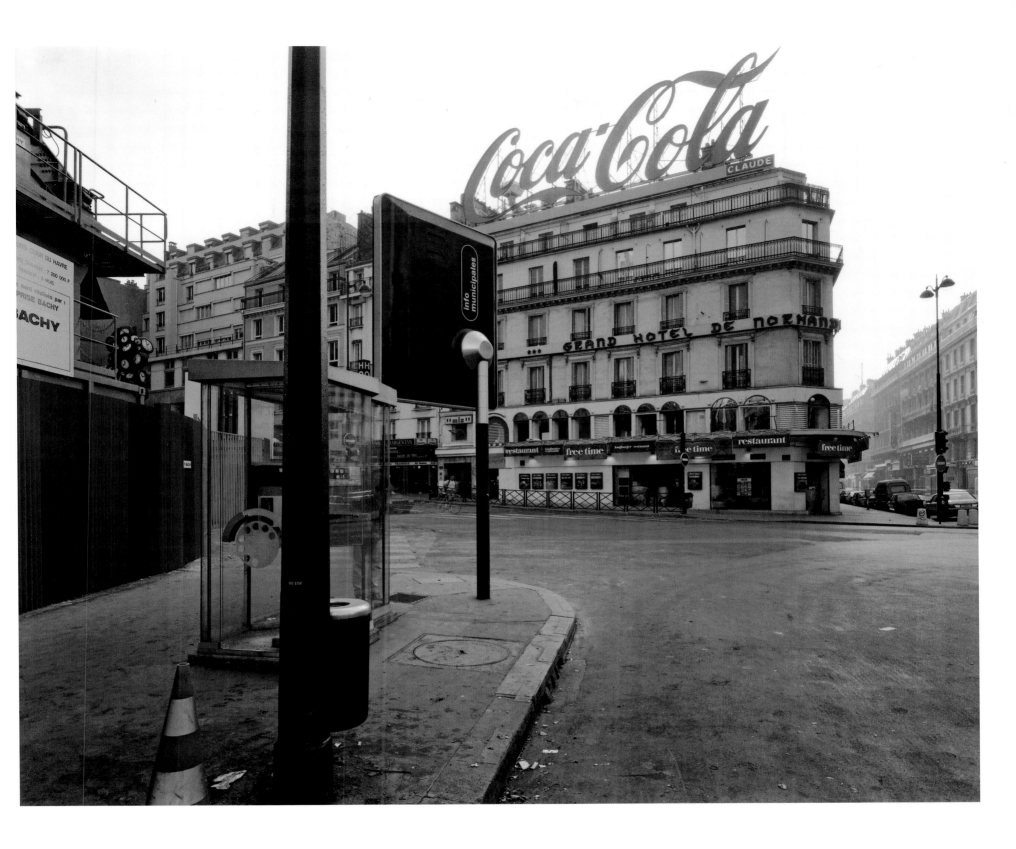

43. IN FRONT OF THE GARE SAINT-LAZARE, PARIS

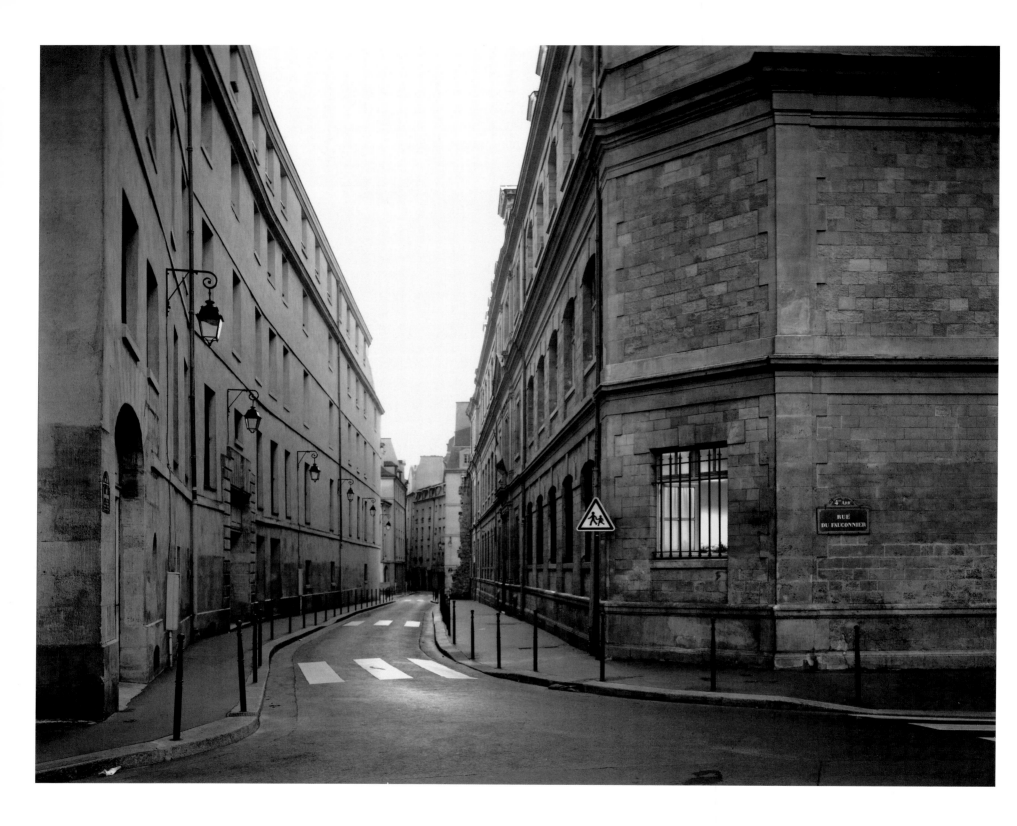

44. RUE CHARLEMAGNE, PARIS

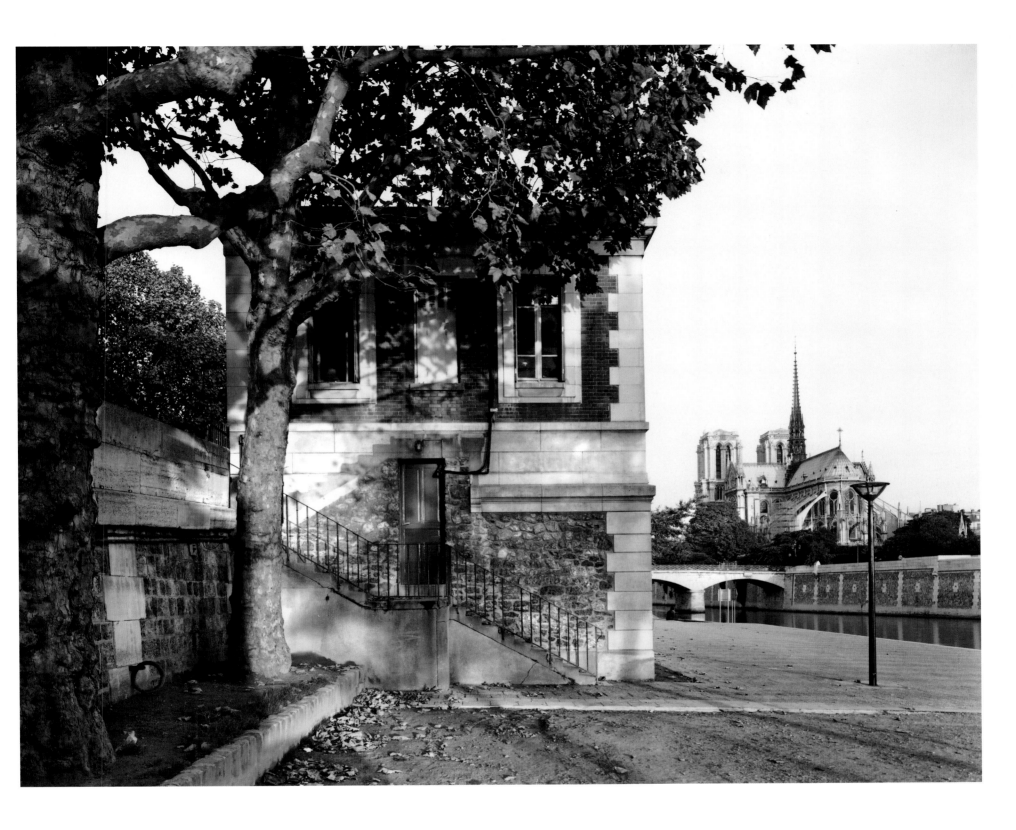

45. QUAI DE LA TOURNELLE, PARIS

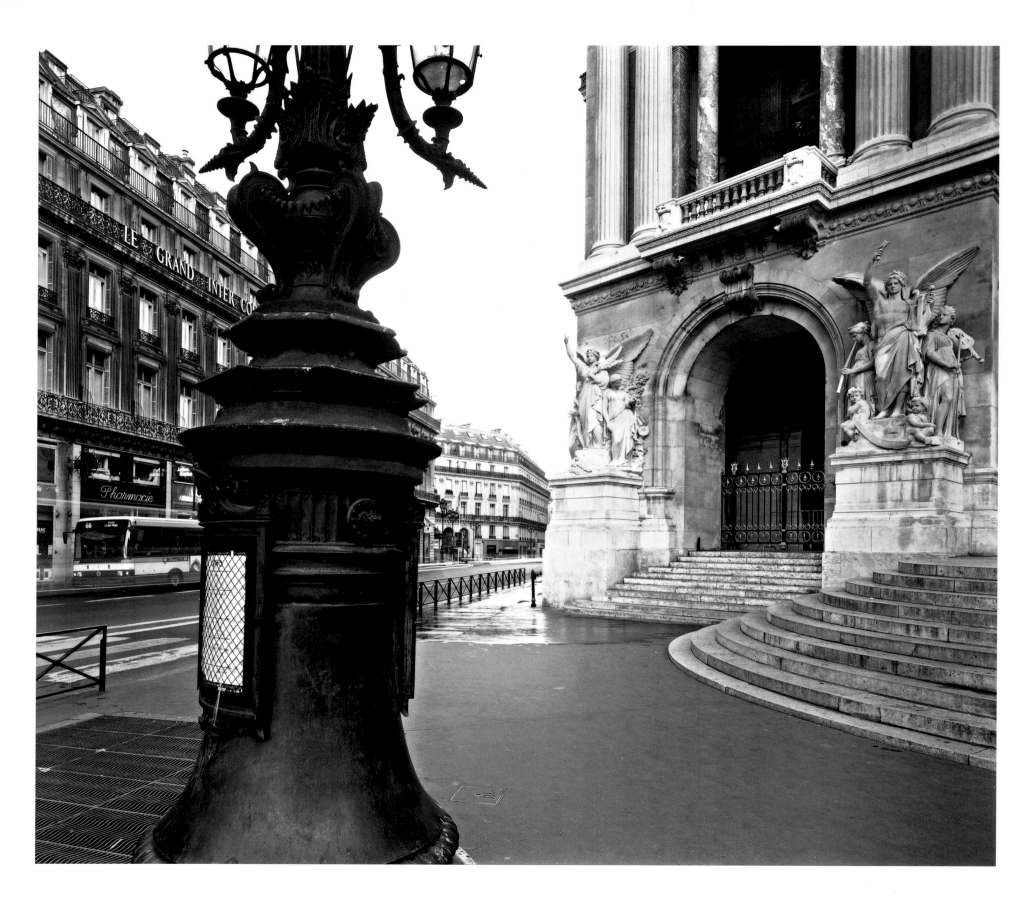

46. L'OPÉRA, RUE AUBER, PARIS

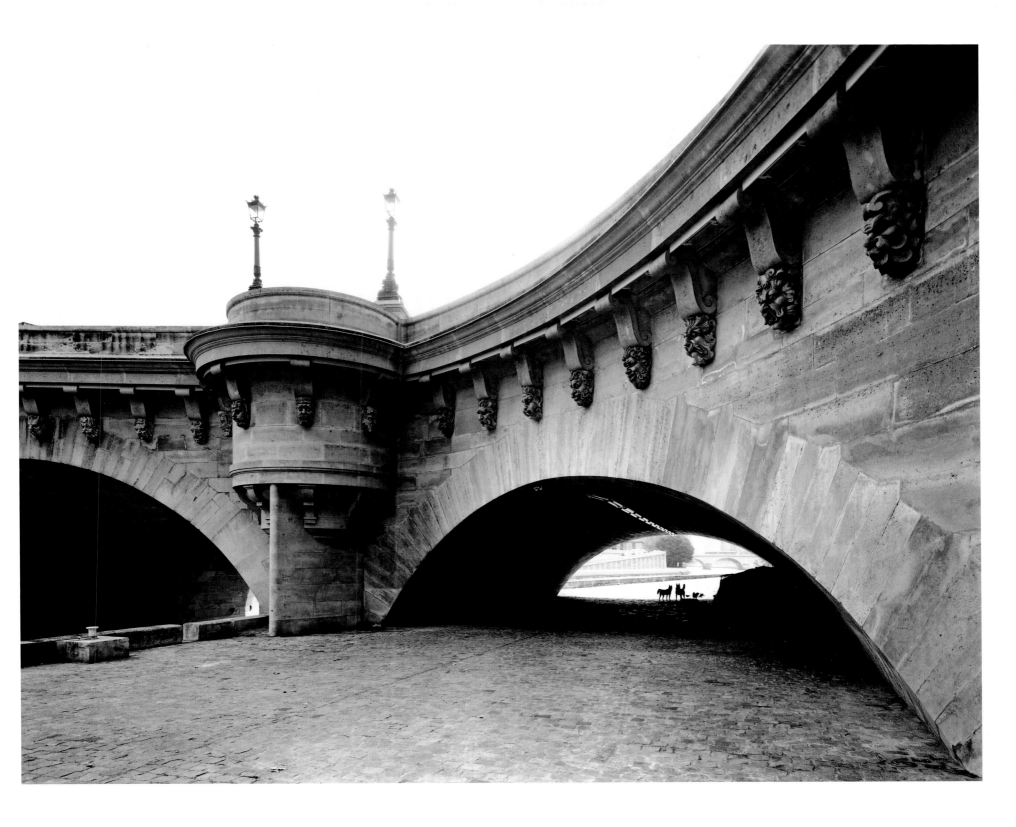

47. PONT-NEUF, PARIS

48. GARE DU NORD, PARIS

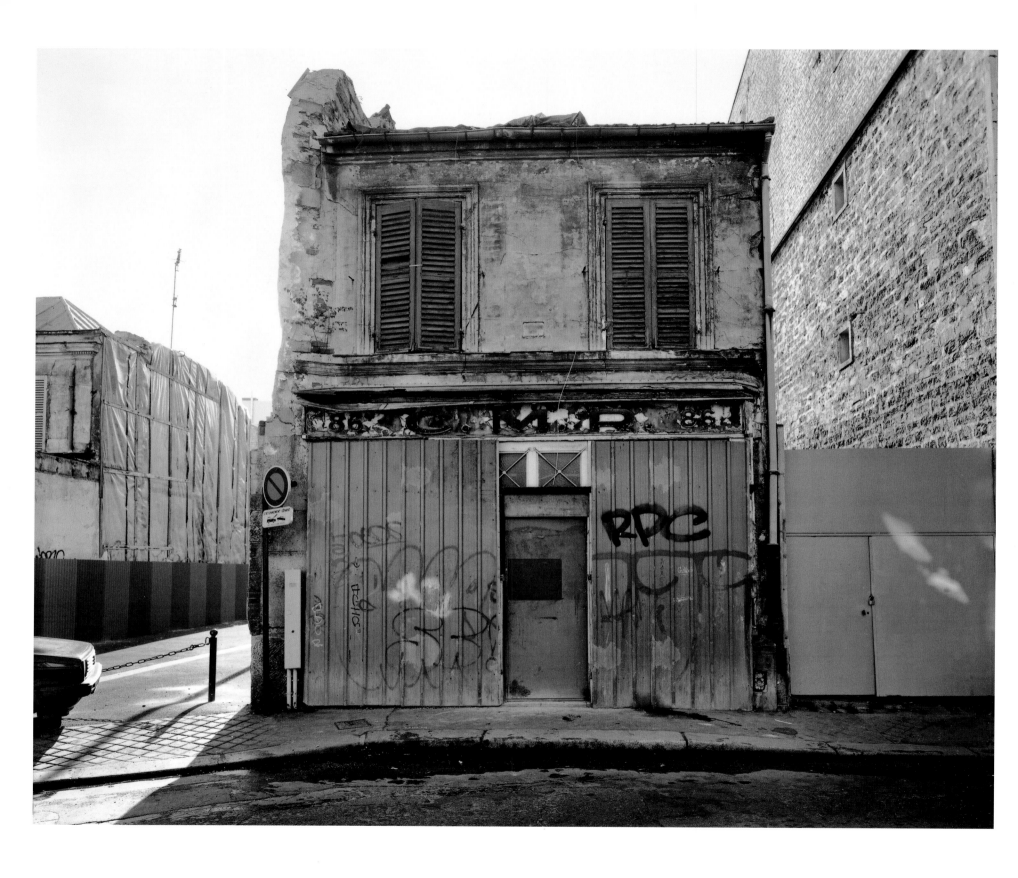

49. RUE DES HAIES, PARIS

50. IMPASSE SATAN, PARIS

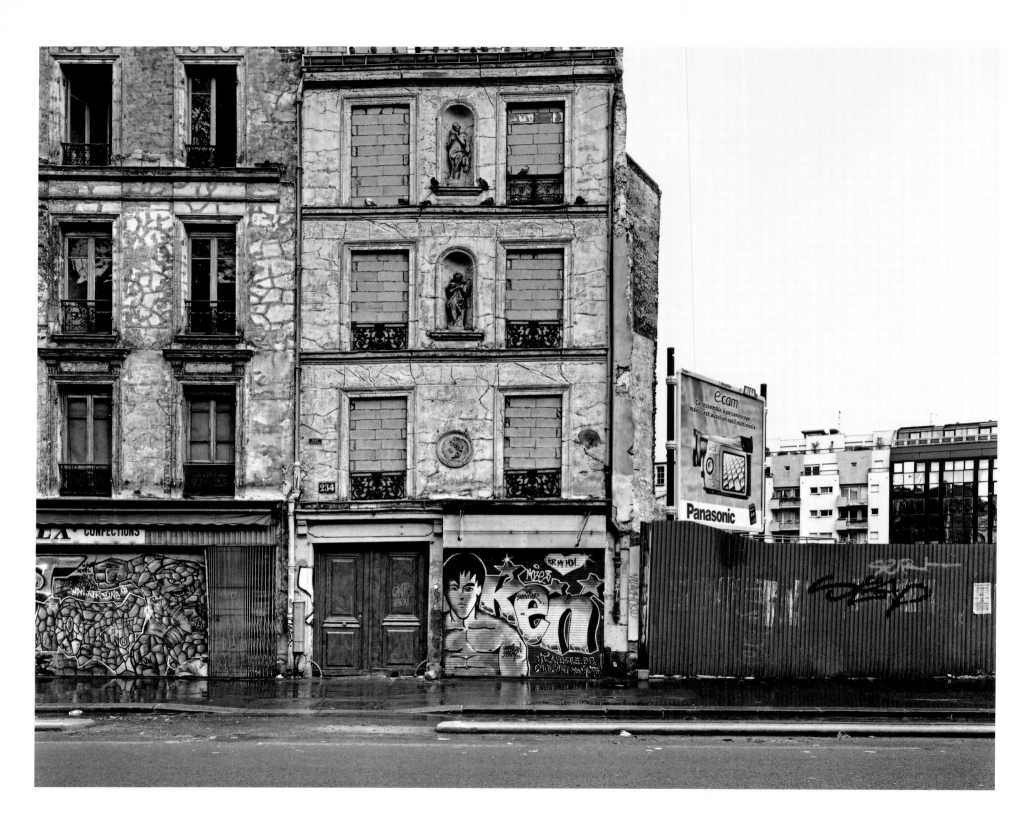

51. BOULEVARD DE LA CHAPELLE, PARIS

52. RUE DE CHARENTON, PARIS

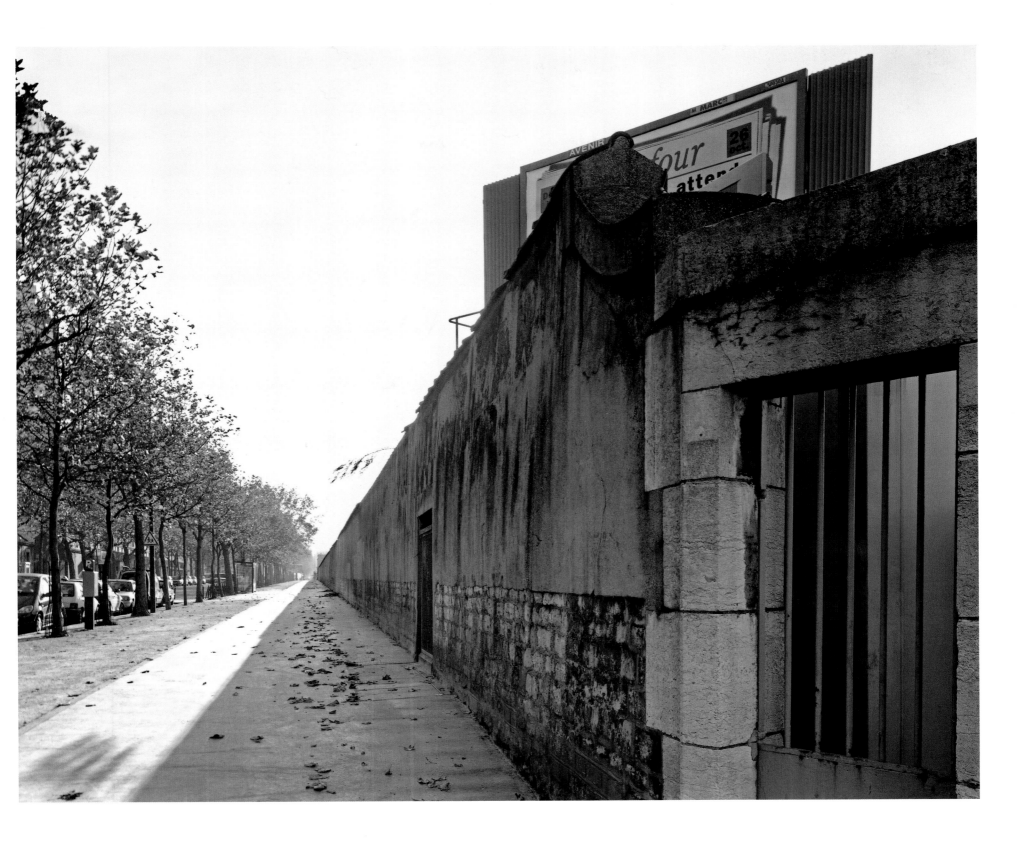

53. RUE DE CHARENTON, PARIS

TREES

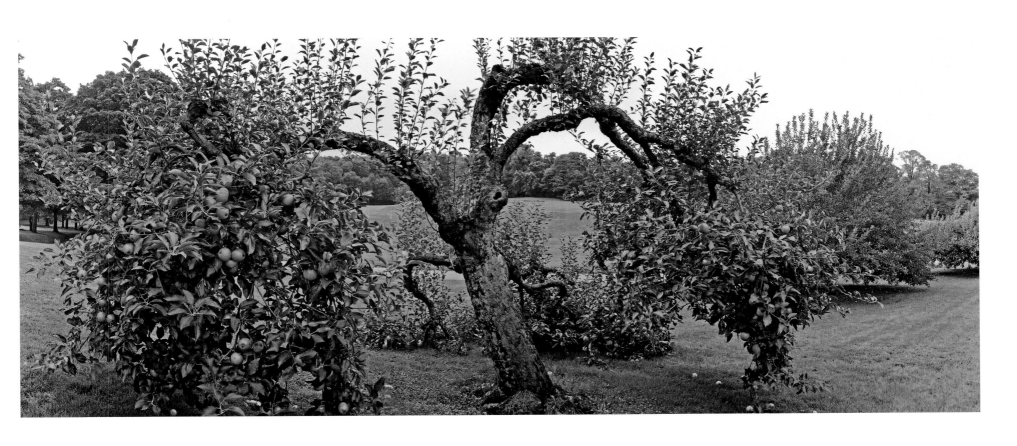

54. ORCHARD, NEW YORK STATE

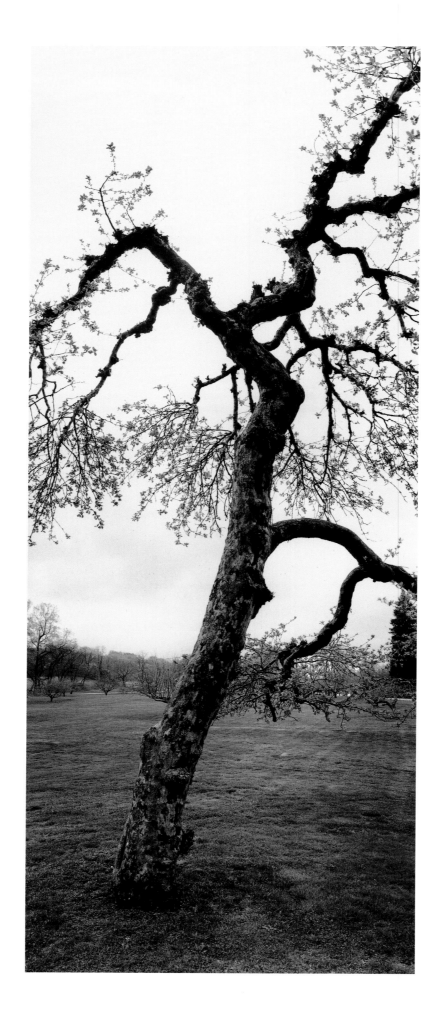

55. APPLE TREE, NEW YORK STATE

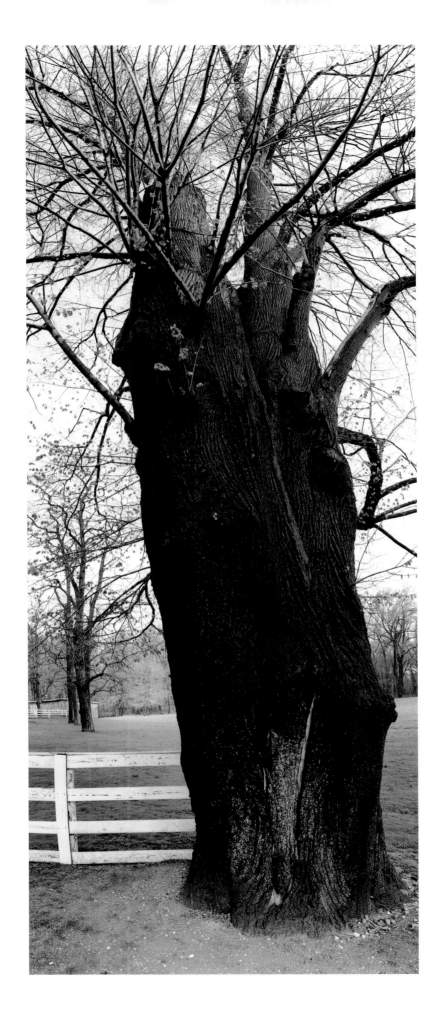

56. LINDEN TREE, NEW YORK STATE

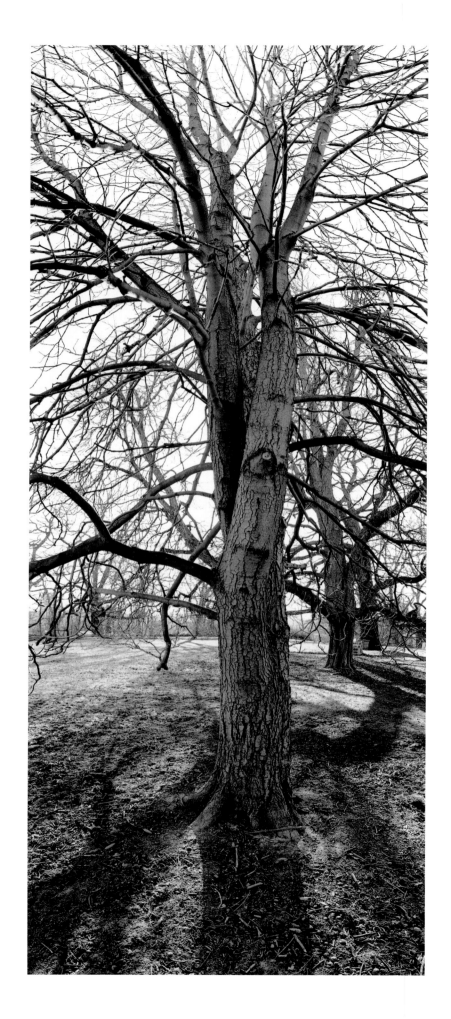

57. CHESTNUT, SPADINA HOUSE, TORONTO

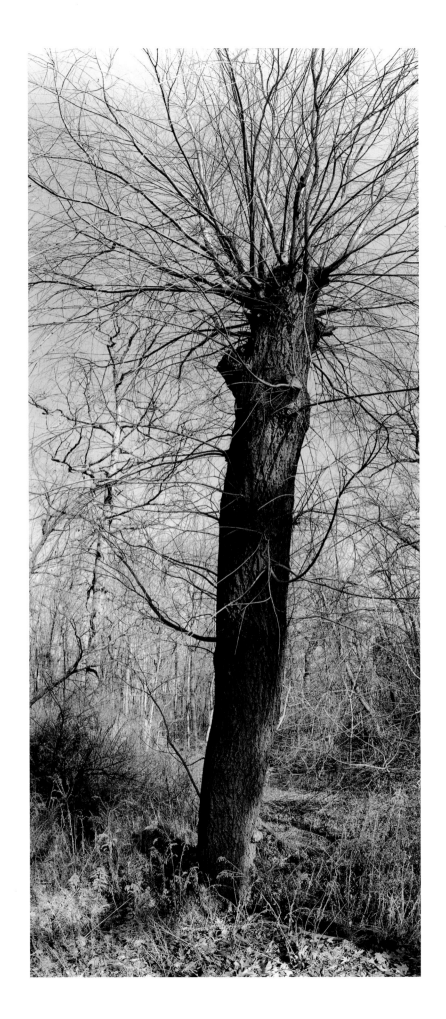

58. TOPPED TREE, HIGH PARK, TORONTO

59. WILLOW, WARD'S ISLAND, TORONTO

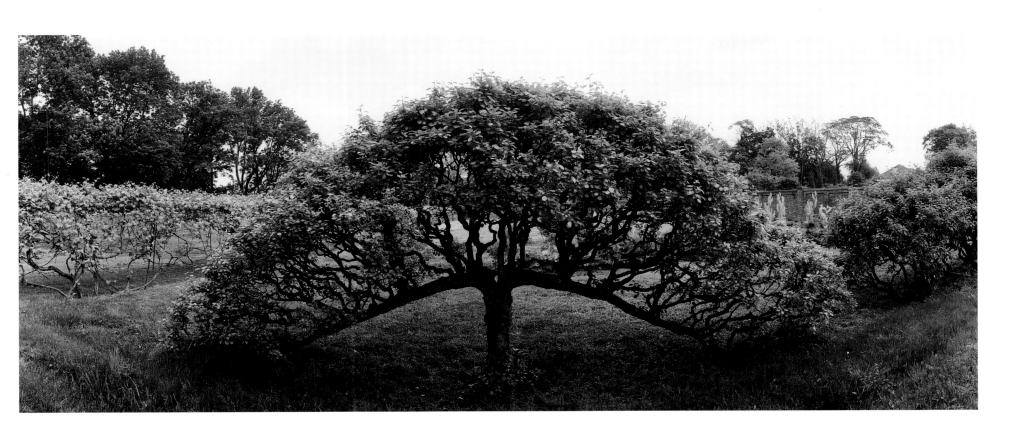

60. ESPALIERED TREE, NEW YORK STATE

TORONTO

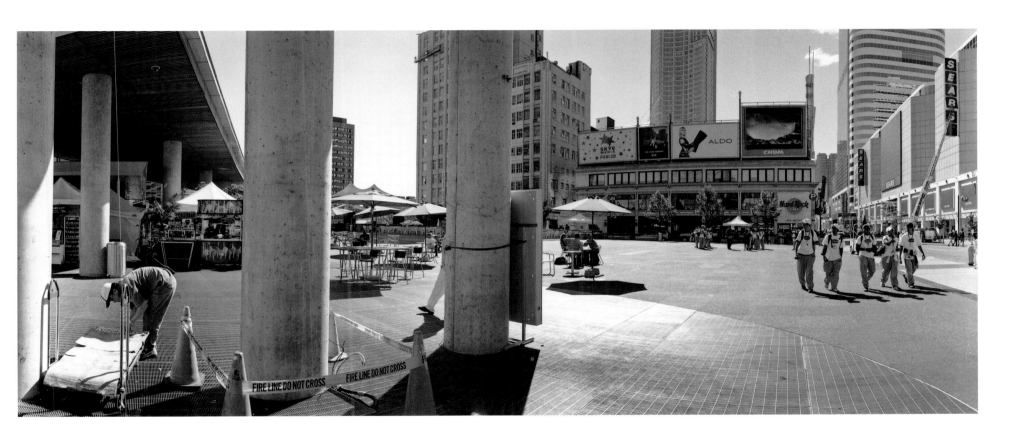

61. DUNDAS SQUARE, TORONTO

62. OAK TREE OFF SPADINA AND DUPONT, TORONTO

63. GLEN BAILLIE PLACE, TORONTO

64. CLOUD GARDEN, TORONTO

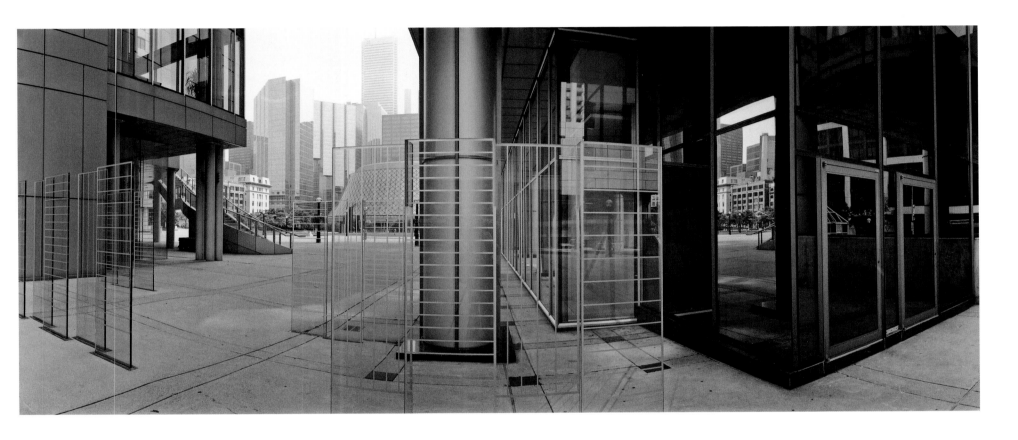

65. METRO HALL, TORONTO

66. BAIN HOUSING CO-OP, TORONTO

67. BAY AND ADELAIDE, TORONTO

68. BILLBOARD FOR LIBERTY VILLAGE, STRACHAN AVENUE, TORONTO

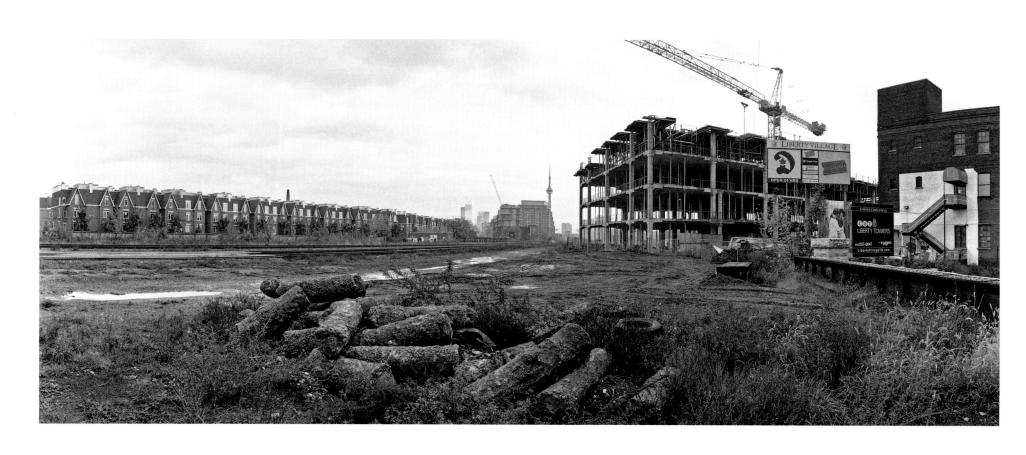

69. RAILTRACKS NEAR LIBERTY VILLAGE, TORONTO

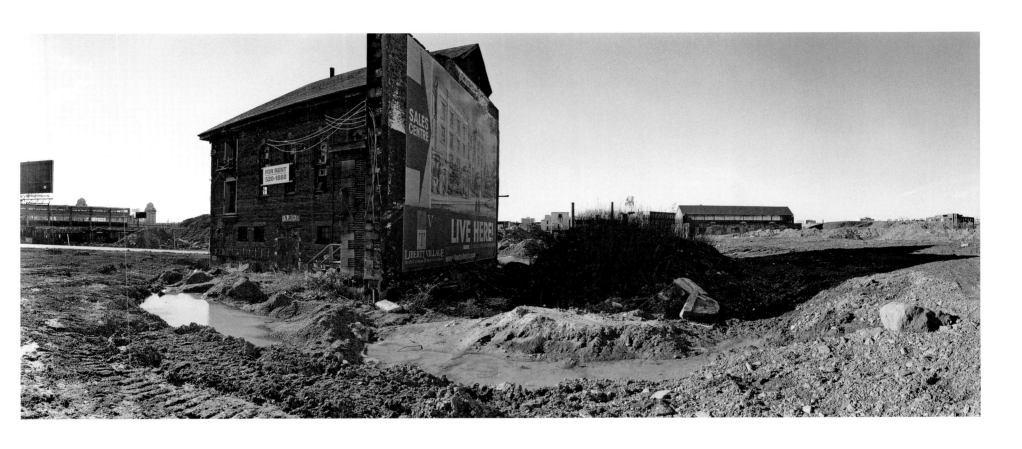

70. FORMER CENTRAL PRISON, NOW LIBERTY VILLAGE, TORONTO

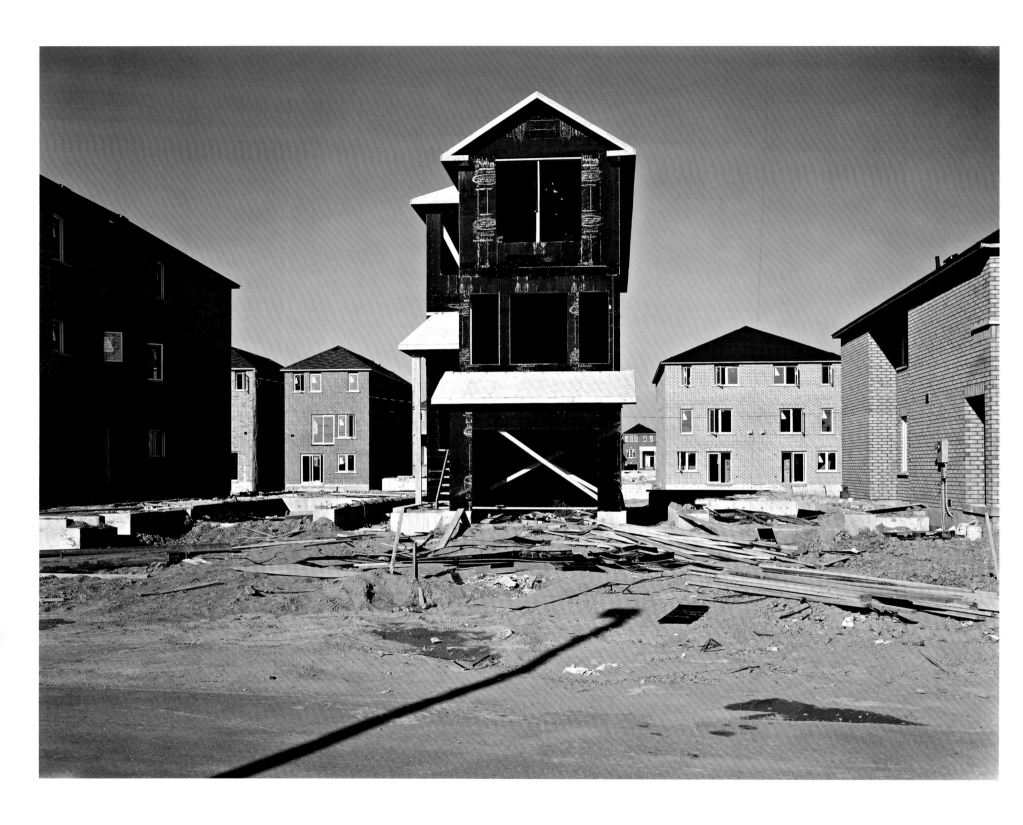

71. NEW HOUSING, LANGSTAFF ROAD AND DUFFERIN STREET, VAUGHAN

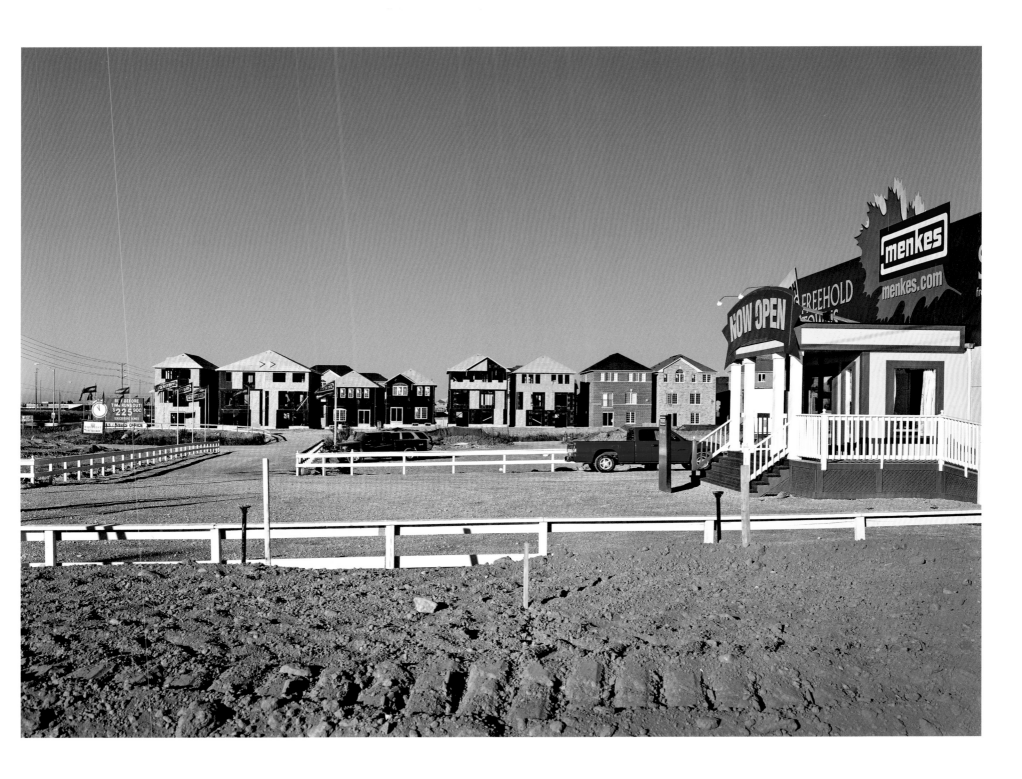

72. NEW HOUSING, NORTH OF HIGHWAY 7, TORONTO, 11TH SEPTEMBER 2001

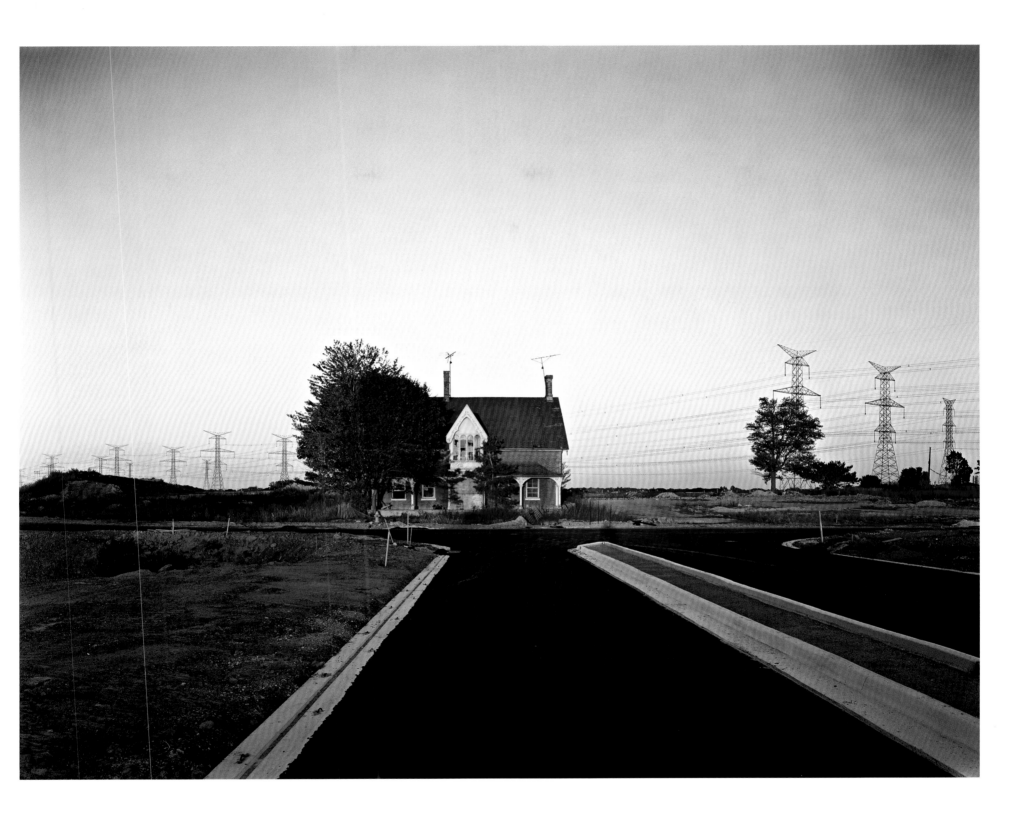

73. UNTITLED, NORTH OF TORONTO

ASBESTOS

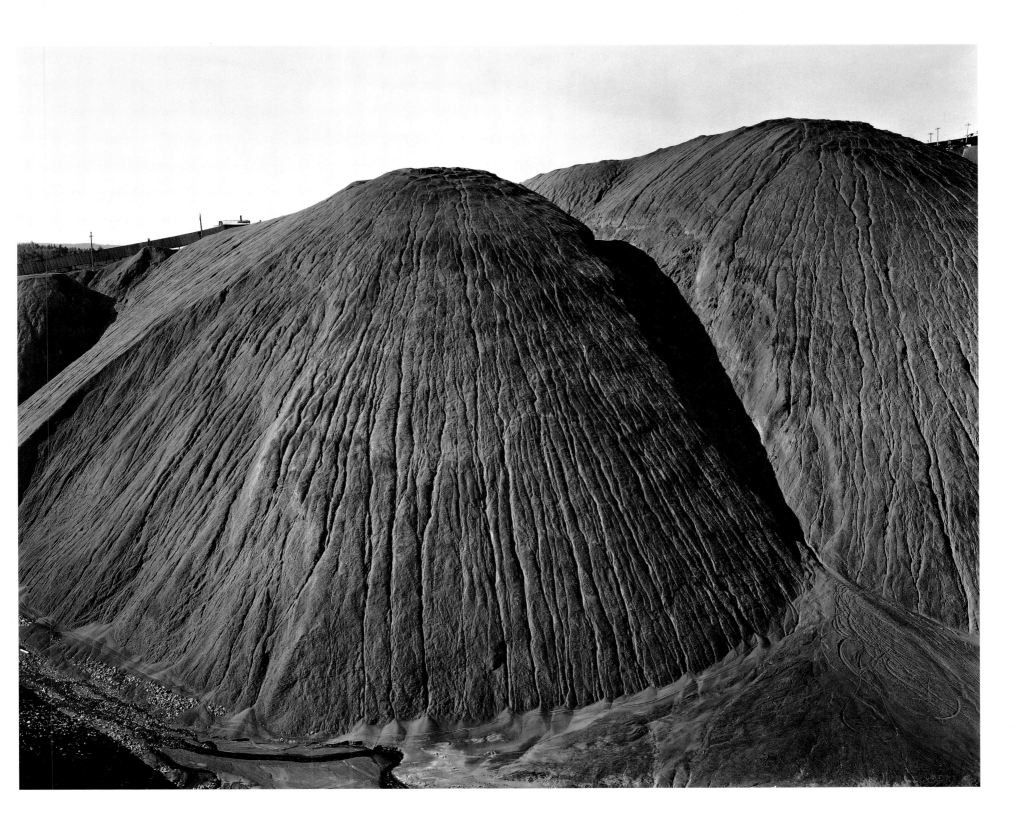

74. VIMY-RIDGE

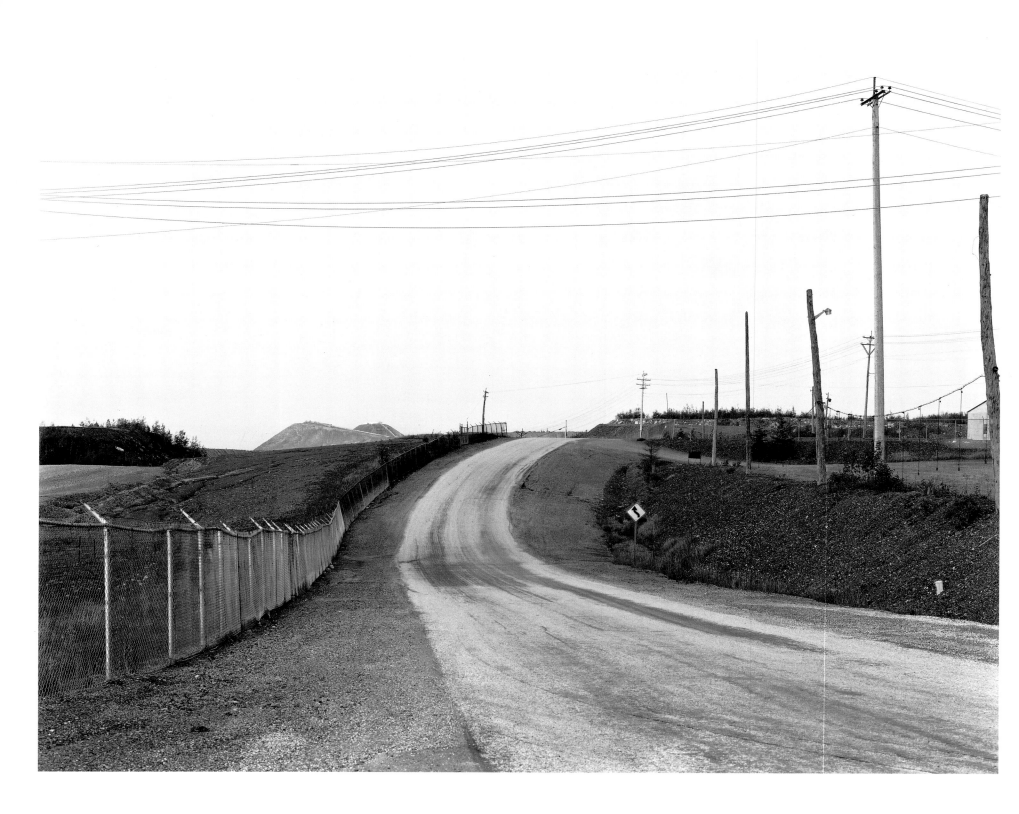

75. VIMY-RIDGE

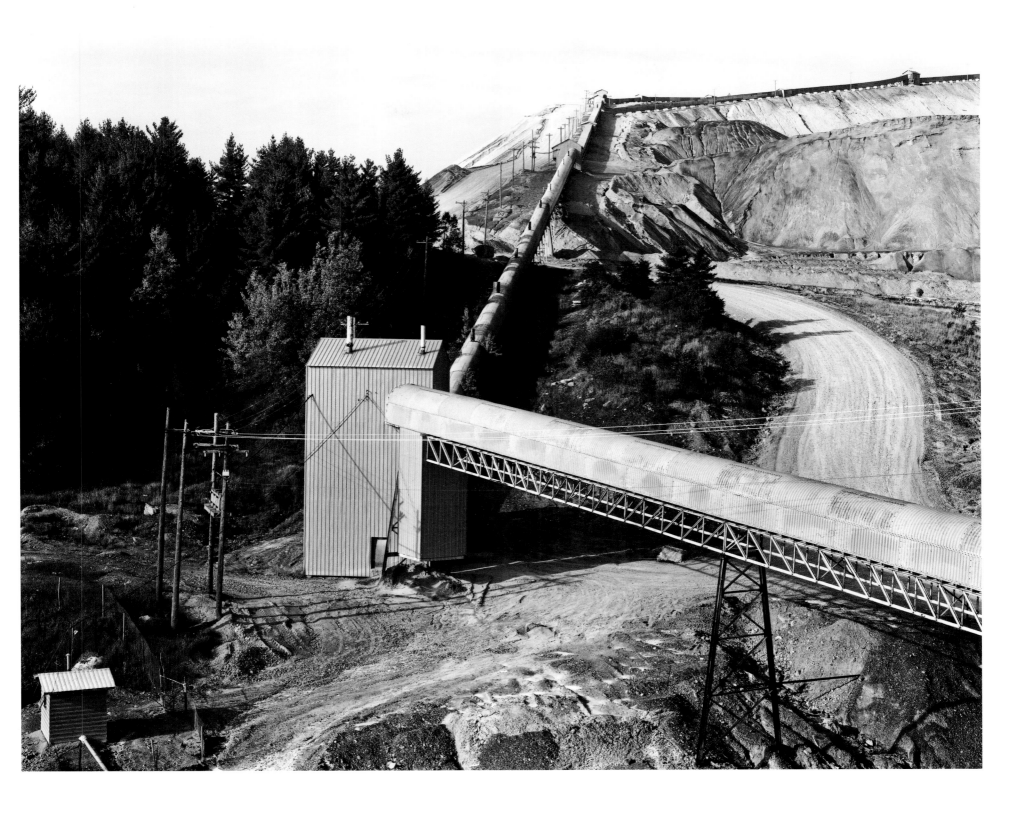

76. BLACK-LAKE

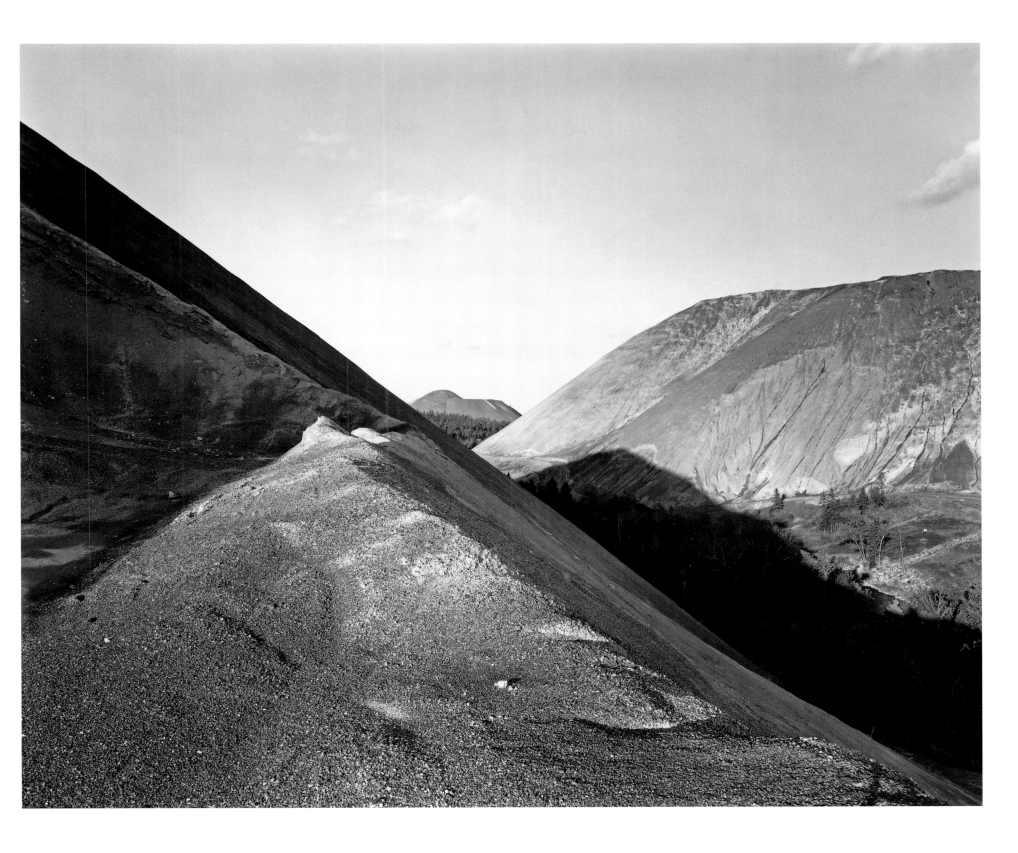

77. BLACK-LAKE

RUNNING FENCE

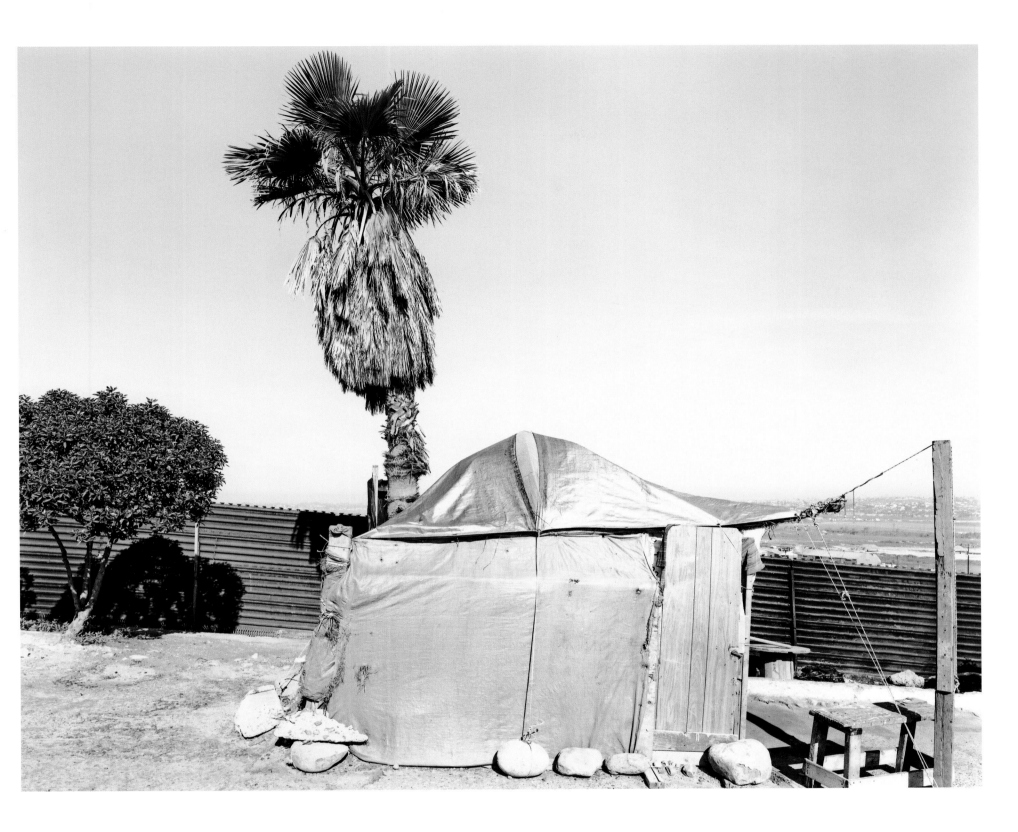

78. CROSSING SUPPLIES TENT, AVENIDA INTERNACIONAL, TIJUANA

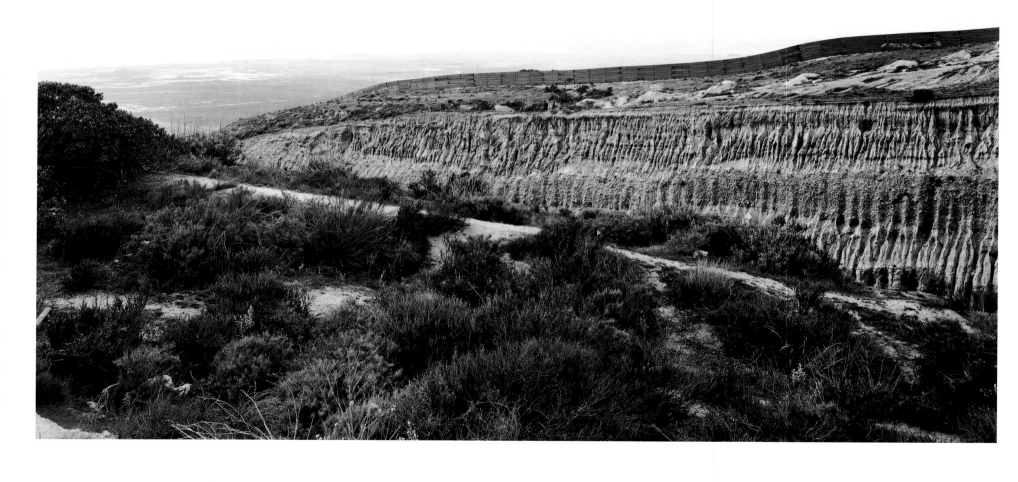

79. LOOKING NORTH TOWARD SAN DIEGO AT THE SECOND BORDER MARKER 1

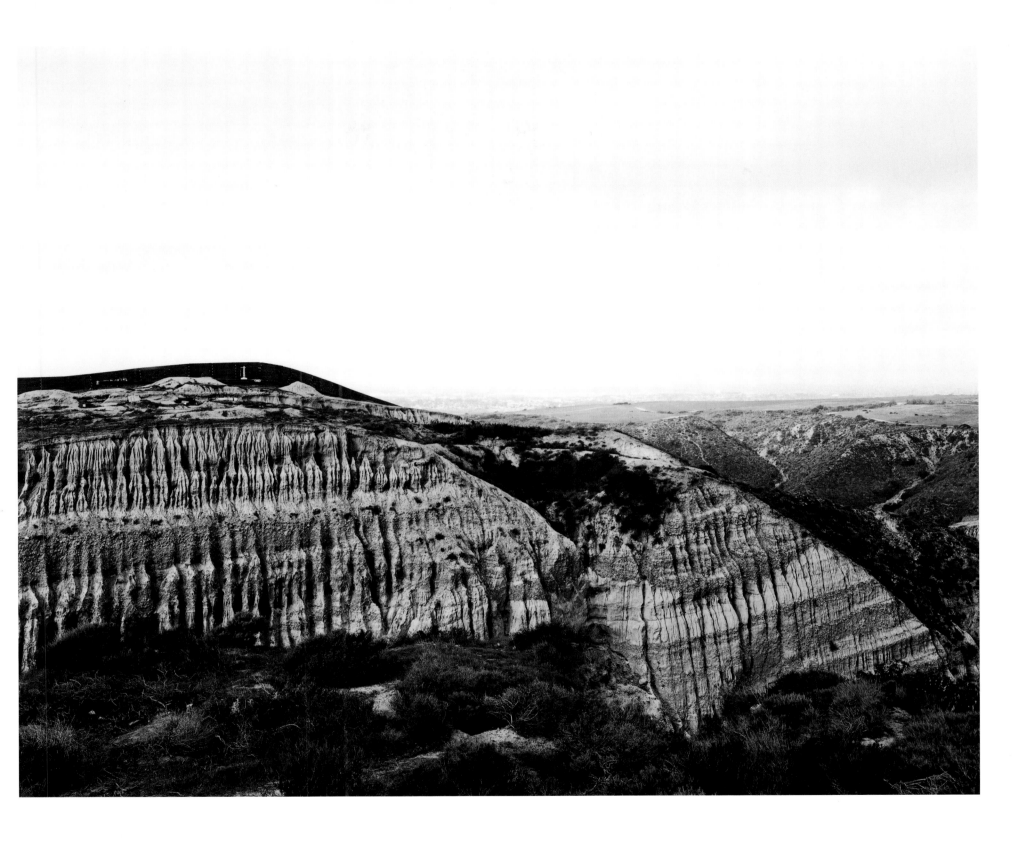

80. LOOKING NORTH TOWARD SAN DIEGO AT THE SECOND BORDER MARKER 2

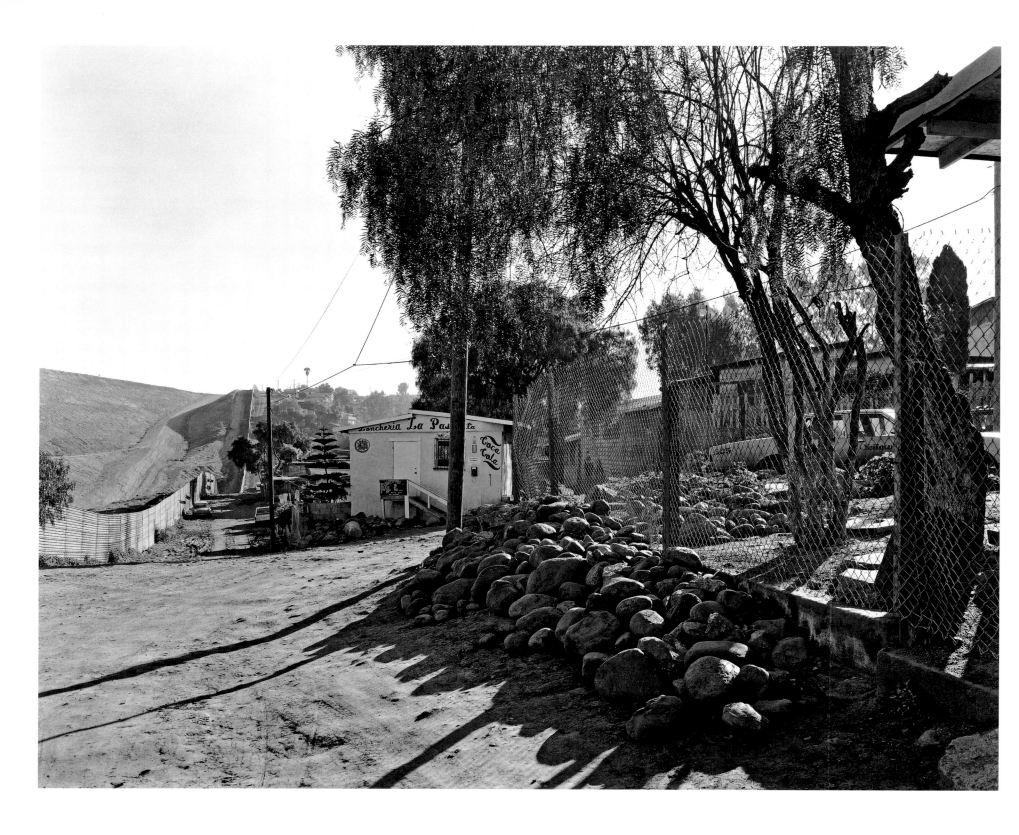

81. RESTAURANT, COLONIA LIBERTAD, TIJUANA

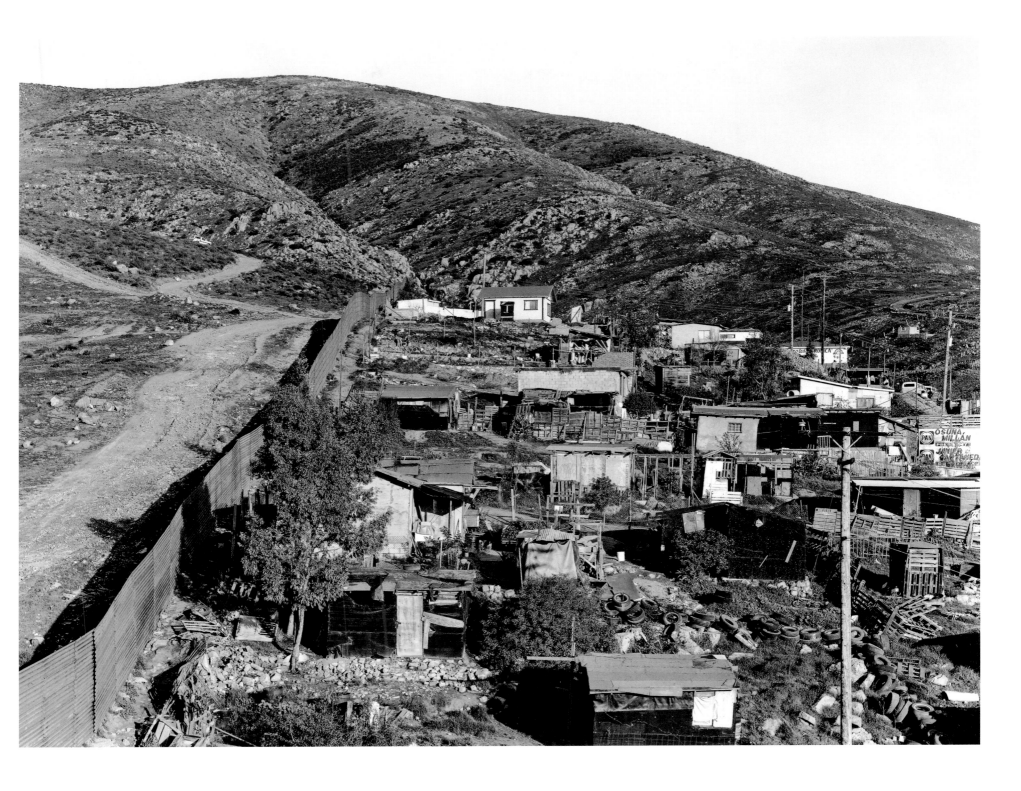

82. SETTLEMENT ALONG THE FENCE, TIJUANA

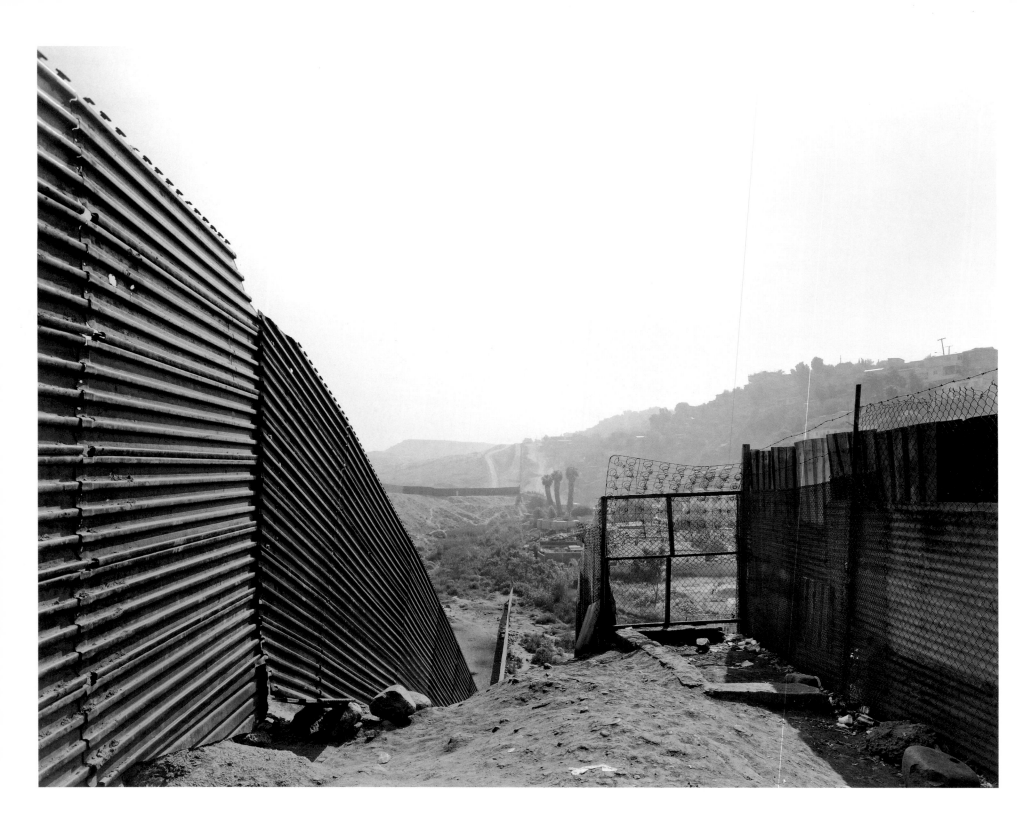

83. ABOVE THE SOCCER FIELD, A HOLDING AREA EXTENDING INTO U.S. TERRITORY, TIJUANA

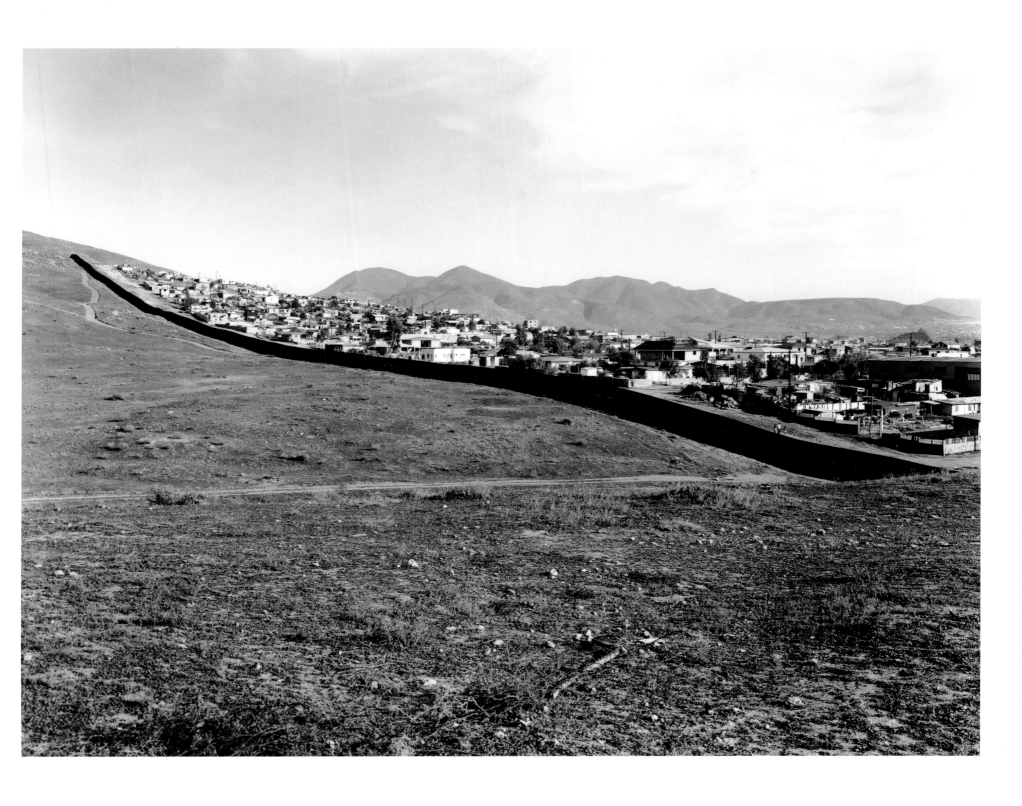

84. PARTIAL VIEW OF THE UNITED STATES–MEXICO BORDER WITH OTAY MESA, SAN DIEGO COUNTY, IN THE FOREGROUND AND MESA DE OTAY, TIJUANA, IN THE BACKGROUND

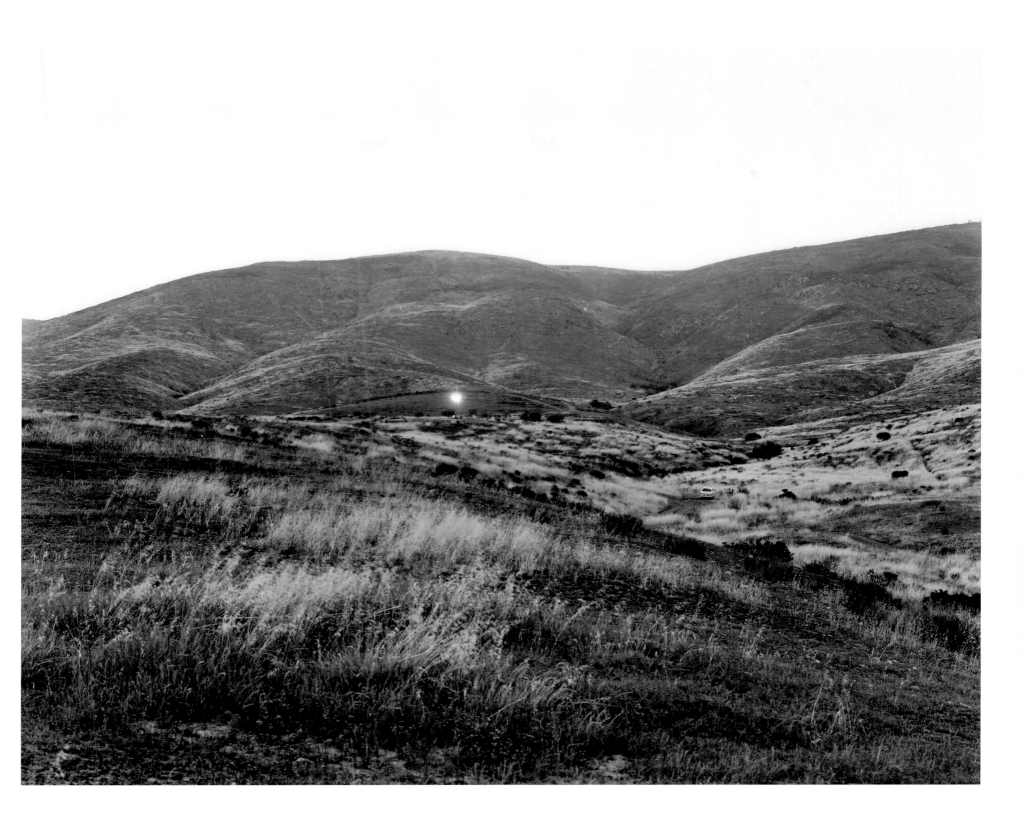

85. SURVEILLANCE LIGHT, OTAY MESA, U.S. SIDE

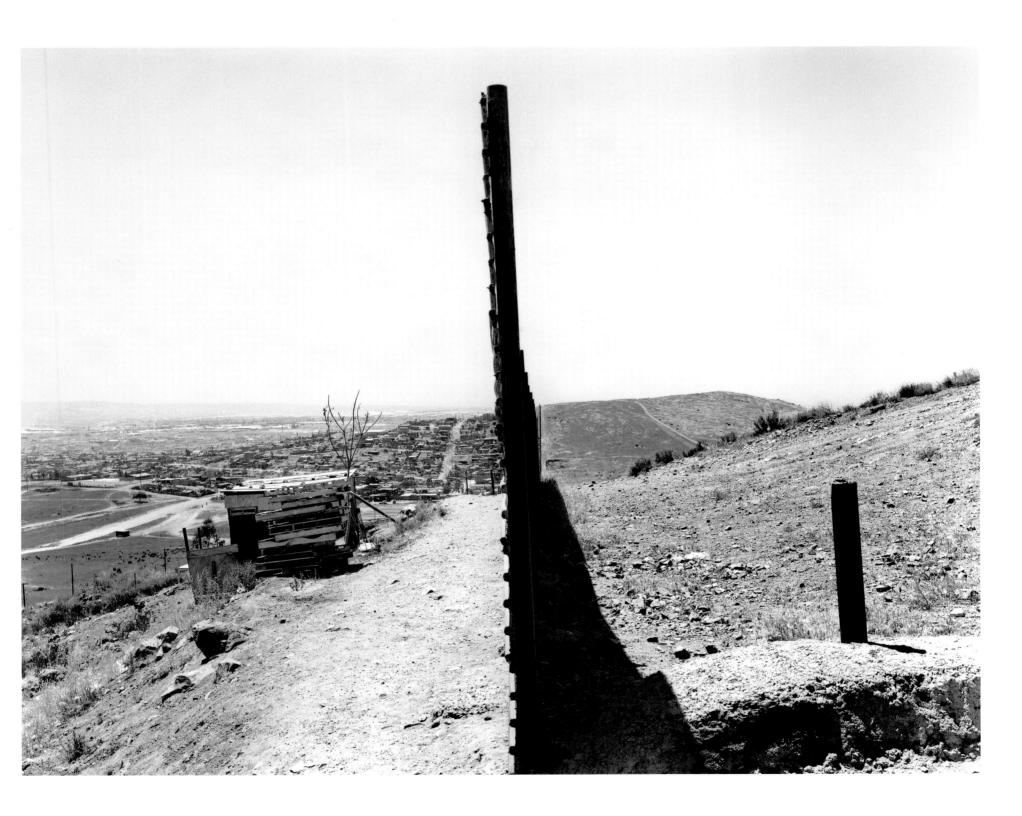

86. THE END OF THE FENCE, LOOKING WEST, OTAY MESA

LIST OF WORKS

Dimensions given are image size.

Frontispiece
Conservatory Water, Looking North, Central Park, New York
1994
Gelatin silver print
19.5 × 24.5 cm
Canadian Centre for Architecture, Montreal

1
Etruscan Road, Veio
1989
Gelatin silver print
8.5 × 26.3 cm
Collection of the artist

2
The Aqueduct Claudio (left side of double)
1989
Gelatin silver print
8.5 × 25.8 cm
Collection of the artist

3
The Aqueduct Claudio (right side of double)
1989
Gelatin silver print
8.5 × 26.4 cm
Collection of the artist

4
Villa Medici, Rome (Alley from the Pincio Wall to the Courtyard Garden)
1984
Gelatin silver print
8.5 × 26.5 cm
Canadian Museum of Contemporary Photography, Ottawa

5
Villa Medici, Rome (The Loggia)
1984
Gelatin silver print
8.5 × 26.5 cm
Canadian Museum of Contemporary Photography, Ottawa

6
Villa Valmarana, Saonara
1984
Gelatin silver print
8.6 × 26.4 cm
Collection of the artist

7
Saint-Cloud
1989
Gelatin silver print
8.6 × 26.4 cm
Collection of the artist

8
Desert de Retz
1985
Gelatin silver print
8.6 × 26.6 cm
Collection of the artist

9
Villa Brenzone, San Vigilio, Lago di Garda
1984
Gelatin silver print
15.4 × 48.6 cm
Canadian Museum of Contemporary Photography, Ottawa

10
Marly-le-Roi
1985
Gelatin silver print
8.5 × 26.5 cm
Collection of the artist

11
Villa Medici, Rome (Niobe and Her Children)
1984
Gelatin silver print
8.5 × 26.3 cm
Canadian Museum of Contemporary Photography, Ottawa

12
Chiswick Park, London
c. 1984
Gelatin silver print
8.5 × 26.3 cm
Collection of the artist

13
Powis Castle, Wales
1982
Gelatin silver print
20.3 × 50.4 cm
Canadian Museum of Contemporary Photography, Ottawa

14
La Gamberaia, Settignano, Florence
1984
Gelatin silver print
8.6 × 26.7 cm
Canadian Museum of Contemporary Photography, Ottawa

15
Villa Barbarigo, Valsanzibio
1984
Gelatin silver print
8.5 × 26.5 cm
Canadian Museum of Contemporary Photography, Ottawa

16
Castel di Leva
1989
Gelatin silver print
8.5 × 26.4 cm
Collection of the artist

17
Viaduct of the Ohio Turnpike over Cuyahoga National Park
2005
Gelatin silver print
44.2 × 106.2 cm
Collection of the artist

18
Colton and Houghton Mausoleums, Mountain View Cemetery, Oakland, California
1993
Gelatin silver print
19.5 × 24.5 cm
Canadian Centre for Architecture, Montreal

19
Sycamore, Just East of the Ramble, Central Park, New York
1991
Gelatin silver print
19.5 × 24.4 cm
Canadian Centre for Architecture, Montreal

20
Tree Roots and Rocks, Looking towards the Dakota, Central Park, New York
1993
Gelatin silver print
19.5 × 24.8 cm
Canadian Centre for Architecture, Montreal

21
East Meadow, Central Park, New York
1991
Gelatin silver print
19.3 × 22.7 cm
Canadian Centre for Architecture, Montreal

22
Druid Hills, Atlanta
1990
Gelatin silver print
19.5 × 24.4 cm
Canadian Centre for Architecture, Montreal

23
View from the Edge of the Scarboro Pond towards the Country Park, Franklin Park, Boston,
1994
Gelatin silver print
19.5 × 24.5 cm
Canadian Centre for Architecture, Montreal

24
View of the Nethermead, Prospect Park, Brooklyn
1994
Gelatin silver print
19.5 x 24.2 cm
Canadian Centre for Architecture, Montreal

25
The Meadowport Arch, Prospect Park, Brooklyn
1994
Gelatin silver print
19.5 × 24.1 cm
Collection of the artist

26
Stranger's Gate and 110th Street, Central Park, New York
1994
Gelatin silver print
19.6 × 24.5 cm
Canadian Centre for Architecture, Montreal

27
The Ramble, Central Park, New York
October 1991
Gelatin silver print
70.3 × 89 cm
National Gallery of Canada

28
At the Water's Edge, Marine Park, Bridgeport, Connecticut
1991
Gelatin silver print
37.1 × 46.2 cm
Canadian Centre for Architecture, Montreal

29
Country Meadow, Franklin Park, Boston
1992
Gelatin silver print
19.5 × 24.4 cm
Canadian Centre for Architecture, Montreal

30
Jackson Park, Chicago
1991
Gelatin silver print
71.3 × 90.5 cm
Collection of the artist

31
30th Street W., West Lethbridge
1999
Gelatin silver print
47.1 × 58.3 cm
Collection of the artist

32
Paradise Canyon, Lethbridge
August 1999
Gelatin silver print
44.2 × 59.2 cm
Canadian Museum of Contemporary Photography, Ottawa

33
Deco House, Lethbridge
1999
Gelatin silver print
19.5 × 24.3 cm
Collection of the artist

34
Beside the High Level Bridge, Lethbridge
1999
Gelatin silver print
47.1 × 58.7 cm
Collection of the artist

35
The High Level Bridge, Lethbridge, Looking West
October 1999
Gelatin silver print
45.5 × 55.5 cm
Canadian Museum of Contemporary Photography, Ottawa

36
Seed Company, Lethbridge
1998
Gelatin silver print
19.5 × 24.3 cm
Collection of the artist

37
Top Hat, Lethbridge
1999
Gelatin silver print
19.4 × 24.4 cm
Collection of the artist

38
Sporting Goods, Lethbridge
1999
Gelatin silver print
19 × 24.3 cm
Collection of the artist

39
Bow On Tong Co., Lethbridge
1998
Gelatin silver print
19.4 × 24.3 cm
Collection of the artist

40
Seed Company, Lethbridge
1999
Gelatin silver print
19.4 × 24.3 cm
Collection of the artist

41
Uplands, Lethbridge
1999
Gelatin silver print
46.8 × 58.3 cm
Canadian Museum of Contemporary Photography, Ottawa

42
Approaching Storm, West Lethbridge
1999
Gelatin silver print
47.1 × 58.7 cm
Collection of the artist

43
In Front of the Gare Saint-Lazare, Paris
1992
Gelatin silver print
37.8 × 46.1 cm
Canadian Museum of Contemporary Photography, Ottawa

44
Rue Charlemagne, Paris
2000
Gelatin silver print
48.5 × 58.5 cm
Canadian Museum of Contemporary Photography, Ottawa

45
Quai de la Tournelle, Paris
2000
Gelatin silver print
48.4 × 58.3 cm
Canadian Museum of Contemporary Photography, Ottawa

46
L'Opéra, rue Auber, Paris
2000
Gelatin silver print
19.5 × 22.2 cm
Collection of the artist

47
Pont-Neuf, Paris
2000
Gelatin silver print
76.5 × 92 cm
Collection of the artist

48
Gare du Nord, Paris
2000
Gelatin silver print
35.4 × 44.9 cm
Canadian Museum of Contemporary Photography, Ottawa

49
Rue des Haies, Paris
2000
Gelatin silver print
19.5 × 23.1 cm
Collection of the artist

50
Impasse Satan, Paris
2000
Gelatin silver print
46.3 × 58.8 cm
Collection of the artist

51
Boulevard de la Chapelle, Paris
2000
Gelatin silver print
47.1 × 58.7 cm
Canadian Museum of Contemporary Photography, Ottawa

52
Rue de Charenton, Paris
2000
Gelatin silver print
19.4 × 24.4 cm
Collection of the artist

53
Rue de Charenton, Paris
2000
Gelatin silver print
19.5 × 23.8 cm
Collection of the artist

54
Orchard, New York State
2005
Gelatin silver print
23.8 × 58.3 cm
Collection of the artist

55
Apple Tree, New York State
2005
Gelatin silver print
56.2 × 23.5 cm
Collection of the artist

56
Linden Tree, New York State
2005
Gelatin silver print
58.3 × 24.1 cm
Collection of the artist

57
Chestnut, Spadina House, Toronto
2005
Gelatin silver print
116 × 47.7 cm
Collection of the artist

58
Topped Tree, High Park, Toronto
2005
Gelatin silver print
59.1 × 24.8 cm
Collection of the artist

59
Willow, Ward's Island, Toronto
2005
Gelatin silver print
100.7 × 41.4 cm
Collection of the artist

60
Espaliered Tree, New York State
2005
Gelatin silver print
23.4 × 56.3 cm
Collection of the artist

61
Dundas Square, Toronto
2003
Gelatin silver print
24.7 × 58.5 cm
Collection of the artist

62
Oak Tree off Spadina and Dupont, Toronto
2005
Gelatin silver print
23.4 × 56.9 cm
Collection of the artist

63
Glen Baillie Place, Toronto
2005
Gelatin silver print
23.4 × 56.9 cm
Collection of the artist

64
Cloud Garden, Toronto
2004
Gelatin silver print
24.5 × 58.6 cm
Collection of the artist

65
Metro Hall, Toronto
2003
Gelatin silver print
26.4 × 60.4 cm
National Gallery of Canada, Ottawa

66
Bain Housing Co-op, Toronto
2004
Gelatin silver print
23.5 × 56.9 cm
Collection of the artist

67
Bay and Adelaide, Toronto
2004
Gelatin silver print
24.6 × 59.1 cm
Collection of the artist

68
Billboard for Liberty Village, Strachan Avenue, Toronto
2005
Gelatin silver print
24.4 × 58.7 cm
Collection of the artist

69
Railtracks near Liberty Village, Toronto
2005
Gelatin silver print
24 × 59.3 cm
Collection of the artist

70
Former Central Prison, now Liberty Village, Toronto
2004
Gelatin silver print
24 × 57.9 cm
Collection of the artist

71
New Housing, Langstaff Road and Dufferin Street, Vaughan
1999
Dye coupler print
101.6 × 127 cm
National Gallery of Canada, Ottawa

72
New Housing, North of Highway 7, Toronto, 11th September 2001
11 September 2001
Dye coupler print
90.8 × 121.9 cm
National Gallery of Canada, Ottawa

73
Untitled, North of Toronto
2003
Dye coupler print
78.7 × 99.7 cm
Collection of the artist

74
Vimy-Ridge
1993
Gelatin silver print
70.9 × 89.4 cm
National Gallery of Canada, Ottawa

75
Vimy-Ridge
1993
Gelatin silver print
45.1 × 55.4 cm
Collection of the artist

76
Black-Lake
1993
Gelatin silver print
43.9 × 55.4 cm
Collection of the artist

77
Black-Lake
1993
Gelatin silver print
81.4 × 88.8 cm
Collection Musée d'art contemporain de Montréal

78
Crossing Supplies Tent, Avenida Internacional, Tijuana
1997
Gelatin silver print
46 × 58 cm
Collection of the artist

79
Looking North toward San Diego at the Second Border Marker 1
1997
Gelatin silver print
44.5 × 115.5 cm
University of Toronto Art Centre

80
Looking North toward San Diego at the Second Border Marker 2
1997
Gelatin silver print
44.5 × 115.5 cm
University of Toronto Art Centre

81
Restaurant, Colonia Libertad, Tijuana
1997
Gelatin silver print
46.2 × 58 cm
Collection of the artist

82
Settlement along the Fence, Tijuana
1997
Gelatin silver print
71.5 × 89.7 cm
Collection of the artist

83
Above the Soccer Field, a Holding Area Extending into U.S. Territory, Tijuana
1997
Gelatin silver print
71 × 87.5 cm
Museum of Modern Art, New York

84
Partial View of the United States–Mexico Border with Otay Mesa, San Diego County, in the Foreground and Mesa de Otay, Tijuana, in the Background
1997
Gelatin silver print
46.1 × 57.9 cm
Collection of the artist

85
Surveillance Light, Otay Mesa, U.S. Side
1997
Gelatin silver print
71.2 × 89.6 cm
Collection of the artist

86
The End of the Fence, Looking West, Otay Mesa
1998
Gelatin silver print
74.6 × 93.6 cm
Collection of the artist

CHRONOLOGY

KATHERINE STAUBLE

1942

David Geoffrey Sedgwick James is born on 9 January in St. Asaph, Wales.

Geoffrey James's mother, Beryl (Williams) James, is a primary school teacher. His father, Arthur James, an officer in the British 8th Army, is killed later this year in North Africa while fighting against Rommel at the Second Battle of El Alamein.

1942–1960

James, his mother, and his brother, John, lead a nomadic existence.

1947

Early in the year, the family takes a *Train Bleu* to Italy, where Beryl James takes on the job of headmistress in a school for the families of the British army of occupation. Located in Grado, near Trieste, the school is housed in a former dance hall.

At Easter, the family travels to Venice and Rome with a friend of Beryl James's, who is a historian and member of the intelligence corps. James's first really vivid memories of childhood are of this trip, and he will long retain the memory of "the ordinary" in Italy.

We lived in a hotel in Grado, and though we did all the tourist things (the indelible odors of Venice, chasing my brother through the Villa d'Este, the nightmare of the Vatican, etc.) I still remember the plane trees, the terrifying gap between a fishing boat and the quai, the everyday smell of soup.
– Geoffrey James, artist statement, in *Identificazione di un Paesaggio*, ed. Sandro Mescola (Cinisello Balsamo [Milan]: Silvana, 2000), n.p.

At the end of the year, the family moves to the canal zone of Egypt, where Beryl James takes another posting.

1948

The entire James family falls ill a few months after arriving in Egypt and returns to England, where Beryl James teaches in various schools.

1949

When Beryl James takes a job in Weyhill, Hampshire, not far from Stonehenge, she sends the seven-year-old Geoffrey to boarding school.

1955–1960

At age thirteen, Geoffrey James moves on to Wellington College, Berkshire, a school closely associated with the military. He begins playing the trumpet at age fourteen and soon starts a band, but has no education in the visual arts.

Beryl James moves to Germany to teach in the British army school at Soltau, near Hanover. James travels there during school holidays, often stopping in northern France and Paris, and playing with various bands in France and Germany.

James completes his A-level exams in history.

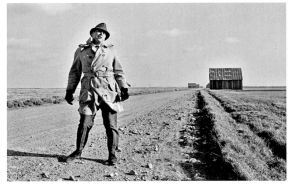
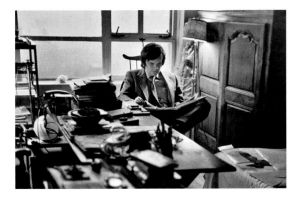

1960–1961

For about nine months, James works as a waiter in London and plays in a bebop band.

1961–1964

James reads history at Wadham College, Oxford and leads the university jazz band. Through his musical activities, he meets Terry Jones and Michael Palin, later of Monty Python fame. During his last term, he is editor of the university weekly *Isis*, which is transformed under his leadership from a largely political magazine to one heavily oriented towards the arts. The cover of one issue features a drawing by the renowned *New Yorker* artist Saul Steinberg. Another well-received issue is devoted to the making of the 1963 Alain Resnais film *Muriel*. Occasionally, James includes photo-essays. In this final undergraduate year, James finds himself selling stories to newspaper publishers on London's Fleet Street.

I became a journalist. I just sort of took to it.
– Geoffrey James, interview with Lori Pauli and Katherine Stauble, Ottawa, 4 September 2007

1964

James completes his B.A., hoping to land a job at the *New Yorker* magazine and immerse himself in the New York jazz scene. Instead, he accepts a job as a reporter with the now defunct *Philadelphia Evening Bulletin*, and sails to the United States in July. On arriving in New York he meets Whitney Balliett, jazz critic for the *New Yorker*, who becomes a lifelong friend. In Philadelphia, he files "colour" stories about life in the city.

James begins photographing scenes of Philadelphia. He purchases a twin-lens Rolleiflex and learns the rudiments of the technique from the photographers at the newspaper. Although he is unable to find a photography scene in Philadelphia, he travels to New York each week to play in a band, often visiting the permanent collection at the Museum of Modern Art (MoMA).

Because Philadelphia was so strange to me, I felt the urge to photograph.
– Geoffrey James, interview, 4 September 2007.

1965

James buys a 35 mm Pentax, which he uses as his primary camera. At MoMA, he starts buying books on photography, especially on the photographers André Kertész, Brassaï, and Henri Cartier-Bresson.

I thought they were magical. The pictures seemed to me to be enchanted. They didn't bear any relation to the real world.
– Geoffrey James, interview, 4 September 2007

James buys a book on Dorothea Lange and soon discovers Bill Brandt, Walker Evans, and Eugène Atget.

Geoffrey James is not alone in conceiving photography less in terms of pictures than of books. If a history of photography exists for him, it boils down to photographers' books, from Fox Talbot's *The Pencil of Nature* to Robert Frank's *The Americans*, passing through the albums of Baldus and Atget.
– Hubert Damisch, "Crossed Lines," in Geoffrey James and Hubert Damisch, *Paris* (Paris: Services culturels de l'Ambassade du Canada, 2001), p. 26.

1966

As U.S. involvement in the Vietnam War becomes increasingly intense and controversial, James moves to Montreal to take a job with the *Montreal Star*. He marries the art historian Ellen Sulkis, who works at the Montreal Museum of Fine Arts before moving on to Concordia University. James finds he has an affinity to Montreal's cultural community. He meets the photographer Sam Tata, and travels frequently to New York.

1967

At Montreal's Expo 67, James buys a book of Josef Sudek's photographs taken from his studio window.

Books are what kept me going through the winter.
– Geoffrey James, telephone conversation with Katherine Stauble, 17 September 2007.

1967–1975

James works for *Time* magazine Canada, primarily writing on the arts. He produces cover stories on leading Canadian figures, including Robertson Davies, Arthur Erickson, and Mordecai Richler, and occasionally takes photographs, such as his portrait of Alex Colville.

1968

The American photographer Cornell Capa mounts an exhibition at the Riverside Museum, New York, to raise money for the Fund for Concerned Photography (now the International Center for Photography). James visits the show and meets André Kertész, whom he will frequently visit on subsequent trips to New York.

1970

Around this time, James meets the Quebec artist Charles Gagnon and his wife, Michiko Yajima; they become lifelong friends.

Early 1970s

James travels to Europe several times during this period, and begins photographing gardens using a 35 mm camera.

On assignment with *Time* magazine, James travels to Lethbridge, Alberta, to research an article on the architect Arthur Erickson. The architect tours him around University Hall, designed (by Erickson with Geoffrey Massey) to mirror the surrounding landscape. James is taken by the distinctive coulees – large gullies formed between the plains and the river – and will return thirty years later to photograph them.

John, Geoffrey James's brother, at Villa d'Este, 1947

Reporter Geoffrey James at Connie Mack Stadium, Philadelphia, 1964

Geoffrey James, *Alex Colville on the Tantramar Marshes*, c. 1970

André Kertész, portrait of Geoffrey James, New York, c. 1969

> The coulees that rise up from the Oldman River, with their flowing, anthropomorphic forms, assumed in my mind an almost mythic stature, like the background of a Leonardo painting. What was astonishing about them was that, primeval as they seem, they were right on the edge of town.
>
> – Geoffrey James, preface, in *Place: Lethbridge, a City on the Prairie* (Vancouver: Douglas & McIntyre, 2002), p. 8.

1971

James teaches a course in the history of photography at Sir George Williams University (now Concordia University), and is invited to hold his first solo exhibition there. He shows a variety of 35 mm images, including portraits and city scenes. James buys a Leica.

He travels to France and interviews the American photographer Paul Strand for an unpublished article in *Vie des arts*.

Solo exhibition
Sir George Williams University, Montreal

1972

James's son, David, is born. Around this time, Kertész introduces James to Brassaï.

1973

In his first publishing collaboration, James begins taking photographic portraits of musicians for a book by Whitney Balliett.

1974

Balliett's *Alec Wilder and His Friends* is published. James is commissioned to write an article on the Art Bank for the Canada Council's annual report.

1975

Michiko Yajima opens the Yajima/Galerie on Sherbrooke Street, Montreal, and mounts, as its first solo show, an exhibition of Geoffrey James's 35 mm photographs.

The *Toronto Star* publishes a cover story in its *Canadian Magazine* citing James as "the most influential art critic in Canada."

James edits an issue of *Arts Canada* on photography. Foreseeing its demise, *Time* Canada invites James to work for its European edition in Paris. At the same time, the Canada Council offers him a position.

The French photographer Jacques Henri Lartigue visits Montreal for an exhibition of his works held at Galerie Optica; Lartigue stays with Geoffrey James as a houseguest.

Solo exhibition
Yajima/Galerie, Montreal

Sir George Williams University exhibition poster, 1971

Canadian Magazine cover, 1975

1975–1982

James works as Head of the Visual Arts, Film and Video section at the Canada Council. He organizes exhibitions of the Art Bank's works, including *Transparent Things: The Artist's Use of the Photograph*, an exhibition that travels across Canada, and *Five Canadian Painters*, which travels to Australia; he helps coordinate *O Kanada* in Berlin.

Aware of what might appear to be a conflict of interest in the Canadian art scene, James begins to exhibit his work outside the country, including at the Sander Gallery in Washington and at New York's Photograph Gallery.

1977

Geoffrey James and Ellen Sulkis are separated.

The Ottawa-based American photographer Randal Levenson gives James a 1920s Kodak panoramic camera for which roll film is no longer made commercially. James begins experimenting with the camera, following in Sudek's footsteps by cutting his own film to size. James finds that the camera "conforms to human vision," capturing very complex spaces in their entirety, even if it frequently breaks down.

> I have an irrational belief that the panoramic shape comes closer to the horopter of human vision, more closely duplicating our peripheral sense of inhabiting space.
>
> – Geoffrey James, "On Photographing Gardens," in *Genius Loci* (Ottawa: Canadian Museum of Contemporary Photography, 1986), p. 7.

Group exhibition
13 Canadian Photographers, Madison Art Center, Madison, Wisconsin

1977–1978

James buys a second Kodak panoramic camera. He photographs in Ottawa, Montreal, Victoria, Tuscany, and the Var region of southern France.

1978

Solo exhibition
Yajima/Galerie, Montreal

Late 1970s – early 1980s

James begins to study garden history, reading such books as the Dumbarton Oaks series, Georgina Masson's *Italian Gardens* and, most particularly, J.B. Jackson's *The Necessity for Ruins*. He takes a special interest in the French gardens of André Le Nôtre, as well as the eighteenth-century English tradition.

1980

Group exhibition
Photographers, Sander Gallery, Washington, D.C.

1981

While in Europe working on *O Kanada* in Berlin, James visits and photographs the baroque gardens of Marly-le-Roi, outside Paris.

> I'm interested in investigating people's aspirations because when you build a garden, especially a big one, you're building an ideal world. Each generation has gardens which reflect the aspirations of that age, so there are different styles ... They're very strange, they're like time capsules, complete environments which take you back into another world ... The people who built them had no material problems except when they bankrupted themselves building the gardens. They're utopian and they always fail. They're symbols of mortality and I find them sort of poignant.
>
> – Geoffrey James in Robert Enright, "Gardening Utopia: An Interview with Geoffrey James," *Border Crossings* 9, no. 1 (Winter 1990): 14.

James also travels to Italy and photographs, for the first time, the landscape of the Roman Campagna.

In September, James marries the curator Jessica Bradley.

Solo exhibition
Photograph Gallery, New York

1982

James leaves the Canada Council to devote himself to photography. He attends the Venice Biennale, where Bradley is Commissioner for the Canadian pavilion, and spends time photographing gardens. He travels to Wales and photographs the gardens of Powis Castle.

Solo exhibition
Yajima/Galerie, Montreal

1982–1984

James photographs while working as a visiting professor at the University of Ottawa, Department of Visual Arts, where he teaches studio courses as well as documentary photography and the history of photography.

1983

Solo exhibitions
Yarlow Salzman Gallery, Toronto
Panoramic Photographs, Anna Leonowens Gallery, Nova Scotia College of Art and Design, Halifax
Coburg Gallery, Vancouver

Group exhibition
Panoramic Photographs, Equivalents Gallery, Seattle

1984

James receives a grant to photograph Italian gardens from the Graham Foundation for Advanced Studies in the Fine Arts, Chicago, which supports architecture-related projects. The final exhibition and book, *Genius Loci*, will bring together his photographs of twenty-four French and Italian gardens, representing four centuries of landscape design. James travels twice this year to Venice and Rome.

To inhabit a garden for any length of time is to have a deep body-memory of that place – a memory that is corroborated by one's feet. I know by heart (or rather by foot) the ascending levels of the Villa Lante, the false perspectives at the Villa Pisani at Stra, the endless distances at Caserta.
– Geoffrey James, "On Photographing Gardens," p. 6.

1984–1985

The Agnes Etherington Art Centre at Queen's University mounts the solo exhibition *Entrances and Exits: The Garden as Theatre*, publishing an accompanying catalogue.

I am really interested in the poetics of space. I like to work in places that are very complex and that have many entrances and exits, because the visual game is more fun as it gets more complicated.
– Geoffrey James, "Gardening Utopia," p. 14.

James's sentimental journey unfolds as if it were taking place ten centimeters above the earth (somewhere between the realms of Peter Pan and Zen), rapidly gliding, without pleasant stopovers, without a sure base. He is a solitary tripper in a world that has acquired greater dimension and fullness. Solitary, above all, because the species he belongs to risks disappearing or, perhaps already having vanished, it lives in a clandestineness which he must first penetrate to see whether or not anyone is alive.
– Pier Luigi Tazzi, "Rome: Geoffrey James," review of *Giardini Italiani*, *Artforum* 24, no. 3 (November 1985): 115.

Solo exhibition
*Entrances and Exits: The Garden as Theatre**, Agnes Etherington Art Centre, Queen's University, Kingston

1985

In April, Jessica Bradley gives birth to a son, Charles. In May, *Giardini Italiani* is published.

―――
Throughout the Chronology, * indicates an exhibition catalogue.

In June, James is invited to be artist in residence for six months in Villeneuve lez Avignon, France, at the Centre International de Recherche, de Création et d'Animation (CIRCA). While there, he abandons his original project to photograph the work of the landscape architect André Le Nôtre, who designed the gardens of Louis XIV, instead focusing his camera on the less formal gardens of the Enlightenment. These gardens, as James finds, are often quite rundown and difficult to access.

So many of the key gardens are inaccessible to even the most persistent inquirer... and, like the Désert de Retz, are perhaps better addressed with a chainsaw than with a camera... I slowly came to the conclusion that I was dealing less with gardens than with some notion of Arcadia. The gardens of late 18th-century France exude regret, nostalgia and the desire to be elsewhere.
– Geoffrey James, artist statement, in John Harris and Geoffrey James, *Landscape with Ruins* (London: Heinz Gallery, Royal Institute of British Architects, 1986), pp. 3–4.

In Nice, James meets the garden historians John Dixon-Hunt and Monique Mosser as well as John Harris of the Royal Institute of British Architects (RIBA). They take an interest in his work from Villeneuve lez Avignon. Harris urges James to visit the UK and photograph late eighteenth-century English gardens.

James returns to Ottawa.

Solo exhibitions
*I Giardini Italiani**, Palazzo Braschi, Rome; University of Palermo, Italy; CIRCA, Villeneuve lez Avignon, France
Italian Gardens, University of Kent, Canterbury
Genius Loci, Graham Foundation, Chicago

Group exhibition
*Contemporary Canadian Photography**, National Gallery of Canada, Ottawa

1986

Genius Loci is published. James travels to England to photograph gardens; the work is exhibited at the RIBA as *Landscape with Ruins: 18th-century English and French Gardens*. An accompanying catalogue is published in November.

I have concentrated on transitional gardens that hover between the dream of Italy and the agreeable reality of the English countryside.
– Geoffrey James, artist statement, in *Landscape with Ruins*, p. 5.

The photographs from Villeneuve lez Avignon are published in *Morbid Symptoms: Arcadia and the French Revolution*, with an afterword by Monique Mosser.

Solo exhibitions
*Landscape with Ruins**, Heinz Gallery, RIBA, London; Coburg Gallery, Vancouver; University of Palermo, Italy

Yajima/Galerie exhibition poster, 1978

Business card, with an image of Marly-le-Roi

Morbid Symptoms book and exhibition poster, 1986

1986–1994

Solo exhibition

*Genius Loci**, Canadian Museum of Contemporary Photography, Ottawa; Graham Foundation, Chicago (1986); The Whyte Museum of the Canadian Rockies, Banff, Alberta (1986); Edmonton Art Gallery, Edmonton (1987); Toronto Photographers Workshop, Toronto (1987); Vu – Centre d'animation et de diffusion de la photographie, Quebec City (1987); MacDonald Stewart Art Centre, Guelph, Ontario (1987); Centre culturel de l'Université de Sherbrooke, Sherbrooke, Quebec (1988); Art Gallery of Greater Victoria (1988); Sir Wilfred Grenfell College Art Gallery, Corner Brook, Newfoundland and Labrador (1989), Petro-Canada Art Gallery, Calgary (1989); Kamloops Art Gallery, Kamloops, British Columbia (1989); University of Houston College of Architecture Art Gallery, Houston (1990); Musée régional de Rimouski, Rimouski, Quebec (1990); MacKenzie Art Gallery, Regina (1991); Oakville Galleries, Oakville, Ontario (1991); Chicago Botanic Garden Gallery, Chicago (1992); Surrey Art Gallery, Surrey, British Columbia (1993); The Gallery, Southern Methodist University, Dallas (1993); Art Gallery of Peterborough, Peterborough, Ontario (1994)

1987

James and Bradley move to Montreal, where she can pursue graduate studies and he can photograph a larger urban environment; their son Matthew is born. James travels to Toronto, where he has been commissioned to photograph contemporary architecture for the group exhibition *Toronto: Le Nouveau Nouveau Monde*.

I didn't grow up in Montreal but all my friends say that your first interesting experiences happen in alleys if you live in the east end of Montreal. What's fascinating is the way that people create gardens and the way that the alleys frame all kinds of important buildings. You get a kind of unauthorized view of the city and you also get a really good look at how people create their own environments.
– Geoffrey James, "Gardening Utopia," p. 14.

Group exhibitions

Michel Denée, Geoffrey James, Galerie René Blouin, Montreal
Classical Concerns, Twining Gallery, New York
*Elementa Naturae**, Musée d'art contemporain de Montréal, Montreal
*Diverse Secrecies: The Garden Photographed**, Presentation House, North Vancouver

1987–1988

Group exhibition

*Toronto: Le Nouveau Nouveau Monde**, Maison de l'architecture, Paris (1987–88); Bagatti Valsecchi, Milan (1987–88), Casa de Architectura, Barcelona (1988); John B. Aird Gallery, Toronto (1988).

1988

Inspired by a Robert Smithson essay on the American landscape architect Frederick Law Olmsted, James presents to Phyllis Lambert of the Canadian Centre for Architecture a detailed proposal to photograph Olmsted's work. The goal is to document the current condition of the many sites designed by Olmsted, including public parks, private gardens, and cemeteries, some of which are in a state of decay. James suggests engaging two additional photographers, including Lee Friedlander and Robert Burley. Lambert enthusiastically endorses the project.

It is perhaps a good idea to photograph the work of Olmsted with a wide knowledge of his aims, but also recognizing that much, if not most, of what he has done has been profoundly altered by neglect, fashion and changing social needs and the passage of time. It may be that the corners of Olmsted's bucolic, restorative world still exist; but

the photographer cannot ignore the chain link fences in the Long Meadow of Prospect Park, the private parking lot that has replaced the first link in Boston's Muddy River system. I do not see this as a strictly historical project, but one in which there is a subtle dialectic between past and present.**
– Geoffrey James, "The Legacy of Olmsted" (proposal to the CCA for the Olmsted project), 1988.

Group exhibitions

Italian Journeys (two-person show with Adolf Benca), Twining Gallery, New York
Jan Turner Gallery, Los Angeles

1989

James begins working on the Olmsted project, using his Kodak Panoram as well as a 5 × 7 camera.

After all the immense effort of earth-moving and draining and planting, after all the striving for picturesque effects, for a rusticity that would provide spiritual relief and moral uplift, what, finally, remains of these places? Now just past the point of maturity, the great parks of Frederick Law Olmsted have become almost entirely severed from the idealistic intentions of their creator. By their emptiness they bespeak the absence of any common ground. In America they are the closest thing to ruins – but ruins that are part of a new geography of fear.
– Geoffrey James, "A Note on Olmsted: An Archaeology," in *Documenta IX*, vol. 2 (Stuttgart: Edition Cantz; New York: Harry N. Abrams, 1992), p. 237.

James wins a John Solomon Guggenheim Memorial Foundation award to photograph the Roman Campagna, where centuries-old farms are being invaded by modernity. He moves to Italy with his family for several months, working primarily on the Campagna Romana series, but also photographing some gardens as well as Etruscan sites, using his 8 × 10 camera.

Arriving [in Italy] for three months in the autumn of 1989, I imagined traversing the landscape on foot, perhaps camping like Piranesi or walking in a determined English line like Richard Long. As it turned out, I ended up doing as the Romans do and driving everywhere. In a sense, the road is the real armature of this book. All of the sites were reached by car and most of the photographs were taken within the sound of traffic.
– Geoffrey James, foreword, in *La Campagna Romana* (Montreal: Éditions Galerie René Blouin, 1991), n. p.

130

Geoffrey James Project Proposal

For some time I have been interested in constructed landscapes — in formal gardens or landscape ensembles that are rich in both a visual and a philosophical sense. I have made several visits to Italy to explore the idea of the Italian garden. While single-mindedly grappling with the problem of how to deal with these complex spaces, I kept getting tantalizing glimpses of another world. It was a world seen suddenly from an autostrada, or behind a line of new high-rise apartments — the Roman campagna. This extraordinary landscape, which attracted travellers and artists for at least three hundred years, now rubs against the modern world of autostradas and suburbs and the sprawl of light industry. It is the friction between these two worlds that interests me. I should like to spend seven months in the middle of the campagna, from late summer to late spring of the following year, attempting to address a subject of infinite richness. I suspect that I shall have to employ a rather large camera with longer lenses to deal with the scale of this landscape. The panoramic camera that I habitually use seems to function best in intimate, enclosed spaces. When I mentioned this dream to an Italian curator a couple of years ago, her response was direct and intelligent: "Anti-Poussin." I might even be able to draw a few people's attention to a condition that, with rare exceptions, most Italians take for granted: the rapid disappearance of one of the most extraordinary landscapes in the world.

Proposal for Guggenheim fellowship, 1988

Solo exhibition
Equinox Gallery, Vancouver

Group exhibitions
A Garden Walk, Twining Gallery, New York
Contemporary Canadian Photography, Budapest
*Anamnèse** (with Pierre Boogaerts, Annette Messager, and the Starn Twins)
Dazibao, Montreal
Galerie René Blouin, Montreal

1989–1995
James continues to work on the Olmsted project, primarily in the spring, fall, and winter. He switches to a Noblex panoramic and an 8 × 10 camera.

During this period, James learns from his friend Austin Metze of the murder, in Brooklyn's Prospect Park, of Metze's friend Alan Winslow.

His name was Alan Winslow – he was a drama teacher and he used to do fire ceremonies with us just above the Long Meadow in Prospect Park – near the cemetery. I remember one night we took a walk with him and his family around the lake in Prospect. As the sun had just gone down I said we had better be going home but he said 'I've been doing this for years. There's nothing to worry about.' He was from Texas and he had that fearlessness of someone who didn't grow up in New York. He was killed, I guess it was the Fall of '93. He had a new mountain bike and he went to the place near the cemetery to meditate. There were some kids there who wanted his bike, but he just pedaled off and one of them shot him in the back. He went down the hill into the Long Meadow and just fell over. There was a woman there with a child. She talked to him and comforted him as he lay dying. We had a ceremony after the funeral and she came and told us about it. It really affected people in Brooklyn. It caught their imagination. A name like Winslow. Say no more.
– Austin Metze, quoted by Geoffrey James, artist statement, in *The Edge of Town*, by Stephen Bann (West Hartford, Conn.: Joseloff Gallery, University of Hartford, 1995), n .p.

1990
James returns to Italy to photograph Italian gardens and Etruscan sites.

I've always been drawn to special places. I grew up near Avebury and Stonehenge and found them absolutely extraordinary. When I was in Italy, after doing the Italian gardens, photographing the Campagna, I became very interested in the Etruscan sites. These are essentially sacred places, the Etruscan sites and Avebury. What's interesting about them is that they have several characteristics in common. They're sited so that they command views all around, and they are defensible. They often have water, not the prehistoric British sites, but certainly the Etruscan sites – they have rivers and ravines.
– Geoffrey James, interview with David Harris, in *Viewing Olmsted* (Canadian Centre for Architecture: Montreal, 1995), p. 95.

Solo exhibitions
Geoffrey James, Galerie René Blouin, Montreal
Geoffrey James, Equinox Gallery, Vancouver
Geoffrey James: Photographies 1979–1990, Galerie Verticale Art Contemporain, Quebec City

Group exhibitions
Works for the Garden, Blum Helman Gallery, Los Angeles
The Shaping of Nature, Oakville Galleries, Oakville, Ontario

1991
La Campagna Romana is published at the beginning of the year. The Dutch curator Jan Hoet sees the Italian Gardens series at Vancouver's Equinox Gallery and invites James to participate the following year in *Documenta IX*, for which Hoet is artistic director.

James travels to Toronto to take photographs for the book *Toronto Places*, one of his earliest urban projects. He is entranced by the Bain Co-op, built in 1914 as affordable family housing, and designed with courtyards and hedgerows. For James, this is "the single most congenial place" among the subjects he must photograph.

It's about an old Arts and Crafts idea of community. Very idealistic.
– Geoffrey James, speaking about the Bain Co-op, in "Ugly Beauty," p. 20

James will return over a decade later to photograph the Bain Co-op again for the book *Toronto*.

The Italian Garden is published in the fall.

Solo exhibition
Twining Gallery, New York

Group exhibitions
Raymonde April, Geoffrey James, Galerie René Blouin, Montreal
*20th-century Photography**, Equinox Gallery, Vancouver
*Un archipel de désirs**, Musée du Québec, Quebec City
*Corriger les lieux**, Dazibao, Montreal

1991–1994
James is awarded an "A" Grant from the Quebec Ministry of Cultural Affairs to photograph the Domaine de Kerguéhennec, in Brittany, with its eighteenth-century château and nineteenth-century park. He travels to France on several occasions, photographing the entire park, where he manages to turn his camera away from all but one of the sculptures that litter it. He experiments with photographing single trees using a panoramic camera, and also creates a number of images of the château's dilapidated interior, including the maids' rooms. The photographs remain unpublished.

1992
The Canada Council honours James with the Victor Martyn Lynch-Staunton Award for outstanding artistic achievement in Visual Arts. James participates in *Documenta IX* in Kassel, Germany, along with the photographers Thomas Struth, Zoe Leonard, and James Welling, and fellow Canadians Stan Douglas, Vera Frankel, Rodney Graham, and Angela Grauerholz. Photography has a particularly large presence at this edition of *Documenta*, and James presents for the first time large prints measuring almost one square metre.

There are some trenchant juxtapositions, such as the placement of Mike Kelley's "whacky" sculptures, ironically dealing with the American government's attempt to censor sexually explicit art, in the same space as Geoffrey James's documentary photographs of Frederick Law Olmsted's parks as places conveying the loss of idealism and the rise of fear in the United States.
– Donald Kuspit, "Documenta: The Atmosphere of Anomie," *C Magazine*, no. 35 (Fall 1992): pp. 20–28.

Lee Friedlander, portrait of Geoffrey James, c. 1991

La Campagna Romana, 1991

Unknown photographer, installation of *Documenta IX* exhibition, 1992

In October, James travels to La Malbaie, Quebec, on the north shore of the St. Lawrence, to photograph the garden of the American horticulturalist Francis Cabot. On his way back to Montreal, he stops at Thetford Mines to see the largest open-pit asbestos mine in the Western hemisphere. Inspired by its scale and suggestions of an unsettling past, he begins photographing the site, marking the beginning of the Asbestos series.

It is this tension between past and present that drives James's work. His photographs are never simply documentary. Nor do they evoke any nostalgia or regret that would represent a dreaming backward to the past. On the contrary, James walks a mediating line. He takes photographs like a historian (the discipline in which he was trained), encouraging the thinking-through of history's overlap with the contemporary world.
Richard Rhodes, "Thinking through Time," in *Asbestos* (Toronto: The Power Plant), p. 63.

Solo exhibitions
Geoffrey James – Forgotten Zones, Laurence Miller Gallery, New York
Olmsted: Une archéologie, 1990–1992, Galerie René Blouin, Montreal

Group exhibitions
Reinvented Sites, TrépanierBaer Gallery, Calgary
*Documenta IX**, Kassel, Germany
*Il Secondo Paradiso: Natura e giardino nelle immagini dei grandi fotografi**, Mole Antonelliana, Turin
Une seconde pensée du paysage, Domaine de Kerguéhennec, Centre d'art contemporain, Bignan, France
*La collection: Tableau inaugural**, Musée d'art contemporain de Montréal, Montreal
Photography without Apology, Charles H. Scott Gallery, Emily Carr College of Art, Vancouver
Turner/Krull Gallery, Los Angeles
Stux Gallery, New York

1992–1993
Group exhibition
*Beau: A Reflection on the Nature of Beauty in Photography**, Canadian Museum of Contemporary Photography, Ottawa (1992); Canadian Embassy, Paris (1992–93)

1993
James returns to Thetford Mines to continue photographing mining sites in the region.

Utopian plans and conceptions haunt these images. Their fevers underlie the work's immediacy with anxiety about what role is left for us to play ... It is the bloom of a recognition that places filled with the stranded relics of high thinking are parallel vicinities to Modernism's dead ends and fallen visions.
– Richard Rhodes, "Thinking through Time," pp. 64–65.

The Power Plant in Toronto mounts *Asbestos*. At the gallery, James meets Hugh Davies, who invites him to do a residency at the Museum of Contemporary Art, San Diego, where Davies is Director. Initially not drawn to the landscape of Southern California, James will wait three years before committing himself.

James's panoramic garden photographs are exhibited in Dallas at Southern Methodist University.

The fifty-six black and white panoramic images of abandoned and deteriorated gardens convey a dynamic sense of the intellectual, political and spiritual climate that created them. In a James photograph this is often expressed by giving a sense of what it is like to move through the gardens with the awareness of the vistas that movement provides.
– Philip Van Keuren, *Vista to View: The Panoramic Image in Landscape Photography* (Dallas: The Gallery at Southern Methodist University, 1993), p. xx.

Solo exhibitions
*Geoffrey James: Asbestos**, The Power Plant, Toronto
Galerie Verticale Art Contemporain, Quebec City
Galerie Charles & Martin Gauthier, Quebec City

Group exhibitions
*Vista to View: The Panoramic Image in Landscape Photography** (two-person show with David H. Gibson), The Gallery at Southern Methodist University, Dallas
Observing Traditions: Contemporary Photography, National Gallery of Canada, Ottawa
Arcadia/Paradise/Utopia, Surrey Art Gallery, Surrey, British Columbia
*Reflecting Paradise**, Canadian Pavilion, Expo '93, Taejon, Korea

1994
Asbestos is published.

Solo exhibition
*Geoffrey James: Asbestos**, Galerie René Blouin, Montreal

Group exhibitions
Geoffrey James, Charles Gagnon (two-person show), Galerie René Blouin, Montreal
*Le regard de l'autre**, Maison de la culture Côte-des-Neiges, Montreal, and various locations in Italy
*Neapolis Metropolis**, Palazzo Reale, Naples
Une île, des villes: Montréal, mission photographique, Centre intercultural Strathearn, Montreal

1994–1999
Group exhibition
*Carnets de voyages / Travel Journals**, Canadian Museum of Contemporary Photography, Ottawa (1994); EPTEK National Exhibition Centre, Summerside, Prince Edward Island (1995); University of Manitoba, Winnipeg (1995); Centre international d'art contemporain de Montréal, Montreal (1996); Musée du Québec, Quebec City (1997); Beaverbrook Art Gallery, Fredericton (1997); Centre culturel universitaire de Sherbrooke, Sherbrooke, Quebec (1997); The Station Gallery, Whitby, Ontario (1998); Moose Jaw Art Museum, Moose Jaw, Saskatchewan (altered version, 1998); Leaf Rapids National Exhibition Centre, Leaf Rapids, Manitoba (1999); *International Photo Exhibition*, Le Pont Gallery, Aleppo, Syria (altered version, 1999)

1995
In the summer, Geoffrey James and Jessica Bradley move to Toronto.

Solo exhibitions
Geoffrey James – Olmsted: An Archeology, Linda Genereux Gallery, Toronto
Geoffrey James: Thinking through History: Recent Photographs, TrépanierBaer Gallery, Calgary
Equinox Gallery, Vancouver
Panoramas: Geoffrey James, Côte Saint-Luc Public Library, Montreal

Group exhibitions
*World Tea Party**, Transculture, Palazzo Giustiniani, Biennale di Venezia, Venice
*Instants photographiques**, Musée d'art contemporain de Montréal, Montreal
*Silent Witness**, United Nations, New York and Geneva

ASBESTOS
–
Geoffrey James
–

Asbestos exhibition poster, 1993

November 2 - December 7 1996

Reception
Saturday November 2
4 – 6pm

ANGLESGALLERY

2230 MAIN STREET, SANTA MONICA, CALIFORNIA 90405
TEL 310.396.5019 FAX 310.396.3797

RODNEY GRAHAM
STANLEY PARK CEDARS

GEOFFREY JAMES
OLMSTED: AN ARCHAEOLOGY

RICHARD LONG
IDAHO QUARTZ CIRCLE

1995–1996
Group exhibition
*The Edge of Town**, Joseloff Gallery, University of Hartford, West Hartford, Connecticut

1996
James travels to San Diego with Bradley, who is curating an exhibition there. He makes an excursion to Mexico and catches his first glimpse of the border fence between the two countries. James is immediately inspired, and upon his return to San Diego, stops at the Museum of Contemporary Art to accept the residency offered three years earlier. James is awarded a short-term "A" Grant from the Canada Council. In the fall, *Viewing Olmsted* is published.

Solo exhibitions
Thinking through Time, TrépanierBaer Gallery, Calgary
Geoffrey James: Photographies françaises, Galerie Charles & Martin Gauthier, Quebec City
Geoffrey James: Photographies, Domaine de Kerguéhennec, Centre d'art contemporain, Bignan, France
French Pictures, Equinox Gallery, Vancouver

Group exhibitions
Rodney Graham: Stanley Park Cedars; Geoffrey James: Olmsted: An Archaeology; Richard Long: Idaho Quartz Circle, Angles Gallery, Santa Monica, California
*Prospect 96, Photography in Contemporary Art**, Triennial Frankfurter Kunstverein, Frankfurt
Instants photographiques, Couvent des Cordeliers, Paris

1996–1998
Group exhibitions
*Viewing Olmsted: Photographs by Robert Burley, Lee Friedlander and Geoffrey James**, Canadian Centre for Architecture, Montreal (1996–97); Equitable Gallery, New York (1997), Wexner Center for the Arts, Columbus, Ohio (1997); Wellesley College Davis Museum and Cultural Center, Wellesley, Massachusetts (1997); The Field Museum, Chicago (1998)
*Crossing the Frontier: Photographs of the Developing West, 1849 to the Present**, San Francisco Museum of Modern Art, San Francisco (1996–97); Yale University Art Gallery, New Haven, Connecticut (1997); Phoenix Art Museum, Phoenix, Arizona (1997), Tokyo Metropolitan Museum of Photography, Tokyo (1998)

1997
James begins the Running Fence series, travelling to San Diego in January, and again in April, to photograph the Mexico–U.S. border. In order to mimic the motion of surveillance, James uses a new, extra-long lens.

James's handsome and uninhabited images suggest a failure of ideology, a modernist utopian dream defeated by time and changing demographics, ironically echoed in the elegant formalism of the photographic images themselves.
– Susan Gibson Garvey, "Introduction: The Works," in *Work, Workers, Works: Rearranging the Land* (Halifax: Dalhousie University Art Gallery, 1997), p. 6.

In late spring, James photographs Highway 407, the newly constructed toll road north of Toronto, on the eve of its opening.

Solo exhibitions
Geoffrey James: De l'esprit des lieux, Fondation pour l'architecture, Brussels
Geoffrey James, Galerie René Blouin, Montreal
Running Fence, Museum of Contemporary Art, San Diego
Geoffrey James, Galerie Charles & Martin Gauthier, Quebec City

Group exhibitions
Landscapes in Democracy, Frederick Law Olmsted, Musée de l'Elysée, Lausanne
*Work, Workers, Works: Rearranging the Land**, Dalhousie University Art Gallery, Halifax

1998
James approaches Joan Stebbins, Director and Curator of the Southern Alberta Art Gallery, about his interest in photographing the landscape in and around Lethbridge. She invites him to do a project at the Gallery; he is able to obtain support from the Canada Council's Millennium Fund.

Around this time, James begins a series of photographs of Toronto, taking an interest in the streets and alleyways, houses and public spaces, and new mixed-use developments such as Liberty Village.

He also begins photographing the suburban "905" region using colour film in order to transmit the "violent" colours of building materials and the "vulgarity" of the subject.

Toronto is consistently denied any grand city building. It's always fizzled. It just ended up in streets of little houses and narrow sidewalks. Liberty Village is the opposite of utopian. It's all based on selling the notion of lifestyle. It's suburban to the extent that it denies the idea of street. And it seems predicated on a big box store that you have to drive to. There's no urban street. It all breaks down.
– Geoffrey James, interview with Lori Pauli and Katherine Stauble, Toronto, 13 September 2007.

Asbestos, 1994

Angles Gallery invitation, 1996

While exploring Toronto's constructed environment, James is drawn to the city's six million trees, and begins photographing them.

Solo exhibitions
Trees, Equinox Gallery, Vancouver
Geoffrey James: Past, Present, Future: A Survey, TrépanierBaer Gallery, Calgary

Group exhibition
*Univers urbains: La Représentation de la ville dans l'art québécois du XX^e siècle**, Musée du Québec, Quebec City

1998–1999
James travels to Lethbridge to begin photographing the area.

What's interesting about Lethbridge, what tickled my antennae, is that so much has completely disappeared. The railway station has been engulfed. It's so willful.
– Geoffrey James, "Ugly Beauty," p. 17.

Solo exhibition
*Running Fence**, Presentation House Gallery, North Vancouver (1998); MacKenzie Art Gallery, Regina (1998), Illingworth Kerr Gallery and Alberta College of Art and Design, Calgary (1998), Ottawa Art Gallery, Ottawa (1999); Centre international d'art contemporain, Montreal (1999); Oakville Galleries, Oakville, Ontario (1999)

1999
Presentation House publishes the catalogue *Running Fence*.

Bernard Lamarche of *Le Devoir* selects *Running Fence* as the best exhibition of the year.

James points his camera at the borderlands and mirrors back a barren landscape resonant with conflict.
– Dot Tuer, "Imaging the Borderlands," in Geoffrey James, *Running Fence* (North Vancouver: Presentation House, 1999), p. 107.

James receives an invitation from the Italian curator Sandro Mescola to photograph the industrialized area around Marghera, Venice's modern port.

Solo exhibitions
*Geoffrey James, The Lethbridge Project**, Southern Alberta Art Gallery, Lethbridge
Geoffrey James, The Lethbridge Project: New Pictures, TrépanierBaer Gallery, Calgary

Group exhibitions
*Paradise Revisited**, Freedman Gallery, Albright College, Center for the Arts, Reading, Pennsylvania
Land Marks, National Gallery of Canada, Ottawa
Mysterious Voyages, Exploring the Subject of Photography (with Cindy Sherman, Gregory Crewdson, Thomas Struth, Hiroshi Sugimoto, and others), Contemporary Museum, Baltimore
Natural Order, Edmonton Art Gallery, Edmonton

1999–2000
Group exhibition
En chantier: The Collections of the CCA, 1989–1999, Canadian Centre for Architecture, Montreal

2000
James travels to Italy in April.

The city streets he shows us are often generic, the industrial sites are almost abstractions. He seems determined to honour obscure corners of the world that will never otherwise be noticed – the melancholy bridge that is too much like other bridges to be memorable, the street-corner where we can't be sure anything important has ever happened or will.
– Robert Fulford, "Of Time and the Landscape: The Photographs of Geoffrey James," in *Geoffrey James: Past, Present, Future*, p. 13.

James is granted use of the Canada Council studio in Paris for a series of photographs of the surrounding suburbs, or *villes nouvelles*. He travels to France in September, but is forced to abandon his original plan because of railway strikes. Instead, he focuses on the city of Paris, which he finds changed since his first visit in the late 1950s.

I had first gone to Paris at the age of 16 or 17, hitchhiking and biking. Rents had been frozen since World War II and everything was crumbling. By the time I was photographing, it was fixed up. All the buildings had been cleaned and the concierges replaced by codes.
– Geoffrey James, interview, 13 September 2007.

James walks the streets of Paris every day with an 8 × 10 camera, drawn especially to the east end and the Right Bank, as well as to the "Zone" that so interested Atget.

I was trying to find places where things were rubbing together. One of the things that's interesting to me is the way the city's a collage, the ultimate collage – disparate elements often abutting each other. It's one of those situations where you don't know it unless you see it, and in order to see it, you just have to walk. So I did an enormous amount of walking.
– Geoffrey James, interview, 13 September 2007.

Solo exhibition
Photographies européennes, 1981–1999, Centre culturel canadien, Paris

Group exhibitions
David Urban, Geoffrey James, Galerie René Blouin, Montreal
*Identificazione di un Paesaggio**, Parco Scientifico Tecnologico di Marghera, Marghera, Italy

2000–2001
Group exhibition
Pictures, Positions, Places, Vancouver Art Gallery

2001
In September, James photographs the agrarian landscape in the Mitis region of Quebec's Gaspé peninsula. The work will be exhibited in 2002 in *Regarding Landscape*. *Paris* is published in October.

Solo exhibitions
Paris, 2000, Galerie René Blouin, Montreal
*Paris: Photographies de Geoffrey James**, Centre culturel canadien, Paris
Paris: Photographs by Geoffrey James, TrépanierBaer Gallery, Calgary
*Parks and Walkways of Oshawa**, Robert McLaughlin Gallery, Oshawa, Ontario

Group exhibitions
Substitute City: Artists Infiltrate Toronto (including a collaborative work with Atom Egoyan), The Power Plant, Toronto
Escales transcanadiennes, points de vue sur la ville, Galerie d'art de l'Alliance française, Paris
TrépanierBaer Gallery, Calgary

2002
James is awarded the Gershon Iskowitz Prize for sustained artistic excellence, as well as the Roloff Beny Award for the book *Paris*.

A typical James photograph, while equally unpeopled, implies an army of off-stage extras, wearing down the stones of ancient streets, trampling Olmsted parks, operating their sinister machinery to make asbestos tailings. It is a characteristic of the James universe that humans express their place in nature as unseen agents of change and mutation.
– Robert Fulford, "Of Time and the Landscape," p. 14.

Place is published.

Dear Geoffrey,

I think *Running Fence* is very fine, but I like *Place* even more. In fact, I am giving some thought to trying to get a job in Lethbridge for a term or two, excluding only the so-called spring semester, which I might leave to the younger fellows ... So, Geoffrey, if it has been your ambition in life to deceive people, and persuade them to go to godforsaken places in search of ineffable, virtuous qualities, I guess you have succeeded.

– John Szarkowski, 2003, in John Szarkowski and Sandra Phillips, *John Szarkowski Photographs* (New York: Bullfinch Press, 2005), p. 116.

Group exhibitions
Bringing to Order: Form and Expression in Canadian Photographic Practice, Canadian Museum of Contemporary Photography, Ottawa
Regarding Landscape, presented concurrently at the Museum of Contemporary Canadian Art, Art Gallery of York University, and Koffler Gallery, Toronto; travelling to the Liane and Danny Taran Gallery, Saidye Bronfman Centre for the Arts, Montreal
Les siècles de l' image, Musée d'art de Joliette, Joliette, Quebec (permanent exhibition)
Show and Tell, TrépanierBaer Gallery, Calgary

2002–2003
Solo exhibition
Place Lethbridge: Portrait of a Prairie City: Photographs by Geoffrey James, TrépanierBaer Gallery, Calgary

2003
Geoffrey James: Past, Present, Future is published in April. Penelope Curtis, Director of the Henry Moore Institute in Leeds, England, invites James to participate in a project to examine the relationship between sculpture and gardens. He travels to Yorkshire in late spring and photographs three sites: the Yorkshire Sculpture Park, Lister Park in Bradford, and Studley Royal. The photographs will be published in 2006 in *Sculpture and the Garden*.

James begins a project with the Vancouver publishing house Douglas & McIntyre to produce the book *Toronto*.

Solo exhibitions
*Geoffrey James: Past, Present, Future**, University of Toronto Art Centre, Toronto
*The Edge of Town**, Eric Arthur Gallery, University of Toronto, Faculty of Architecture, Landscape and Design, Toronto

Group exhibitions
*Confluence: Contemporary Canadian Photography**, Canadian Museum of Contemporary Photography, Ottawa
*Spread in Prato 2** (with Peter Fischli and David Weiss, James Welling, Olafur Eliasson, Bill Henson, among others), Dryphoto arte contemporanea, various locations in Prato, Italy
What Dreams Are Made Of (with Atom Egoyan and Corinna Schnitte), Goethe Institute, Toronto

2003–2004
Group exhibition
Temporal Surfaces, Vancouver Art Gallery, Vancouver

2004
In the summer, James photographs in northern Montana for an anthology of Prairie writing; *The Wide Open* will appear in 2008, with additional photographs by Lee Friedlander and Lois Conner, and essays by the acclaimed American authors Barry Lopez, Peter Matthiessen, David James Duncan, Richard Ford, and Jim Harrison, among others. At the end of the year, James travels to New York State to begin work on a private commission.

Solo exhibitions
Geoffrey James: Zones of Contact, The Americas Society, New York
Toronto: Extended Vision, Nicholas Metivier Gallery, Toronto

Group exhibition
Future Cities, organized by the Art Gallery of Hamilton, various locations, Hamilton, Ontario

2005
James buys a wide-angle Rolleiflex camera. As part of an ongoing project to document aspects of the city of Cleveland and its surroundings, James is invited by the George Gund Foundation to contribute photographs to its annual report. He travels in the fall to Ohio and photographs Cuyahoga Valley National Park, including the Ohio Turnpike Viaduct.

Solo exhibition
Canopy, TrépanierBaer Gallery, Calgary

2005–2007
Group exhibition
*Contemporary Photography and the Garden: Deceits and Fantasies**, organized by American Federation of Arts, New York; travelling to Middlebury College Museum of Art, Middlebury, Vermont (2005); Parrish Art Museum,

Running Fence, 1999

Place, 2002

Geoffrey James, *Self-Portrait with Tree*, 2006

Toronto, 2006

Southampton, New York (2005); Columbia Museum of Art, Columbia, South Carolina (2005–2006), Tacoma Art Museum, Tacoma, Washington (2006); Cheekwood Museum of Art, Nashville, Tennessee (2006); Hudson River Museum, Yonkers, New York (2007); Delaware Art Museum, Wilmington (2007)

2006
On assignment for the *Globe and Mail*, James travels to Haida Gwai, or Queen Charlotte Islands, in British Columbia to photograph Aboriginal communities and, for the first time, the natural landscape. After returning to Toronto, he travels to Nanton, Alberta, to photograph the garden of Jim Coutts, advisor to former prime minister Pierre Trudeau.

Toronto is published.

Group exhibitions
Heteropias, Ottawa Art Gallery
Landscape: Recent Acquisitions (with Olafur Eliasson, Noriko Furunishi, David Goldblatt, An-My Lê, Sze Tsung Leong, Scott McFarland, and Clifford Ross), Museum of Modern Art, New York
TrépanierBaer Gallery, Calgary

2007
In March, James makes a brief trip to Cuba, with Toronto's Museum of Contemporary Canadian Art, to visit artists' studios. He finds himself fascinated by the visible contradiction between Cuba's idealistic socialism and the decay of central Havana. Later that spring, James travels to New York to photograph Olmsted sites once again.

In the fall, James photographs the "905" region of Toronto's suburbs. He is named Scholarly, Research and Creative (SRC) Associate at Ryerson University, Toronto, for a project to examine the patterns of settlement on the edges of the city.

It's very fashionable to sneer at the '905' region, but that is where many people choose to live. There are strange things that happen in '905,' which I am just now beginning to investigate. There's an incredible Muslim community built around a mosque, there are Italian communities. Somewhere in that somewhat tawdry environment there are a lot of people with aspirations.
– Geoffrey James, "Ugly Beauty," pp. 22–23.

Solo exhibition
Geoffrey James: Landscape and Memory, Part I, TrépanierBaer Gallery, Calgary

Group exhibitions
Roll Up: How the West Was Really Won, TrépanierBaer Gallery, Calgary
Le musée côté jardin (with Rodney Graham, Ian Hamilton Finlay, Seton Smith, among others), Musée d'art et d'histoire, Saint-Brieuc, France

2007–2008
Group exhibition
*Is there a there there?**, organized by Marnie Fleming for the National Gallery of Canada, Ottawa; travelling to Oakville Galleries, Oakville, Ontario (2007–2008); Museum London, London, Ontario (2008)

2008
Solo exhibitions
Field Notes, with artist's book, Kitchener-Waterloo Art Gallery, Kitchener, Ontario
*Utopia/Dystopia: The Photographs of Geoffrey James**, National Gallery of Canada, Ottawa

Group exhibition
Tree: From the Sublime to the Social (with Jeff Wall, Rodney Graham, Ian Wallace, et al.), Vancouver Art Gallery, Vancouver

SELECTED BIBLIOGRAPHY

Books and exhibition catalogues

Anamnèse: Pierre Boogaerts, Geoffrey James, Annette Messager, Starn Twins (exh. cat.). Essay by Philippe Dubois. Montreal: Dazibao, Centre de photographies actuelles, 1989.

Balliett, Whitney. *Alec Wilder and His Friends*. Photographs by Geoffrey James. Boston: Houghton Mifflin, 1974.

Bann, Stephen. *The Edge of Town* (exh. cat.). West Hartford, Ct.: Joseloff Gallery, University of Hartford, 1995.

Baraness, Marc, and Larry Richards, eds. *Toronto Places: A Context for Urban Design*. Photographs by Geoffrey James and Steven Evans. Toronto: University of Toronto Press, 1992.

Cahill, Kevin M., and Thomas Roma, eds. *Silent Witness* (exh. cat.). New York: The United Nations Center for International Health and Cooperation / Harper Collins, 1995.

Cawker, Ruth, ed. *Toronto: Le Nouveau Nouveau Monde* (exh. cat.). Toronto: Ruth Cawker, 1987.

Confluence: Contemporary Canadian Photography (exh. cat.). Introduction by Martha Hanna. Ottawa: Canadian Museum of Contemporary Photography, 2003.

Damisch, Hubert. *La Dénivelée: À l'épreuve de la photographie*. Paris: Éditions du Seuil, 2001.

Dessureault, Pierre. *Carnets de Voyage = Travel Journals* (exh. cat.). Ottawa: Canadian Museum of Contemporary Photography, 1994.

Diverse Secrecies: The Garden Photographed (exh. cat.). Essay by Ted Lindberg. Vancouver: The [Presentation House] Gallery, 1987.

Documenta IX (exh. cat.). 3 vol. Stuttgart: Edition Cantz; New York: Harry N. Abrams, 1992.

Eyres, Patrick, and Fiona Russell. *Sculpture and the Garden*. Aldershot, England; Burlington, Vt.: Ashgate, 2006.

Fisher, Jennifer, et al. *World Tea Party* (exh. cat.). North Vancouver: Presentation House, 1996.

Fleming, Marnie. *Is There a There There?* (exh. cat.). Essays by Marnie Fleming and Alan Sears. Ottawa: National Gallery of Canada, 2007.

Gale, Peggy. "Geoffrey James: Italian Gardens." In *1000 Words: Musings on the Medium: Six Essays on Photography* (exh. cat.), ed. Peter Hudson, pp. 16–18. Toronto: Gallery TPW, 1999.

Harris, John, and Geoffrey James. *Landscape with Ruins* (exh. cat.). London: Heinz Gallery, Royal Institute of British Architects, 1986.

Identificazione di un Paesaggio: Venezia-Marghera (exh. cat.). Ed. Sandro Mescola. Cinisello Balsamo (Milan): Silvana, 2000.

James, Geoffrey. "Atget and His Legacy." In *Eugène Atget: Six Photographs*. Edmonton: Edmonton Art Gallery, 1976.

———. *La Campagna Romana*. Montreal: Galerie René Blouin, 1991.

———. Introduction. In Sam Tata, *A Certain Identity: 50 Portraits*. Ottawa: Deneau, 1983.

———. *Entrances and Exits: The Garden as Theatre* (exh. cat.). Kingston: Agnes Etherington Art Centre, Queen's University, 1984.

———. *Genius Loci* (exh. cat.). Essay by Martha Langford. Ottawa: Canadian Museum of Contemporary Photography, 1986.

———. *Geoffrey James: Past, Present, Future* (exh. cat.). Essay by Robert Fulford. Toronto: University of Toronto Art Centre, 2003.

———. *Giardini italiani: Un pellegrinaggio fotografico* (exh. cat.). Rome: Comune di Roma / Embassy of Canada, 1985.

———. *The Italian Garden*. Essay by Robert Harbison. New York: Harry N. Abrams, 1991.

———. *Morbid Symptoms: Arcadia and the French Revolution*. Afterword by Monique Mosser. Princeton: Princeton Architectural Press, 1986.

———. *Parks and Walkways of Oshawa* (exh. cat.). Oshawa: Robert McLaughlin Gallery, 2001.

———. "The Republic of Images." In Maia-Mari Sutnik, *Responding to Photography: Selected Works from Private Toronto Collections* (exh. cat.). Toronto: Art Gallery of Ontario, 1984.

———. *Running Fence: Geoffrey James* (exh. cat.). North Vancouver: Presentation House, 1999.

———. Introduction. In Tom Gibson, *Signature 1: Tom Gibson*. Ottawa: National Film Board of Canada, 1975.

———. Introduction. In *13 Essays on Photography*. Ottawa: Canadian Museum of Contemporary Photography, 1991.

———. *Toronto*. Introduction by Mark Kingwell. Vancouver: Douglas & McIntyre, 2006.

———. Introduction. In *Transparent Things: The Artist's Use of the Photograph: Works from the Canada Council Art Bank*. Ottawa: Canada Council Art Bank, 1977.

James, Geoffrey, and Hubert Damisch. *Paris* (exh. cat.). Paris: Services culturels de l'Ambassade du Canada, 2001.

James, Geoffrey, and Rudy Wiebe. *Place: Lethbridge, a City on the Prairie*. Vancouver: Douglas & McIntyre, 2002.

Lamarche, Lise, and Guy Mercier. *Terrains vagues / Unspecified*. Photographs by Geoffrey James et al. Quebec City: Éditions J'ai VU, 2000.

Lambert, Phyllis, ed. *Viewing Olmsted: Photographs by Robert Burley, Lee Friedlander, and Geoffrey James* (exh. cat.). Montreal: Canadian Centre for Architecture, 1996.

Langford, Martha. *Beau: A Reflection on the Nature of Beauty in Photography* (exh. cat.). Ottawa: Canadian Museum of Contemporary Photography, 1992.

Lessard, Michel, ed. *Montréal au XXᵉ siècle: Regards de photographes*. Montreal: Éditions de l'Homme, 1995.

Marchand, Sandra Grant. "Geoffrey James."

In Josée Bélisle et al., *La Collection: Tableau inaugural* (exh. cat.), pp. 415–20. Montreal: Musée d'art contemporain, 1992.

Mitchell, Michael. "James, Geoffrey." In *Contemporary Photographers*, 2nd ed., ed. Colin Naylor, pp. 498–500. Chicago and London: St. James Press, 1988.

Newlands, Anne. "Geoffrey James." In *Canadian Art from Its Beginnings to 2000*, p. 160. Willowdale, Ont.: Firefly Books, 2000.

Padon, Thomas. *Contemporary Photography and the Garden: Deceits and Fantasies* (exh. cat.). New York: Harry N. Abrams, 2004.

Phillips, Sandra S., et al. *Crossing the Frontier: Photographs of the Developing West, 1849 to the Present* (exh. cat.). San Francisco: San Francisco Museum of Modern Art, 1996.

Rhodes, Richard. *Asbestos: Geoffrey James* (exh. cat.). Toronto: The Power Plant, 1994.

Smith, Annick, and Susan O'Connor, eds. *The Wide Open*. Photographs by Geoffrey James et al. Lincoln, Nebraska: University of Nebraska Press, 2008.

Swain, Robert. *Hidden Values: Contemporary Canadian Art in Corporate Collections* (exh. cat.). Introduction by Robert Fulford. Vancouver: Douglas & McIntyre, 1994.

Tazzi, Pier Luigi, ed. *Spread in Prato* (exh. cat.). Prato: Commune di Prato and Dryphoto arte contemporanea, 2003.

Trépanier, Esther. *Univers urbains: La représentation de la ville dans l'art québécois du XXᵉ siècle* (exh. cat.). Quebec City: Musée du Québec, 1998.

Tuer, Dot. "Photographing against the Grain." In *Le Souci du document: Le Mois de la Photo à Montréal 1999* (exh. cat.), ed. Pierre Blache et al., pp. 68–70. Laval, Que.: Éditions Les 400 coups, 1999.

Van Keuren, Philip. *Vista to View: The Panoramic Image in Landscape Photography* (exh. cat.). Dallas: The Gallery at Southern Methodist University, 1993.

Watson, April. "Geoffrey James." In *Catalogue of Photography*, ed. Tom E. Hinson, pp. 204, 444. Cleveland: The Cleveland Museum of Art, 1996.

Weiermair, Peter. *Prospect 96: Photography in Contemporary Art* (exh. cat.). Frankfurt am Main: Stemmle, 1996.

Work, Workers, Works: Rearranging the Land (exh. cat.). Essays by Robert Bean and Susan Gibson Garvey. Halifax: Dalhousie University Art Gallery, 1997.

Yajima, Michiko. "Geoffrey James." In *Elementa Naturae* (exh. cat.), p. 40. Montreal: Musée d'art contemporain, 1987.

Young, Brian. *Respectable Burial: Montreal's Mount Royal Cemetery*. Photographs by Geoffrey James. Montreal: McGill-Queen's University Press, 2003.

Periodicals

Allemang, John. "Book a Day." *Globe and Mail* (Toronto), 30 October 2006.

Amery, Colin. "Rich Crop of Exhibitions in London." *Financial Times* (London), 17 November 1986.

Anderson, Jack. "Challenging Convictions: 'Running Fence' Illustrates Political Ideologies." *The Leader-Post* (Regina), 30 July 1998.

Aquin, Stéphane. "Geoffrey James." *Voir* (Montreal), 30 January 1997, p. 40.

———. "Paysages choisis." *Voir* (Montreal), 17 August 1994, p. 26.

Baele, Nancy. "Voyages in Inner Space." *Gazette* (Montreal), 30 July 1994.

Barber, John. "Move Over Pinup Girls, The New Calendar Hotties are Tall, Strong and Rugged." *Globe and Mail* (Toronto), 27 November 2004.

Blackwell, Adrian. "Review of *Toronto*." *Prefix Photo* 15 (Fall 2007): 87.

Bogardi, Georges. "To Montreal, Photography by Geoffrey James." *Canadian Art* 9, no. 3 (Fall 1992): 52–59.

Brayshaw, Chris. "Border Histories." *Border Crossings* 17, no. 4 (October 1998): 66–67.

Campeau, Sylvain. "Corriger les lieux, après la photographie de voyage." *Parachute*, no. 64 (October–December 1991): 47–48.

Chambers, Douglas. "Paradise Lost." *Canadian Art* 2, no. 2 (Summer 1985): 58–61.

Charron, Marie-Ève. "Un monde divisé." *La Presse* (Montreal), 18 September 1999.

Chu, Ingrid. "Neither Here / Nor There: Zones of Contact in the Work of Geoffrey James." *Review: Literature and Arts of the Americas* 37, no. 2, issue 69 (2004): 315–17.

Couëlle, Jennifer. "Bien sages voyages." *Le Devoir* (Montreal), 25–26 May 1996.

———. "Paysages." *La Presse* (Montreal), 1 April 2000.

———. "Photos et sculptures en Bretagne." *Le Devoir* (Montreal), 25–26 May 1996.

———. "Review of *Travel Journals*." Exhibition review. *CVphoto* 36 (Fall 1996): 34.

Cron, Marie-Michèle. "Sur la route." *Le Devoir* (Montreal), 13–14 August 1994.

Dault, Gary Michael. "James Zooms in on Toronto." *Globe and Mail* (Toronto), 15 October 2004.

———. "Seeing through America." *Canadian Architect* 41 (October 1996): 22–25.

"Deux expositions à la galerie René Blouin." *Le Devoir* (Montreal), 28 April 1987.

Dillon, David. "Fresh Views of the Familiar." *Dallas Morning News*, 3 September 1993.

Doyon, Jacques. "Geoffrey James: The Lethbridge Project." *CVphoto* 50 (Spring 2000): 7–14.

Duncan, Ann. "Montrealer Turns His Attention from Gardens to Slag Heaps." *Gazette* (Montreal), 29 January 1994.

Durand, Régis. "Uses of the Image, Uses of the World." *Artpress* (Paris), no. 180, May 1993.

Enright, Robert. "Gardening Utopia: An Interview with Geoffrey James." *Border Crossings* 9, no. 1 (Winter 1990): 11–14. Also published as "Geoffrey James: Gardening Utopia." In *Peregrinations: Conversations with Contemporary Artists*, pp. 270–73. Winnipeg: Bain and Cox, 1997.

———. "Viewfinder: The Photography of Geoffrey James." *Border Crossings* 21, no. 1 (February 2002): 44–57.

Fabo, Andy. "Unravelling the Grid: 'Substitute City' at the Power Plant." *C Magazine*, no. 70 (Summer 2001): 34–36.

Faust, Gretchen. "Geoffrey James ..." Review of Twining Gallery exhibition, *Arts Magazine* (New York) 66 (February 1992): 85.

Fisher-Taylor, Gail. "Genius Loci." Book review. *Photo-Communiqué* 9, no. 2 (Summer 1987): 38.

Freedman, Adele. "Olmsted Captured by Three Photographers." *Architecture*, December 1996, p. 33.

Gale, Peggy. "Reviews: Morbid Symptoms, Genius Loci." *Canadian Art* 4, no.2, (Summer 1987): 91–92.

Genocchio, Benjamin. "Welcoming Gardens, Whispering 'Photograph Me.'" Exhibition review of *Contemporary Photography and the Garden. New York Times*, 11 March 2007.

"Geoffrey James: New found land." In "New Eyes: Scenes from the Millennium, Reimagined by Living Artists." Special issue, *New York Times Magazine*, 19 September 1999.

"Geoffrey James Wins Iskowitz Prize." *Globe and Mail* (Toronto), 13 May 2002.

Gessell, Paul. "Running Fence Captures Bleak Divide." *Ottawa Citizen*, 1 March 1999.

Godfrey, Stephen. "Symbolic Reports on the Essence of Mount Royal." *Globe and Mail* (Toronto), 11 July 1991.

Gopnik, Adam. "Olmsted's Trip." *New Yorker*, 31 March 1997, pp. 96–104.

Gopnik, Blake. "Don't Fence Me In." *Globe and Mail* (Toronto), 4 December 1999.

Gusella, Enrico. "Porto Marghera, Storia di un Paesaggio." *La Nuova Venezia*, 3 October 2000.

Guzman, Antonio. "Geoffrey James: Paris." Exhibition review. *Critique d'art* (Paris), no. 19, Spring 2002, p. 93.

Hagen, Charles. "Art in Review." *New York Times*, 12 June 1992.

Hale, Barrie. "Fine Arts Finest: The Powers behind Canadian Art: What They See Is What You Get." *Canadian Magazine*, 29 March 1975.

Hakim, Mona. "Geoffrey James – Charles Gagnon." Exhibition review. *Le Devoir* (Montreal), 26–27 March 1994.

Hilderbrand, Gary R. "Reviews: Viewing Olmsted." *Land Forum*, Harvard University Graduate School of Design, Spring/Summer 1998, n. p.

James, Geoffrey. "André Kertész." *Vie des arts*, no. 57 (Winter 1969–70): 52–55.

———. "Eight Photographs for Frederick Law Olmsted." *Rubicon*, no. 10 (Fall 1988): 41–55.

———. "Erickson: The Architect as Superstar." *Time* Canada, 14 February 1972, pp. 16–21.

———. "Every Picture tells A(nother) Story." *Globe and Mail* (Toronto), 31 December 2005.

———. "Gabor Szilasi Photographs Charlevoix County." *Vie des arts*, no. 62 (Spring 1971): 46–49.

———. "Marghera." Photographs. *Descant*, no. 129 (Summer 2005): 168–76.

———. "Olmsted: Some Other Space." *Descant*, no. 79/80 (Winter/Spring 1992/1993): 113–24.

———. "Pictures from an Explosive World." On Jeff Wall. *Maclean's*, 11 January 1988, pp. 54–55.

———. "A Project for Parachute." *Parachute*, no. 44 (September–November 1986): 9–12.

———. "Responding to Photographs: A Canadian Portfolio." *artscanada* 31, nos. 3 and 4 (December 1974): 1–7. Also published in *An Inquiry into the Aesthetics of Photography*, ed. Anne Trueblood Brodzky et al. Toronto: Society for Art Publications, 1975.

———. "Running Fence." *C Magazine*, no. 57 (February–April 1998): 24–28.

———. "Selections from the Lethbridge Project." *Prefix Photo* 2 (Winter 2001): 62–69.

———. "To Munich, with Many Emotions." *Globe and Mail* (Toronto), 15 November 2003.

———. "Triumph of an Outcast." *Maclean's* 101, no. 22 (23 May 1988), pp. 30–38.

Johnson, Ken. "Art in Review: Geoffrey James – Zones of Control." *New York Times*, 30 July 2004.

Kozinska, Dorota. "Exploring a Human's Place in the Context of Technology." *Gazette* (Montreal), 19 January 1997.

Kozloff, Max. "Olmsted." *Canadian Art* 13, no. 4 (Winter 1996): 50–58.

Kuspit, Donald. "Documenta: The Atmosphere of Anomie." *C Magazine*, no. 35 (Fall 1992): 20–28.

Lamarche, Bernard. "Le Mur de la Honte." Exhibition review of *Running Fence*. *Le Devoir* (Montreal), 11 September 1999.

LeBlanc, Dave. "Collecting for the Future." *Globe and Mail* (Toronto), 12 May 2006.

Lehmann, Henry. "Border Fence Takes on Psychic Significance." *Gazette* (Montreal), 25 September 1999.

———. "James Photos Shed New Light on Old Sites." *Gazette* (Montreal), 12 April 1990.

———. "A Portrait of Paris without Monuments." *Gazette* (Montreal), 27 October 2001.

MacCallum, Peter. "Geoffrey James: The Power Plant, Toronto." Exhibition review. *C Magazine*, no. 41 (Spring 1994): 56–58.

MacKay, Gillian. "Images to Wander through, If Only in the Mind." *Globe and Mail* (Toronto), 12 May 2001.

Martin, Sandra, "Depth of Field." *Globe and Mail* (Toronto), 22 May 2002.

Mays, John Bentley. "Geoffrey James: Brilliant Urban Images." *Globe and Mail* (Toronto), 10 April 1995.

———. "Growing Pains." *Canadian Architect*, June 2004, pp. 14–16.

———. "James Focuses on French Utopias: Exposing the Twilight of the Liberal Dream." *Globe and Mail* (Toronto), 16 May 1987.

———. "Marghera Revisited and Revised." *Descant*, no. 129 (Summer 2005): 177–81.

———. "Nine Canadian Artists, Nine Remarkable Choices." *Globe and Mail* (Toronto), 16 June 1992.

———. "Portrait of a Landscape as Ambiguous." *Globe and Mail* (Toronto), 18 December 1993.

———. "Three to Watch: Geoffrey James." *Globe and Mail* (Toronto), 27 December 2001.

———. "Toronto the Beautiful." *Globe and Mail* (Toronto), 15 November 2003.

Mead, Andrew. "Viewing Olmsted." Book review. *The Architects' Journal*, 26 June 1997, p. 61.

Milroy, Sarah. "Island Spirits Rising." Photographs by Geoffrey James. *Globe and Mail* (Toronto), 27 May 2006.

———. "A Photographer's Double Vision." *Globe and Mail* (Toronto), 10 May 2003.

Morill, Apollonia. "Borders and Others: The Politics of the Documentary." *Camerawork* 27, no. 1 (Spring/Summer 2000): 22.

Morrone, Francis. "The Way Olmsted Saw." *New Criterion* 15, 1997.

Mosser, Monique. "Geoffrey James: De l'esprit des lieux." *Beaux Arts Magazine* (Paris), no. 57 (May 1988): 84–89.

———. "Stops on a Fantastic Itinerary." *Lotus International* (Milan) 52 (1986): 73–86.

Muschamp, Herbert. "Sunday in the Park with Fred: Visualizing Olmsted's Legacy." *New York Times*, 28 February 1997.

Naylor, David. "Viewing Olmsted." Book review. *Journal of the Society of Architectural Historians* 59, no. 1 (March 2000): 134–36.

Ollivier, Sylvie. "Les chemins panoramiques de Geoffrey James." *Vie des arts*, no. 140 (Fall 1990): 71.

Pascucci, Ernest. "Viewing Olmsted." *Artforum* 35, no. 6 (February 1997): 85.

Power, Mark. "Dazzled in an Olmsted Park." *Times Literary Supplement* (London), 11 July 1997, p. 10.

Rochefort, Jean-Claude. "Inquiétantes topiques de l'urbanité contemporaine." Exhibition review of *Substitute City. Le Devoir* (Montreal), 19–20 May 2001.

Rochon, Lisa. "The Good, the Bad and the Ugly." *Globe and Mail* (Toronto), 4 April 2001.

Schwabsky, Barry. "Geoffrey James: Centre Culturel Canadien – Paris." *Artforum* 40, no. 6 (February 2002): 139.

Scott, Michael. "Bordering on the Desperate: Photos Show U.S. and Mexican Corruption." *Vancouver Sun*, 9 May 1998.

———. "Haunting Images Capture Spirit of Chateau Abandoned Long Ago." *Weekend Sun* (Vancouver), 25 May 1996.

Sischy, Ingrid. "Goings on About Town: Photography." Review of *The Italian Garden. New Yorker*, 15 July 1991, p. 12.

Süto, Wilma. "The Artists in Documenta IX." Supplement to *Archis*, no. 6 (1992).

Szarkowski, John. "17 January 2003, To Geoffrey James." In John Szarkowski and Sandra Phillips, *John Szarkowski Photographs*, p. 116. New York: Bullfinch Press, 2005.

Tazzi, Pier Luigi. "Rome: Geoffrey James." *Artforum* 24, no. 3 (November 1985): 114–15.

Temin, Christine. "Revisiting Olmsted's Grand Vistas." *Boston Globe*, 12 September 1997.

Thornton, Gene. "Critics' Choices." *New York Times*, 10 January 1988.

Wallace, Ian. "Geoffrey James: Coburg Gallery, Vancouver." *Vanguard* 12, no. 7 (September 1983): 50.

Walton, Mark. "Subtly Exposing the Socio-economic Landscape." *FFWD* (Calgary), 10 December 1998, n. p.

Watson, Petra Rigby. "The Art of Gardening." *Border Crossings* 12, no. 4 (October 1993): 72–74.

———. "Reviews: Geoffrey James, Equinox Gallery, Vancouver." *C Magazine*, no. 28 (Winter 1991): 55–56.

Woodward, Richard B. "Carving Green Out of Urban Gray." *New York Times*, 5 January 1997.